PHOTOCRAFTY

75 creative camera projects for you and your **digital SLR**

Photocrafty
Published in the United Kingdom in 2012 by
Punk Publishing Ltd
3 The Yard
Pegasus Place
London
SE11 5SD

www.punkpublishing.co.uk
www.photocrafty.net

A catalogue record of this book is available
from the British Library.

ISBN 978-1-906889-57-9

10 9 8 7 6 5 4 3 2

PHOTOCRAFTY

75 creative camera projects for you and your **digital SLR**

Sue Venables

CRAFTWERK

HIT THE LIGHTS!

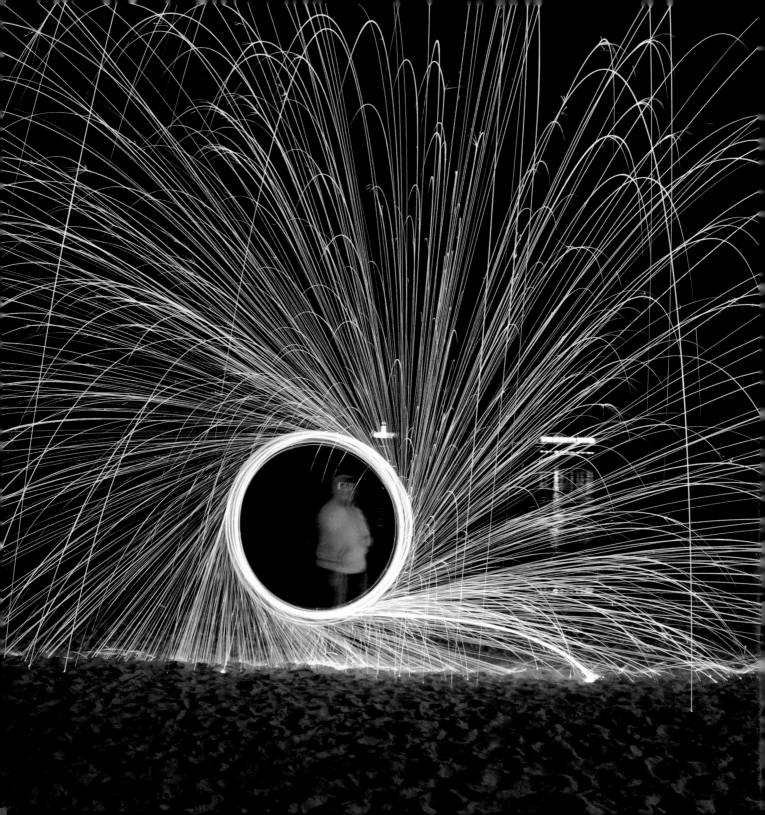

INTRODUCTION

It's probably a miracle that I'm interested in photography at all. One of my earliest childhood memories is of sitting on my grandfather's knee while he showed me endless photographs of flowers and trees. He would often explain that the main subject (a squirrel, butterfly or rabbit) had just left the frame! Then there were the patient explanations from Uncle Ginge on how to get a correct exposure on a camera by balancing the aperture, ISO and shutter-speed settings – handy stuff, but it caused my seven-year-old brain to freeze. Art school didn't manage to convert me either: there was a standard joke that you could recognise a photography student as they were skinny, wore black and had cash to splash on expensive equipment – that wasn't me.

It was the advent of the DSLR camera that saw me bitten by the shutterbug. I suddenly *got* photography and photography got me. DSLRs are brilliant. I love the fact that you can take millions of images at no additional cost and are able to review these instantly; no fumbling around in a dark room, splashing chemicals on blank paper and hoping for the right image to appear. I also learned that taking fantastic shots doesn't require fancy bits of kit, or getting too involved in the inner workings of your camera. It's all about thinking up ideas, experimenting and having fun.

I started writing this book because more and more of my friends had bought fancy DSLR cameras, only to keep them parked in 'auto', which is the photographic equivalent of owning a Porsche and only ever driving it to the corner shop! So *Photocrafty* is aimed at taking you out of first gear and onto the photographic superhighway.

The 75 featured projects range from mastering basic camera techniques like the Rule of Thirds (p16) and Shutter Zoom (p24) to the more creative and crafty: attaching helium balloons to your camera to create aerial photographs (see p202) or drilling your camera cap to shoot lens-free (see p134). Nothing is overly complicated, though; each project has a step-by-step guide and is illustrated by how-to photos. And, conveniently, so many of the crafty contraptions can be made simply from things you'll find in your recycling box. You will be amazed at the results that can be achieved from using inexpensive materials and low-fi equipment.

Along the way, I promise not to melt your brain with elitist camera-geek jargon – although there is a glossary to turn to, should you need it (p218). And with every project you do (we've tried to order them sensibly), you'll find yourself gaining camera confidence while producing a cool collection of engaging images. Whether you're just starting out with photography or already know the ropes, the pages in *Photocrafty* offer exciting shooting opportunities galore – which is bound to liven up your approach to photography.

I hope you enjoy the journey. I'd love to see how you are getting on, so feel free to contact me at www.photocrafty.net.

HAPPY SHOOTING!

SUE VENABLES

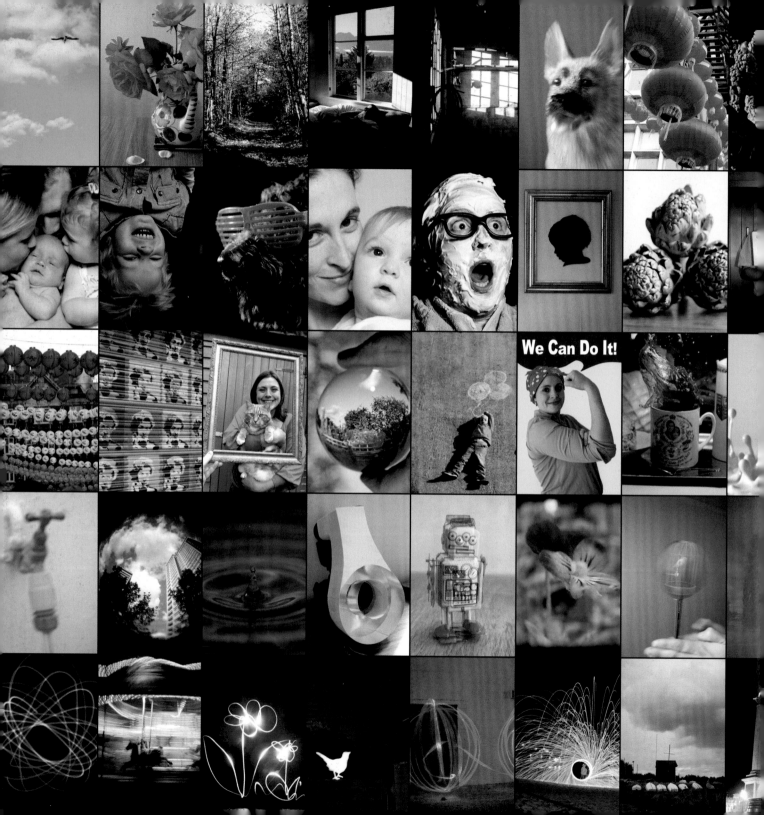

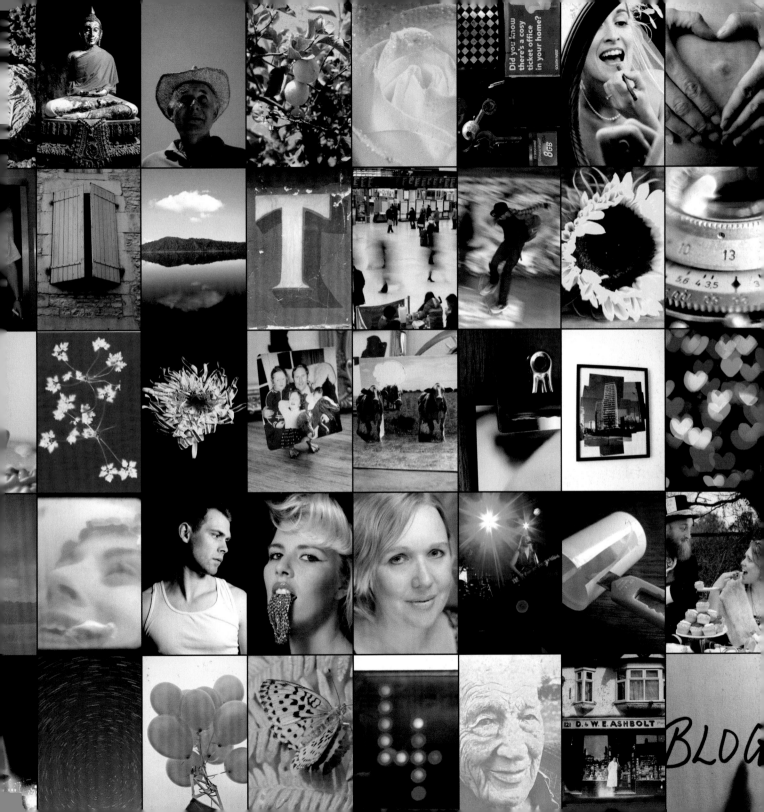

FUNDAMENTALS

MOGIC (MOMENTS OF MAGIC)

kit

- Any kind of camera
- Some mogic to capture on it

The photograph was created to capture a given moment and immortalise it in its printed form. And today, despite the all-singing, all-dancing arrival of the digital age, this principle remains a constant – now we can simply store the immortalised moment on a computer, or other electronic device, as an alternative to having it printed.

Mastering your Mogic (moments of magic) isn't so much a project you can do with your camera; it's more a philosophy for life. Be active in your quest for these magic moments. The more you look, the more you'll see: mogic everywhere. To optimise those often fleeting fractions-of-a-second, where matter and light create something greater than the sum of their parts, you need to have a camera with you at *all times*.

It doesn't matter what camera you use to capture your mogic; it certainly doesn't have to be a fancy one. The best camera is always the one that you have with you at the time. If you own a 21-pixel DSLR and don't take it out, but always have your camera-phone on you, then your camera-phone is definitely the better camera when it comes to capturing mogic.

So, whether it's an iPhone, a little compact or a snazzy camera from your kit bag, keep your mogic-capturing device with you at all times. If you don't, you're unlikely to become a Mogic Master.

If you're in need of a little inspiration and *je ne sais quoi* when it comes to recognising a moment of magic, then take a little look at the works of French artist and photographer Henri Cartier-Bresson. He was a great proponent of the 'decisive moment', as is evident from his compelling reportage photographs, and helped to develop Street Photography, as well as having an amazing eye for geometric composition in his photos.

So, discover the Henri in you, and we're sure you'll never suffer any *ennui* when it comes to taking shots filled with mogic.

Just remember to always take your camera with you, and happy snapping!

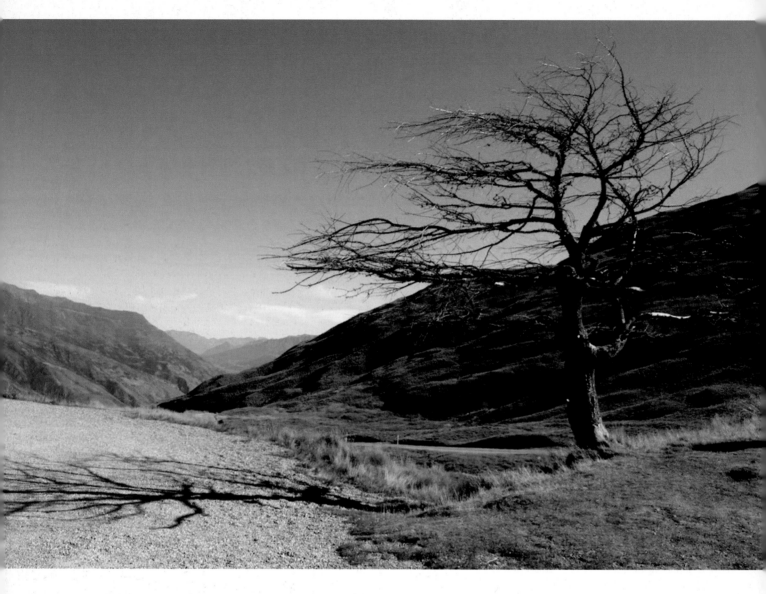

simple but effective

RULE OF THIRDS

I'm not big on rules, but sometimes it's worth learning them just so that you can break them later on! So, here's the learning part:

The rule of thirds is a basic composition guideline. It is essentially to do with dividing the frame of your image into thirds, on both the vertical and horizontal axes. The points at which the axis lines cross are known as 'power points' (see below). These meeting spots are where, according to the rule of thirds, you should position the focal point of your image.

The idea is that by placing the focus on one of these intersecting points, you are creating a sense of balance within the frame of your picture.

So, according to the rule of thirds, image B has a better composition than image A (below), because the flowers comprising the main part of the object are placed on one of the power points.

Paying attention to the rule of thirds when it comes to landscape photography is also very useful when you're considering where to place your horizon line. It is better to avoid placing the horizon line smack-bang in the middle of the image. Instead, try placing it on either the upper or lower horizontal axis line of the frame.

Take a look at the image opposite and mentally sketch in the axes of the thirds. That way, you should be able to see that the tree is within the vertical right third, while the bottom of the tree is within the lowest horizontal third. This kind of placement gives a well-balanced and harmonious feel to the image.

So, to master this technique, go out and take photos that adhere to the rule of thirds. See how it improves your composition, and before long it will become second nature.

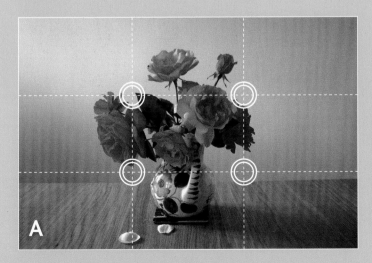

A

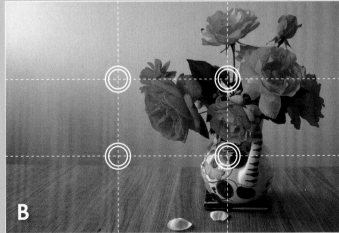

B

DO YOUR LINES

kit
- DSLR
- Lines

Lines are integral tools when it comes to mastering good composition in your photographs. They can add a strong graphic element and lead the viewer's eye around the image. So, before you press the shutter button, always check your lines.

There are four main types of line that can be used in an image to aid composition. These are: horizontal, vertical, radial and diagonal.

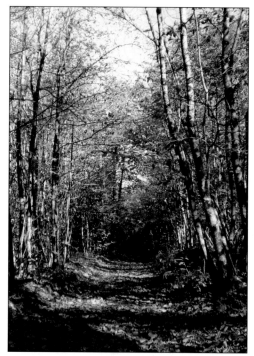

2: Vertical

Strong vertical lines can add a sense of strength and power to an image (think trees and skyscrapers). To exaggerate these lines in your image, it's often a good idea to physically turn your camera to create a portrait rather than a landscape, in order to add more drama to the vertical lines. Alternatively, if the vertical lines in your image are very strong, it might be a good idea to take a landscape shot instead, to give a sense of containment to them. Whichever way up your camera is, though, remember to keep it as straight as possible — if your camera is wonky, it will show in the resulting image.

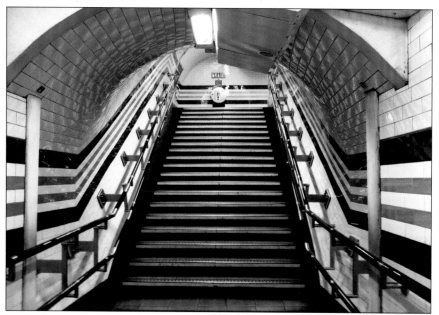

1: Horizontal

Strong horizontal lines, such as those created by a fallen tree in a forest, a horizon or a dog lying flat-out, fast asleep, can add a sense of harmony and calm to a photo. If you want to emphasise this sense of calm, then take a landscape shot, as this will increase the width of the horizontal line. However, it's important to bear in mind that a photo with strong horizontal lines can sometimes look a little too static, even to the point of seeming dull.

3: Radial

Radial lines, such as those created by the leaves fanning out from a palm tree, or a spiral staircase, 'burst out' from a central point or line. These lines can be really visually exciting to explore as they force the eye to the centre of an image and back out again. Once you start noticing radial lines, you'll see them everywhere, from umbrellas to the petals around a flower and the spokes on your bicycle.

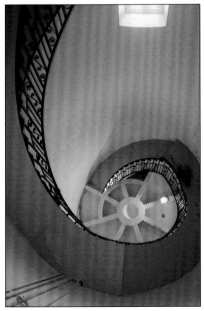

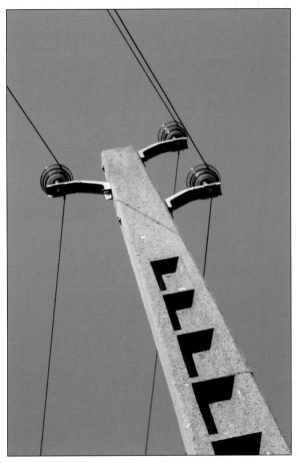

4: Diagonal

Strong diagonal lines can really lift photos, giving the sense of 'whizzing around the page'. But be careful when composing shots with strong diagonals; make sure that the line doesn't start in one corner of the frame and finish in the opposite one, as this can be a little predictable. It's far better if the line starts on one side of the image and ends up at another.

THE BEST WAY TO EXPLORE HOW YOU MIGHT USE DIFFERENT LINES WHEN COMPOSING YOUR PHOTOS IS TO TAKE A CLOSER LOOK AT PHOTOGRAPHS YOU'VE ALREADY TAKEN. SEE HOW THE LINES WORK IN THEM FROM A COMPOSITIONAL POINT OF VIEW – WHAT LOOKS GOOD AND WHAT DOESN'T? THEN GO OUT AND TRY REPEATING THE 'SUCCESSES' IN DIFFERENT LOCATIONS.

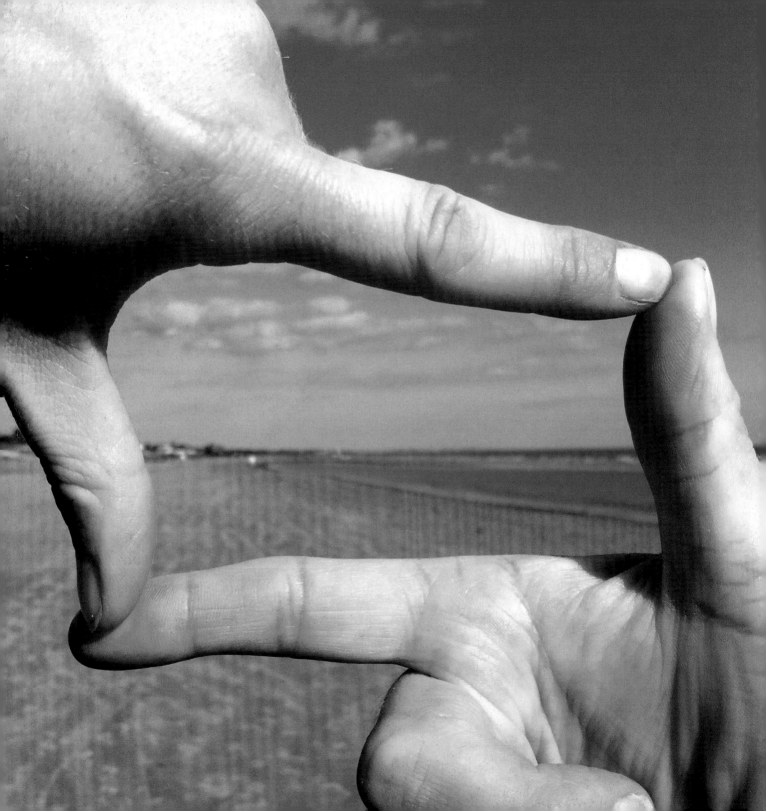

FRAMING

kit

- DSLR
- A natural frame

No, I'm not talking about the frame you put around a picture on a wall! This concerns how one element of your photograph can work to draw attention to another element.

Framing leads your eye towards the focal point of a picture, giving the photographer a certain amount of control over what the viewer looks at. As with reflections (see p70), framing adds another visual layer to the image. Whether the framing is subtle (like the arching pillars in the photo below) or overt (like the fingers in the image opposite), natural frames add a little mystery and intrigue for the viewer's eye.

- Look for opportunities for your subject to be framed by something else. The something else might be a foreground object that you shoot through, like long grass. Alternatively, it might be something behind your subject – an archway, for example – which gives you the 'frame'.
- Before you take the shot, it's important to tell the camera which area of the image is most important and, therefore, should be in focus, as the viewer's eye is always drawn to the sharpest area of an image. To do this you can either use selective focus (take a look at your camera's instructions manual) or manual focus.
- When you are happy, just press the shutter button.

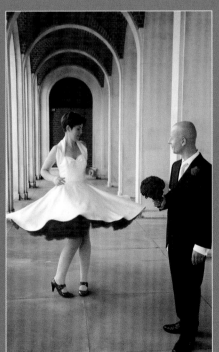

What's a frame?
A frame could be a fence in the foreground of an image or the soft leaves on a tree that draw attention to the church spire (right), or it could be the hard frame of a mirror or window.

The beautiful bride (left) is being framed by the pillars she is dancing between, as well as the door behind her.

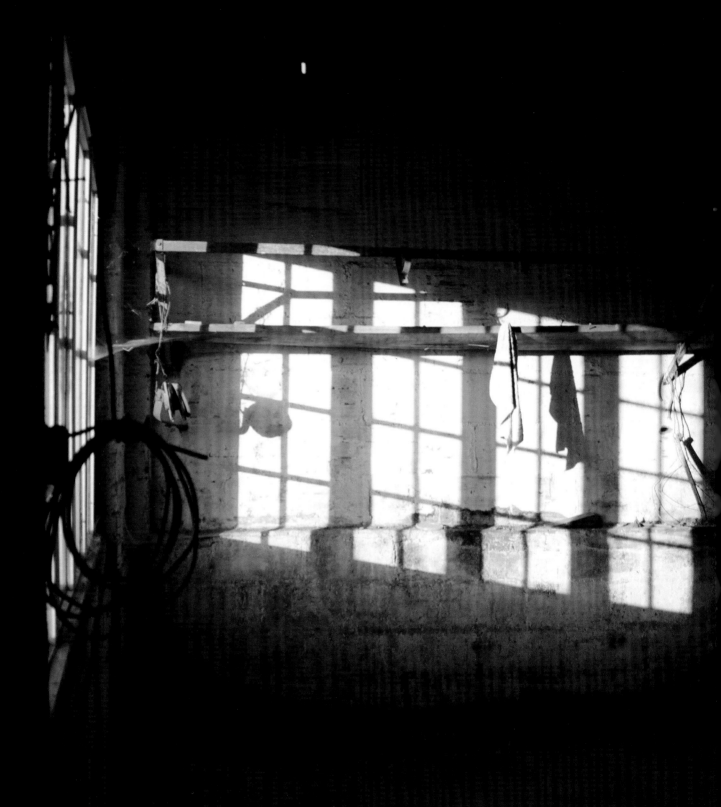

SHADOWS

kit
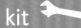

- DSLR
- Sunshine
 (or a table light/
 flash)

Shadows are often considered to be the support act to the show-stopper (the photo's subject). But it's time to give the underdog a chance and get involved in a little shadowy behaviour...

In order to photograph shadows, you need to be shooting either very early or very late in the day. The best shadows are captured when the sun is low in the sky (in the morning and afternoon). For a creative photograph, making a shadow the main focal point can add humour, visual interest and intrigue.

The picture opposite shows how a humble garage can be transformed: the presence of shadows has elevated an otherwise uninspiring view. The low sun has illuminated specific areas of the garage with splashes of golden light, while the hanging towel gives an additional focal point. Without the shadows, the image would be flat and dull. The criss-crossing lines from the window frames' shadows and the shelves add visual interest too.

The good news for those who don't want to get out of bed too early, or stay up too late, is that you don't always have to be in sync with the sun; just use a table light or a flash to create a shadow instead.

Silhouette

A silhouette is a very dark shadow of an object or subject that has a clearly defined outline. Silhouettes can often make interesting images, providing that the dark shape is immediately recognisable (see p60, Victorian Silhouettes).

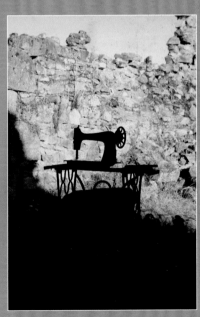

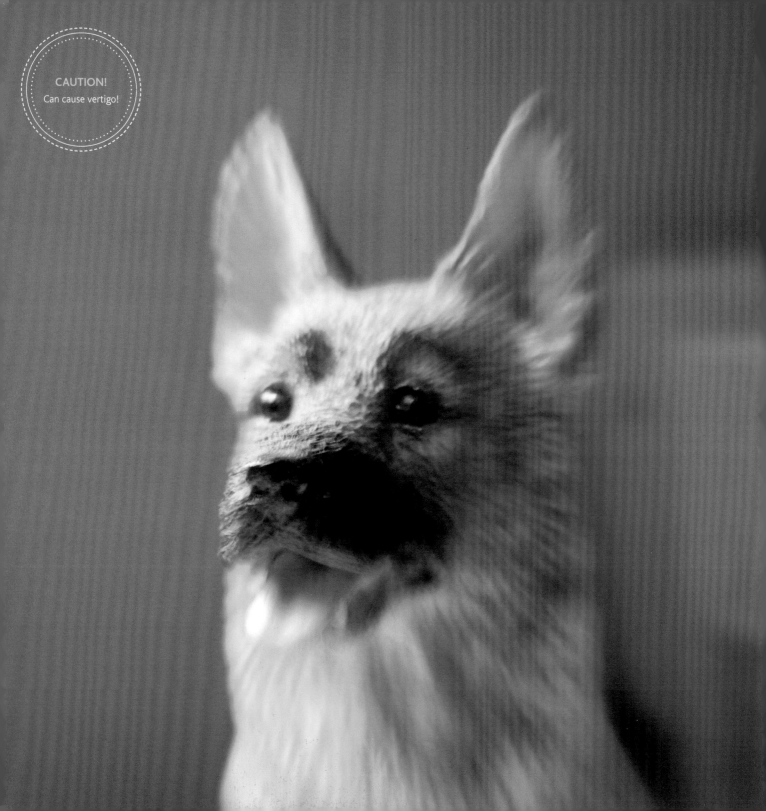

CAUTION!
Can cause vertigo!

SHUTTER ZOOM

kit
- DSLR
- Tripod (optional – but handy for low-lighting situations)

Shutter zoom creates the visual effect of something crashing into focus, and it's a very popular tool in post-production imaging software. But master this technique and you won't need any of that fancy kit. Get ready to give your images some drama...

First of all, carefully select a scene or an object that you think would look good using this technique. Lights at night can be really effective, as can flowers, spiders and clocks. The nature of this kind of shot portrays an almost startling image to the viewer, so I always try to use things that could surprise or spook someone...

- The basic principle of this technique is to trigger the shutter while you're zooming (it doesn't matter whether you zoom in or out; just try to make the zooming as smooth as possible). So, to allow for the shutter-zoom effect to register on the camera sensor, the shutter speed has to be fairly slow.
- The slower the shutter speed, the more the dramatic the zoom effect will look. To help you get a steady shot and to free up your hands, use a tripod.
- Put the camera in shutter priority mode and select a speed of 1/50 of a second or slower. (The photos on this page were actually taken at 1/8 of a second.)
- Before taking the shot, practise zooming a few times until you have a nice smooth movement.
- When you're happy with your zooming technique, you're ready to press the shutter button on your next attempt!

The amount of shutter zoom has a dramatic effect on the final image (see the examples below).

small amount of shutter zoom

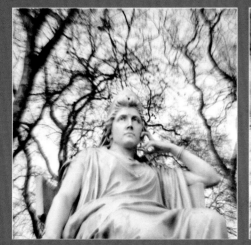

large amount of shutter zoom

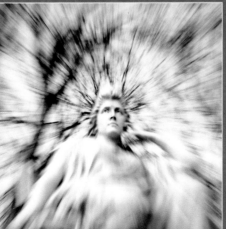

scary amount of shutter zoom!

WORKING WITH...

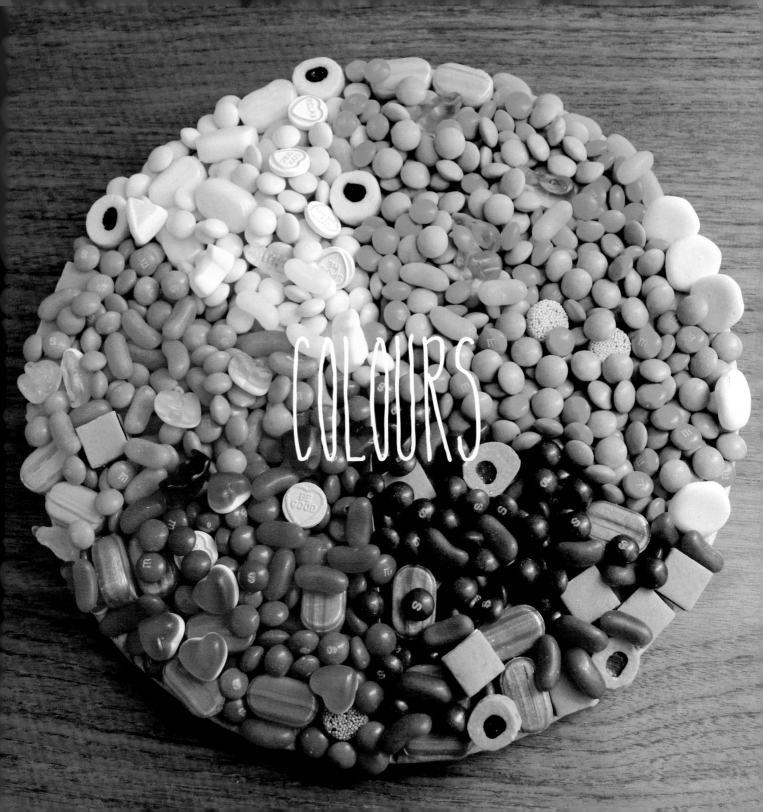

COLOURS

kit

- DSLR
- A keen eye for colour

Seeing colour has a real effect on our emotions. Different shades of the stuff can make us feel happy, excited, irritated, calm, angry or even amorous...

So knowing a little about colour can really help to infuse your images with emotion and meaning. The ability to sway the mood of your viewers is an important asset for any photographer.

Although black-and-white and sepia photos are powerful in their own rights, colour brings an immediate sense of vibrancy to a photograph and is also able to influence and compel the viewer; so, by working with colours in your photographs you're connecting with a viewer's human instincts.

Colours are impactful on the human eye because they affect us on a physical level. Certain colours can speed up our heart rate, make us breath faster, and alter our blood pressure, appetite and body temperature, while others can soothe and calm us. Each colour has its own electromagnetic wavelength; it is thought that these different wavelengths have varying effects upon us. This project will not only help you to kiss goodbye to dull and boring pictures, but will also reveal the different emotional effects that colours can conjure.

It's simple, really; all you need to do is to go on a photographic scavenger hunt that focusses on one particular colour. This activity will help heighten your understanding of the surrounding environment, and you should return with a fantastic themed selection of images as well.

SEEING RED

These are colours that lie opposite to one another on a colour wheel (see the example on p27).

COMPLEMENTARY COLOUR

These are colours that lie opposite to one another on a colour wheel (see the example on p27).

Red's complementary colour is green. This means that when red and green appear next to each other, both colours appear brighter and form an aesthetically pleasing match.

Red is a powerful colour that's often associated with extreme emotions and events, such as passion, love, anger, war, danger, blood, determination and strength.

In fact, the colour red has been proven to directly effect humans physically; apparently it is able to raise metabolisms and speed up respiration. Perhaps this is something that we have Mother Nature to thank for: an extremely visible colour, red is used as part of the natural world's warning system – hence it's the colour of many poisonous plants and animals.

We often use red in the man-made world, too – for instance, on road signs warning of dangers ahead. Its eye-catching visibility has inevitably also lead to retailers and other industries using it to grab attention. How many 'Sale' signs have you noticed that are red?

In photography, the colour red is often used to evoke passion and desire – think of red lips or the Lady in Red, for example. Head off in search of all things red and see what kind of emotions they provoke in your viewers when you print your images and show them off.

COMPLEMENTARY COLOUR

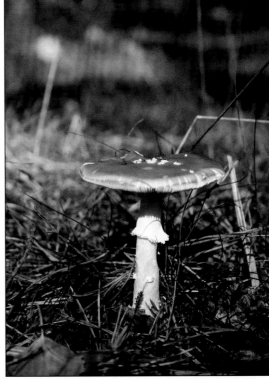

GREEN WITH ENVY

COMPLEMENTARY COLOUR

Green's complementary colour is red (see p27 for the colour wheel).

Green is the colour of nature and, as such, symbolises harmony, growth, stability, freshness and fertility.

Its effect on us is said to be the most calming of all the colours, because the eye finds it restful. So, if you want to create a photograph for, say, a bedroom, green would be a good colour to use. Green is opposite to red in that it often signifies safety as opposed to danger (think traffic lights). You'll also notice that supermarkets (such as Waitrose and Asda) use the colour green in their branding to convey a sense of freshness to their products.

However, green also has the odd negative association: being 'a bit green' can describe a person's inexperience or naivety, and green is also traditionally associated with jealousy.

COMPLEMENTARY COLOUR

ORANGE GLOW

COMPLEMENTARY COLOUR

If you really want the orange in your photos to pop off the page, then pair it with its complementary colour: blue (see p27).

Look out for the varying shades of orange to experiment with in your photos:

Amber
Apricot
Carrot
Coral
Orange Peel
Peach
Pumpkin
Rust
Safety Orange
Tangerine
Vermillion

Orange is a 'hot' colour; to the human eye it creates the feeling of warmth. So, if you want your viewer to feel the heat, use this colour in your images. It also denotes joy, enthusiasm, creativity and endurance.

Although orange isn't as visible a colour as one such as yellow, it can nonetheless be very attention-grabbing, and so works well to attract a viewer's eye towards your photographs, or a particular area within them.

This colour also has associations with healthy foods, such as oranges, carrots and sweet potatoes, and is therefore thought to stimulate the appetite.

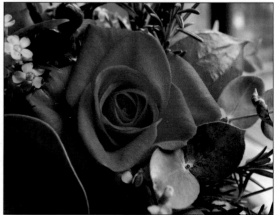

COMPLEMENTARY COLOUR

FEELING BLUE?

COMPLEMENTARY COLOUR

Blue's complementary colour is orange (or an orangey yellow, if we're being pedantic; see p27 for the colour wheel).

MACHO COLOUR

Opposite to the traditionally feminine pink, blue is the colour often used to depict masculinity. According to research, blue is the favourite colour of boys. Dark blue is associated with depth, sincerity, stability and trust. And when blue is used with orange or yellow it creates high impact –

go SUPERMAN!

This is going to be an easy colour-scavenger hunt – the sky is blue, the sea is blue and even our moods are said to be blue, sometimes.

But did you know that blue is often associated with depth too? In an image, this colour is often said to recede away from the viewer. So, to give a sense of depth to your photos, don't be afraid to use a little blue.

This well-loved colour is also said to symbolise trust, loyalty, intelligence, faith and even heaven. It can have a profoundly calming effect upon us. As such, it is often used to promote products or services to do with cleanliness. Just think about the branding used for your local pharmacy or healthcare provider.

Apparently, blue can also act as an appetite suppressor – so avoid it if you're photographing foods that you want to look appetising! Perhaps the café in the photo below should think about re-branding itself?

COMPLEMENTARY COLOUR

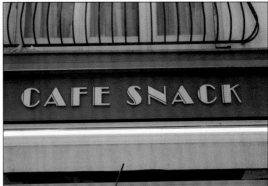

COMPLEMENTARY COLOUR

Yellow's complementary colour is violet (see p27 for the colour wheel).

When you picture yellow in your head, do you think of sunshine, joy and happiness?

Yellow is one of the most positive colours of the spectrum, perhaps because it is the same colour as the life-giving sun. It can cheer us up and creates a wonderful sense of warmth.

A yellow photograph screams for attention. This is because yellow is the most visible of all the colours on the colour spectrum. As such, it's used for highlighting text, for high-visibility vests, and is also the chosen colour of New York taxi cabs.

Yellow is also said to be a spontaneous and child-like colour, however, so avoid it in a photo where you are trying to create a stable and sensible image. But do use yellow when you want to highlight the main focal point of your photo, as the eye can't fail to be drawn to it.

COMPLEMENTARY COLOUR ✳

ALL WHITE?

STAYING NEUTRAL

White doesn't have a complementary colour. It's a member of the neutral colour family (other members include black and grey) and isn't found on the colour wheel.

White is commonly associated with those super-rare things in life: perfection, purity and innocence. White light, angels, peace, pristine sheets of paper – these are just a few things that spring to mind when we think of the colour white.

White is also linked to safety and cleanliness, and is associated with positive things – quite the opposite to the colour black.

Advertisers are well aware of the significance of this colour. White is frequently used to advertise products that promote cleanliness and sterility. One of the reasons that doctors wear white coats is because of the strong positive health and cleanliness associations that this colour carries.

In most Western countries, white is the traditional colour for brides to wear; however, in Eastern countries, it is the colour for mourning and funerals.

COMPLEMENTARY COLOUR?

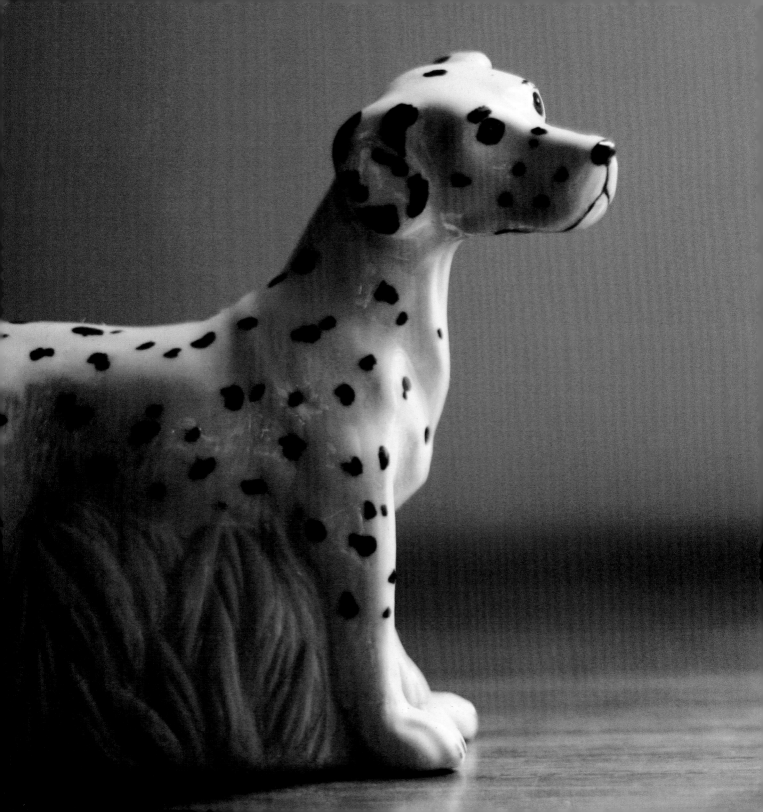

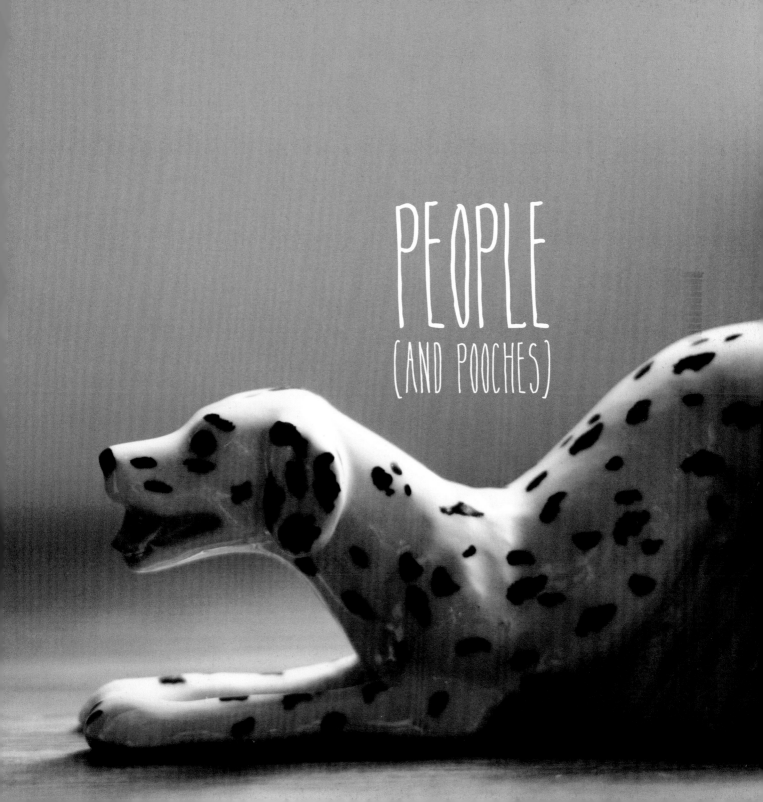

PEOPLE

(AND POOCHES)

Did you know there's a cosy ticket office in your home?

SOUTH WEST TRAINS

Travelcard

OLDSTYLE

Price £81·70X

9077351970

Number 07674

Date STD TRUCO-DCFOTO RENEWAL
Start date 27·MCH·11A

Valid until
& LONDON ZONES 1-6

Between WOKING *

Route

ONLY PERMITTED

Transcend
CompactFlash®
133x
8GB

PEOPLE-LESS PORTRAITS

Instead of just taking someone's photograph, try to depict that person visually through what he or she owns or the space that they inhabit...

Do you ever peer into other people's plastic trays at airport security to find out a little more about them? Perhaps, along with their coins and keys, they carry something quirky or personal about in their pockets... Those 'essential' items we carry around with us can make for fascinating 'people-less' portraits as, often, our possessions can reveal more about us than we realise.

Do you have a lucky coin, an item of make-up or a book that you'd feel naked without? Do you always carry your keys in one pocket and your mobile in the other? Is your handbag usually full of clutter you don't need, but that you keep in there anyway, 'just in case'?

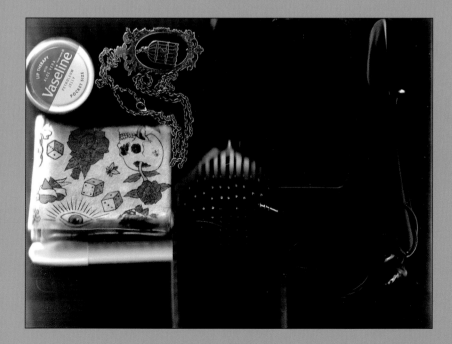

This project turns a healthy interest in other people's possessions into a work of art. Simply ask people you know to empty their pockets and/or handbags and then start snapping the contents while they have a nice cup of tea.

- The image opposite was taken using a scanner with a black backcloth laid on top of the objects. I set the scanner to 300dpi and 'high dust removal'. If you don't have access to a scanner, you could artfully arrange the personal effects on a cloth or plain background to achieve a similar look.
- Play around with the arrangement of the objects when they're on the scanner – for instance, try tessellating them; grouping particular colours together; or maybe placing them in order of size.
- Another approach would be to take your camera to photograph the environment that the person lives in, without him or her being there. The spaces that we create and spend our lives in say so much about who we are, our values and what we love.
- This can also be an interesting way of remembering someone who is no longer with us, or by making a collage with the artefacts gathered together from their friends and family.

Once you have captured several people-less portraits, perhaps you could print them out and invite your friends around for a game of Guess Who?

GET PERSONAL WITH A CREATIVE EDGE.

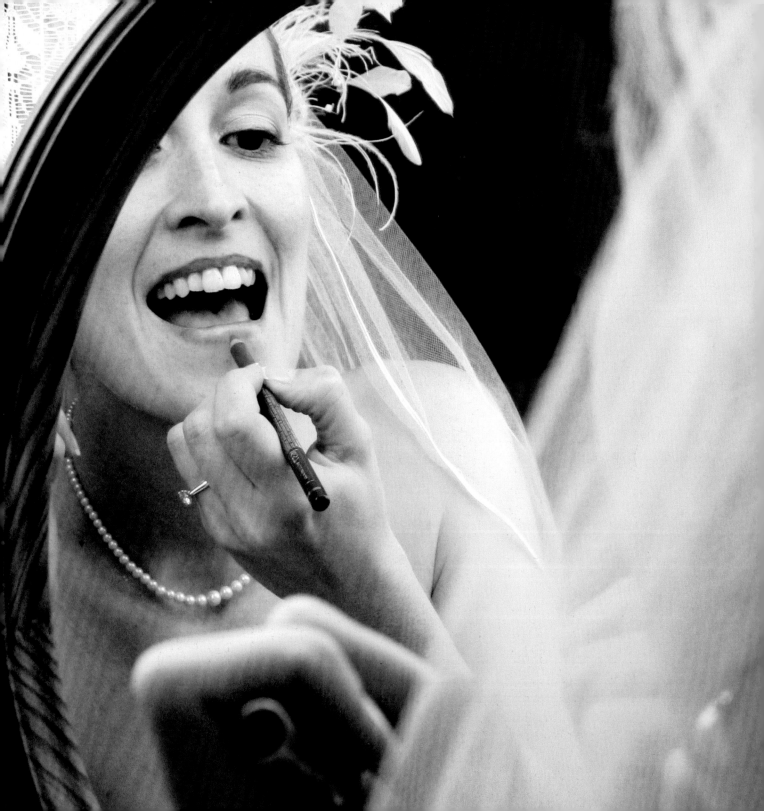

PRE-WEDDING SHOOT

kit
- DSLR
- A behind-the-scenes invitation
- A selection of lenses, such as zoom and portrait (if possible)
- Shoot list
- Tripod (optional – but handy in low-lighting situations)

I've been behind the camera at many weddings and I always find the pre-ceremony 'getting ready' part of the day at the bride's camp more fascinating than the wedding itself. It's full of excitement, tradition and nervous apprehension, and the camaraderie of the bridesmaids and the bride's family can be really touching.

- There's just one opportunity to get these photos right, so make sure that you are thoroughly prepared. Your camera batteries need to be fully charged and, if you're using a flash unit, make sure you put new batteries in it (don't be tempted to use the ones that are already there, just to be on the safe side). Clear all your memory cards and format them if necessary.
- Arrive with plenty of time to spare.
- When you get there, it's often a good idea (with permission from the bride, of course) to have a quick tidy-up: clear away the clutter so your photos will have a calm feel to them.

- Get the lighting sorted. While you're whizzing around the room, turn on any sidelights that might be there. They will illuminate dark corners and give your images extra depth. Maximise the amount of natural light coming into a room by pulling the curtains right back or lifting any blinds. Natural light guarantees that your photos will have a natural feel. If it's still dark inside, you can up your ISO setting, use your pop-up flash with a modifier (see p172) or utilise your flash unit.
- I'd highly recommend bringing a selection of lenses with you. A zoom lens can be a brilliant way of taking reportage photographs; they're a good means of allowing you to keep enough distance between the camera and the subject so that they forget they're being photographed, giving the shots a more natural feel. A portrait lens, which can be set to a far lower f-stop number than an average lens to create incredibly shallow depths of field, will enable you to take some fantastic 'arty' shots of the day.

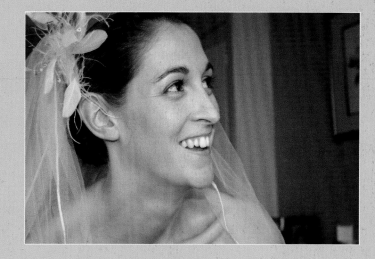

- Bring a 'shoot list' detailing all the photographs you'll need to take. At a minimum, it should have the following on it:

 - Bride's dress hanging up.
 - Bride getting into the dress.
 - Bride putting on her garter.
 - Close-up of the engagement ring.
 - Bride applying her make-up.
 - Bride applying her make-up with a mirror reflection.
 - Bride with her mother/father/family.
 - Bride with her bridesmaids.
 - Close-up of the bride's shoes.
 - Close-up of the bride's flowers.
 - Bride getting into the wedding car.

- You also need to be constantly on the lookout for any personal touches or objects of special significance to the bride that may be in the vicinity. Are there letters from well-wishers or gifts from the groom? Or perhaps she has been given some special jewellery to wear? Anything like this will help tell the story so, with the bride's permission, arrange some of these things together and create a mini still life. For example, one of my shoots the bride's red shoes and handbag looked fantastic on the red chair, which just happened to be in the room (see below). So keep your eyes peeled for suitable backgrounds as well as any objects of special significance.

Once you've captured all the pre-wedding pomp, why not create an album of the images to give to the happy couple as a wedding present for a gift that will last a lifetime?

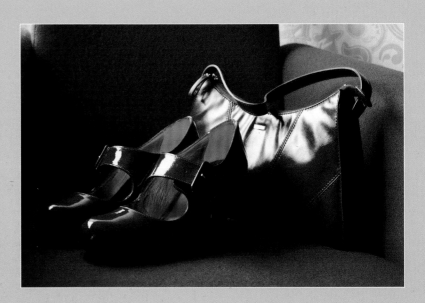

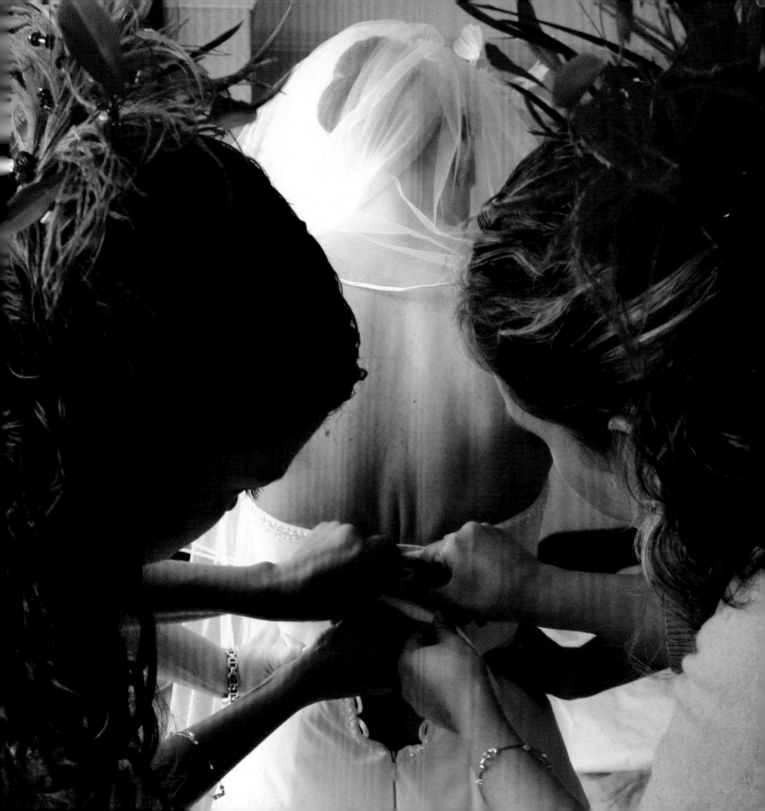

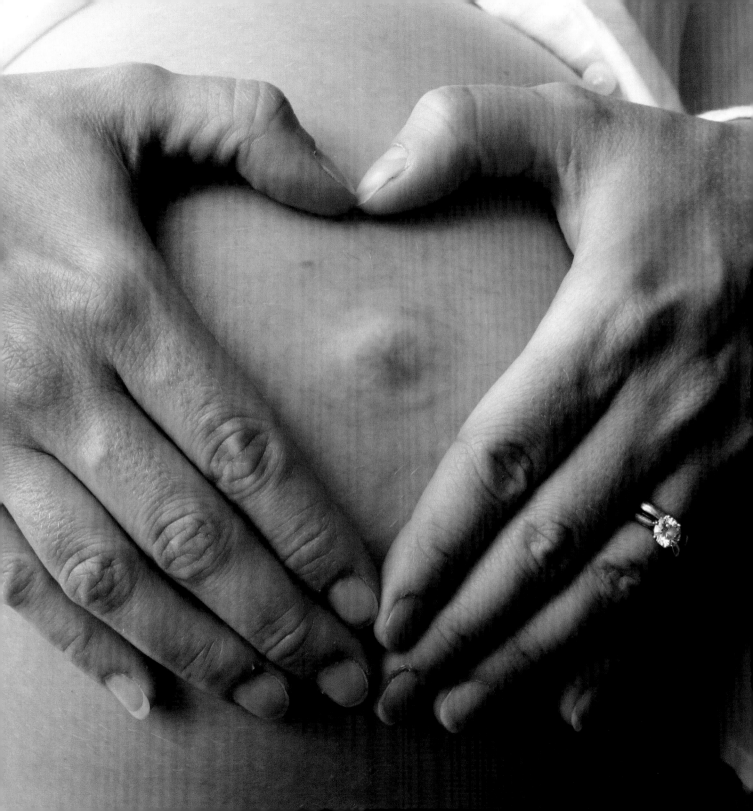

PREGNANT PAUSE

kit

- DSLR
- Pregnant woman
- Tripod (optional)

Whether it's your partner who's pregnant or a friend-of-a-friend, having the opportunity to photograph a heavily pregnant woman is a privileged position to be in. It can also be a lot of fun and, with a little imagination, will produce some really amazing shots.

When taking this kind of portrait shot, it's essential that you give the mother-to-be plenty of words of encouragement. The more relaxed she feels, the more confident she'll be in front of the camera; by building up her confidence, you'll help her to enjoy the shoot more and encourage her to experiment in front of the camera for more interesting shots.

Just make sure that you have a powder compact handy so that you can take off any shine from the mum-to be's face if she gets a bit hot.

Shot suggestions:

- Invite others into the shot – perhaps the subject's partner, other children or even a pet. If you don't know the family very well, it can be helpful to take a candid approach to photographing them at first. This way you'll be able to see how they interact with each other, allowing you to get to know them better and come up with ideas for good shots. Try encouraging the family to touch the baby bump; the small hands of a child can provide a great juxtaposition and perspective against Mummy's tummy.
- The most dramatic shots of a pregnant woman are the ones that capture her round form. The best way to do this is to create a silhouette of her bump, which can be achieved by some clever positioning of light behind her (either daylight through a window, or by using a flash). To emphasise the woman's shape even more, ask her to wear dark, figure-hugging clothes.

- Relax. If your subject is comfortable with it (or feeling a bit tired), you could always run her a bath: photos of the spherical bump rising from the flatness of the water can make for really arresting images. (To protect her modesty, be sure to add plenty of bubble bath!)
- If your subject isn't keen to reveal too much flesh, request that she wears a baggy white shirt (perhaps her partner has one) instead. Then take a naturalistic photo of her as she stands next to a window; this will create a beautiful, floaty form in the picture that will work perfectly in black-and-white.
- A quirky and rather fun approach might be to draw something on the pregnant tummy. Use a (non-toxic!) pen, or eyeliner, to write a witty message such as 'Best before: (insert the due date)', 'Coming soon' or 'Coming... ready or not!'
- Play with scale. Ask your subject to lie down and try balancing small objects on her tummy: a new soft-toy or a cute pair of baby shoes make a great contrast to the bump.
- Another option is to give your camera to the subject and ask her to aim for her feet (whether or not she can see them!), so you'll end up with a picture of the bump from her perspective. This can act as a great reminder of what her pregnancy was like to look back on – or even to show the child – in the years to come.

Once you've sorted through and then developed all the best photos, present your images to the mum-to-be – that's the first few pages of the baby album sorted!

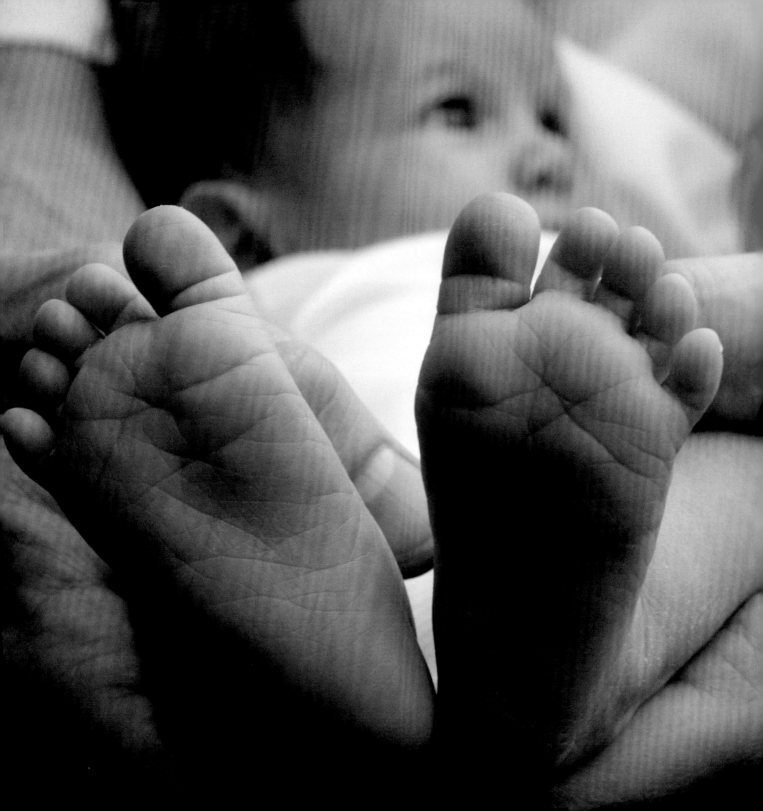

NEWBORN BABIES

kit

- DSLR
- Newborn baby
- Macro lens (optional)
- Blankets
- Plain background and stand (optional)
- Plain white sheet (optional)
- Baby hats (optional)
- Props such as baskets, toys or objects to show how tiny the baby is (optional)

There's something magical about newborn babies; they seem so impossibly small and precious. Recent years have seen a rapid growth in the lifestyle photography market for parents wanting their newborn to be photographed. So if you know someone who's just had a bouncing baby, why not do them a favour and take some pictures?

Photographing a newborn baby is tricky because he or she can't do an awful lot. You might be able to elicit a smile from an older baby by goofing around behind the camera, but this won't work with a newborn. So it's important to simply go with the flow and capture these tiny creatures just the way they are. Most newborn babies are very adept at lying down and sleeping – so go ahead and snap them in the act…

- It's wise to go prepared with a selection of clean, soft blankets of varying colours and textures, as these can look fantastic with the baby lying on them.

- Close-ups of tiny hands and feet work really well visually, so if you have a macro lens be sure to take it with you. To add some drama, and to highlight the difference in size, take a shot of the newborn holding onto a parent's finger – these shots can look very cute.

- Although taking a plain backdrop and stand with you can be beneficial, it's not essential. Ask the parents if they have a plain white sheet, or take one along with you. This can be draped over the sofa to provide a comfortable place for the baby to lie. (The bleached effect on the photograph below was achieved by over-exposing the image. To do this, consult your camera's instructions manual to set it to over-exposure – this floods the camera with too much light for a 'correct' exposure. Alternatively, you could use image software and alter the exposure in post-production.)

- When photographing any little ones, it is important to remember eye level. Wherever possible, ensure your

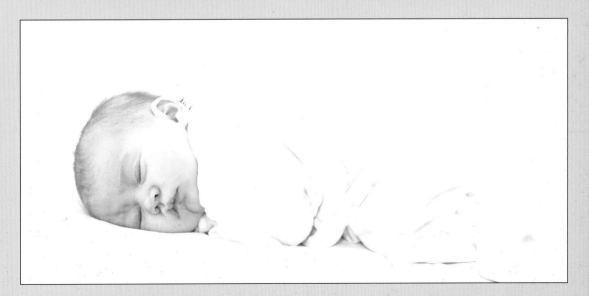

camera and lens are at the same level as the subject you're snapping. This creates a more intimate shot.

- To heighten the sense of intimacy, ask the parents to cuddle their naked baby while topless. There is an obvious risk with going nappy-free, but the shots will be worth it.
- Posing parents with their newborn is surprisingly easy; they're so in love with their little one that often all you have to do is to take the shots.
- If the baby decides to throw a diva-style tantrum in front of the camera, try to use this to your advantage – if at all possible – by asking the parents to mimic the baby's facial expressions. This can make a harmonious and quirky image out of less than harmonious situation.
- Go for a contrast in scale, whether it's using props next to the baby, or his or her family. This will accentuate the newborn's tininess and vulnerability – a sure bet in upping the 'aaah' factor.
- Black-and-white and sepia tones can increase the emotion in your images. It might be worth playing around with these settings – if your camera has them – or experimenting with them later in post-production.

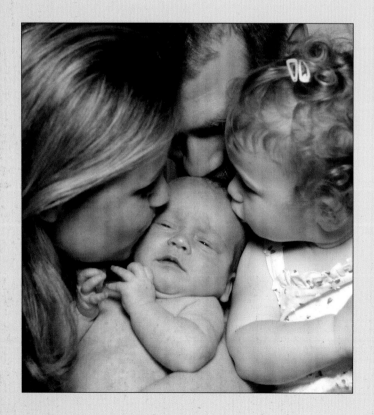

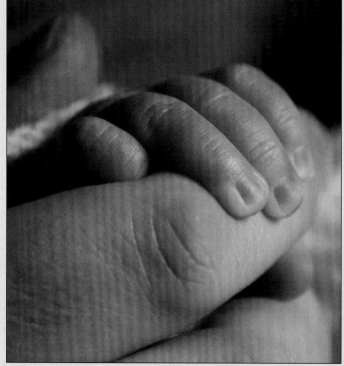

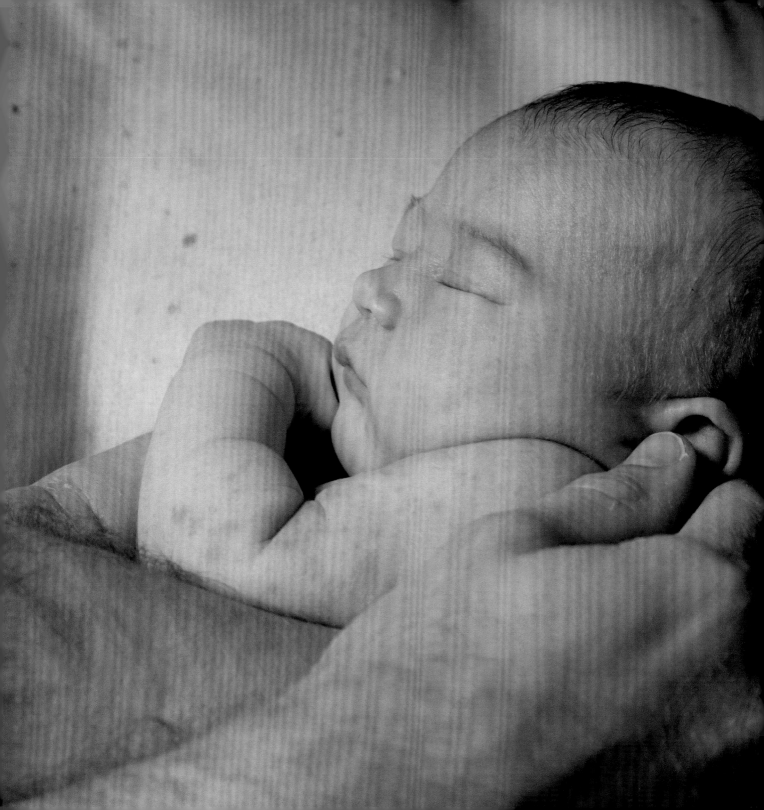

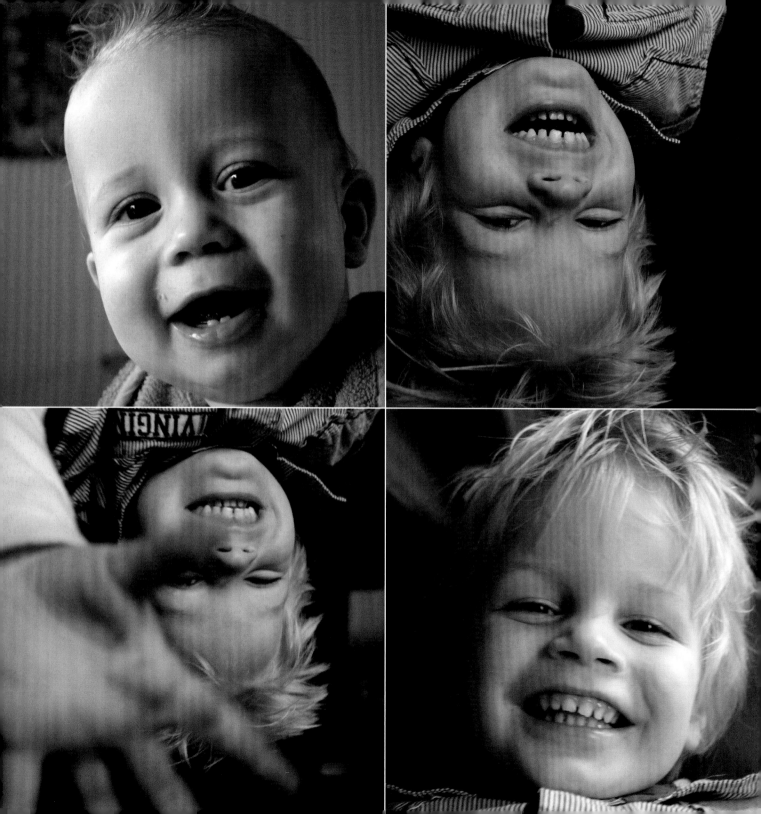

LITTLE PEOPLE

kit

- DSLR
- Child/children
- Props (optional)

We all love looking back on photographs of ourselves when we were small. So create happy memories for future generations by taking some snapshots of little ones before they grow up. You've got less time than you might think...

You'll need to work fast to catch kids on camera – whether they're toddlers or nearly adult-sized, they won't be keen to wait around while you fiddle with your focus.

- Firstly, set the camera to aperture priority mode to control the depth of field within the image. If the child is particularly young and fast moving, it's also advisable to select shutter burst. This will allow you to take several frames per second. Finally, set your camera to single point focussing, making sure that, with every photo you take, the focal point is the child's eyes, as this will be the most important part of the photograph.
- There are two main approaches you can opt for when photographing children: taking candid photos (where you simply 'follow the action' – snapping away while they do what kids do) – or exercising more creative control by giving them set poses. Both approaches require a certain amount of planning. Which location: at the park, at the zoo, at home...? What sort of accessories might you need? It's wise to arrange for the parents to bring along a few toys, blankets and different outfits for their little person.
- To buy you some precious seconds of the child staying in front of the lens, it's worth giving him or her something to hold (perhaps a favourite toy or a carefully chosen prop) or an action to do.
- The key thing to remember when photographing children is to get down to their level. So bend your knees – maybe even lie on the floor – or, if the child is really little and it's safe to do so, bring him or her up to your level by putting them on a table. Getting the eye level right is the key to taking a great photo of a child. When the eye level is right it creates a sense of intimacy between the viewer and the image's subject.
- Alter the amount of space around the child as you compose your shot. But be mindful of distracting backgrounds. If you want to blur out the background, choose a low f-stop number while your camera is in aperture priority mode – remember, the lower the number the more blurred the background will be. Conversely, if you want to include the background, then be sure to use a high f-stop number.
- Clothes can really affect the mood of a photo, and also that of the child... There's nothing worse than trying to photograph a subject (young or old!) who's having a tantrum because he or she doesn't want to wear a particular outfit – so give in and let them choose something that they like and are comfortable in, which hopefully will still reflect their personality.
- To add a bit of variation to the shoot, try going a bit abstract by focussing on a single part of the child: a close-up of their shoes, their long eyelashes or perhaps one of their small hands clutching a teddy.

If you're snapping a few kids, and they're happy to play with you, get some quirky shots by turning the session into a fancy-dress fashion shoot. Gather loads of props and outfits, raid their parents' wardrobe and play dress-up. Your role is to be a whooping and cheering member of the catwalk paparazzi, documenting their not-yet-on-the-high-street looks. (Perfect for embarrassing them when they're older!)

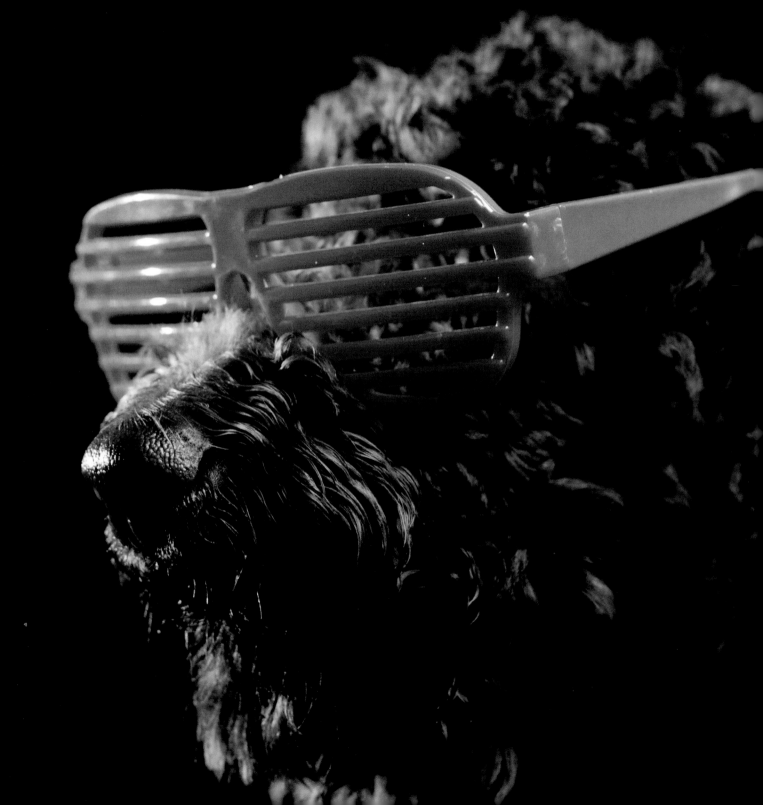

FURRY FRIENDS

kit

- DSLR
- Dog(s)
- Treats for a well-behaved dog
- Props (sunglasses, bow ties, tug toys, and so on – optional)
- Flash units (optional)
- Stand and backdrop (optional)

Now, you know the rule: 'never work with children or animals'. But if you're a natural rebel whose only rule is to break the rules, here are a few ideas on how to photograph man's best friend.

Of course, your pet needs to be looking his or her best for the shoot; but before you clean your model up, be sure that he or she has had a good, long walk to expend a little of that energy. If the dog is high maintenance when it comes to bath time, you can always opt to visit the local pooch parlour beforehand and ask for 'the works'.

Once you've got your gorgeous – and willing – pet prepped and ready, it's show time!

- For the shots I took of the dog wearing the sunglasses, I decided to create a mini 'pooch portrait' set-up (similar to the one used in the Two-Light Set-Up project, p164),

using my backdrop and a few off-camera flash units. Although this approach gives that professional studio feel and can make your dog look like a supermodel, for some dogs it can be taking the biscuit, as they can be startled by the flashes. So it's a safer bet to use a constant light source, if you can, and perhaps dispense with your background if the model feels more comfortable with this.

- If you prefer natural lighting to the manmade stuff, scout out a room with even and plentiful window light. Ideally, the light shouldn't be too hard (casting areas of great brightness and darkness in the room). If the lighting is hard, put up some muslin or tracing paper over the window to diffuse the light.

A 'good' dog photograph manages to capture the beauty and personality of the dog. Instead of trying to catch all this personality in a singular full portrait, an interesting approach is to do a series of close-ups of your pooch that can be displayed together. Focus on what is unique about your subject: ask yourself if it's the dotty markings, droopy ears, wagging tail or chunky paws…

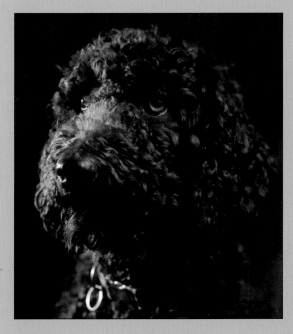

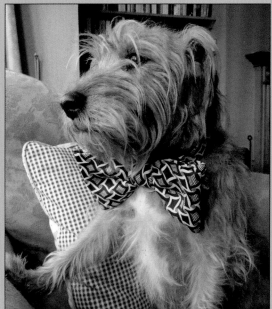

Your doggy portraits don't have to be static – you could try experimenting with panning shots (see p76) next time you're taking the dog out for a run. You're more likely to capture your dog's exuberance and energy when he or she is at play.

If your dog is happiest at the end of a tug toy, try taking a panning shot with a tug toy in one hand and your camera in the other. Put the camera in shutter priority mode; use a slow shutter speed, such as 1/50 and an ISO setting of 400. Rest your camera over the hand on the tug toy and take a spin while snapping away – just be careful not to fall! Hopefully you will get the dog in focus and the background all blurry.

- If you're shooting outside, try to aim for first thing in the morning or late in the afternoon, when the sun is lower in the sky, for a softer light.
- Before choosing your background, think about what colours will complement the colour of your furry friend: you don't want to lose your white dog against a white background, so a contrasting colour works best.
- Set your camera to aperture priority mode – I prefer a portrait to have a shallow depth of field (using the lowest f-stop number available) but, if Fido is feeling camera shy, it might be wise to shoot from a distance and use a zoom lens so that the dog feels more relaxed.
- It's also a good idea to have the owner on hand or, if it's your dog, to have someone off camera to get the dog's attention. Use their favourite toy or treat; I find that making cat noises gets the average dog to look my way (though, yes, they're probably staring at me thinking 'stupid human').
- One of the problems with photographing pets is that they won't stay completely still and, in fact, they often wilfully do the opposite of what you want them to. So, if you are photographing smaller breeds of dog, try putting them on something high (not too high, though!) to keep them in one place. If the dog is the size of a small pony, it's probably more realistic to launch into your best 'STAAAY' command.

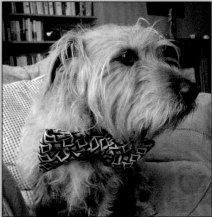

- The top tip for photographing dogs – as with children – is to get down to their level. The eye level is the most important thing, as it creates intimacy between the model and the viewer. To ensure this connection, make sure that the dog's eyes are in focus.
- It can be a tricky job to get down to your canine buddy's level as, if you lie on the ground, they normally see it as the start of 'fun times' and may leap all over you or lick the lens, so either cover your lens and give them plenty of time to calm down or get a commanding owner to keep them in one place while you take the shot.

When everything is looking as good as it's likely to, just press that shutter button!

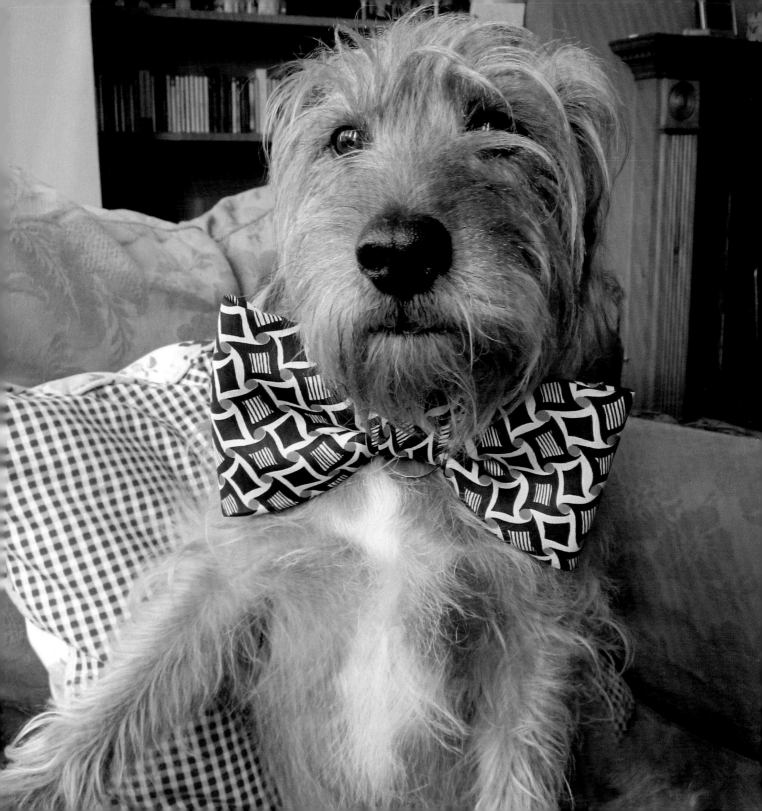

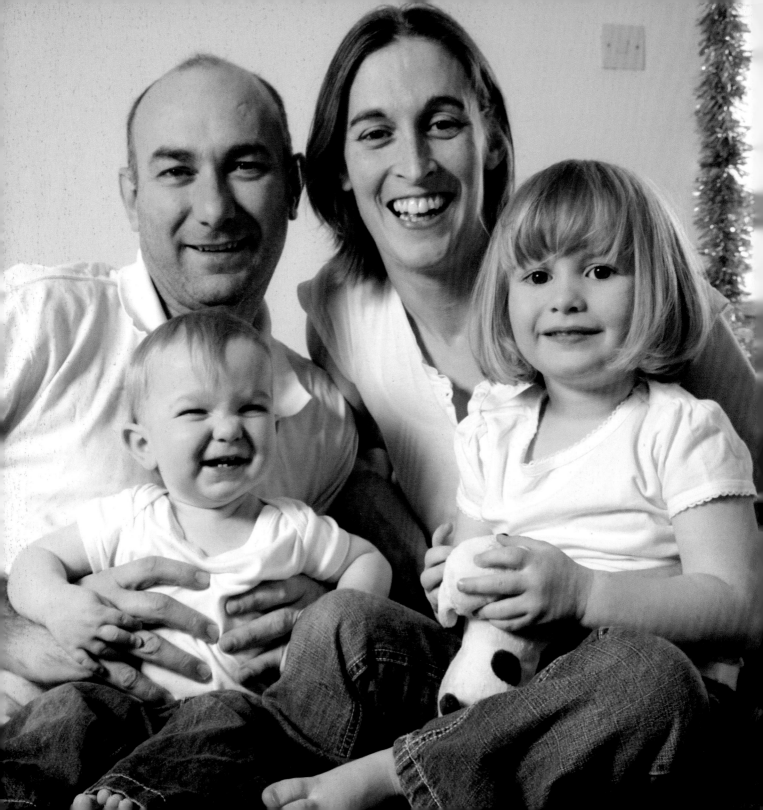

WE ARE FAMILY

kit

- DSLR
- A family
- Flash unit (optional)
- Patience (essential)

To get adults and children to do exactly what you want them to do in front of the camera, all at the same time, is not easy. You need the grown-ups on side to help coerce the best performances from the children, but you also need them listening to you and feeling relaxed so that they don't overdo it in front of the camera. Good luck with that!

When you're photographing a group – especially one with children – at times it can feel a little as though you're spinning a line of plates and, just as you think it's all going well, one of them crashes to the floor. But try to remain calm at all times; once I almost ruined a shoot by raising my voice a bit too loudly at a toddler who was attempting to swing on one of my lights. He nearly burst into tears, which wouldn't have been ideal.

- To begin with, select the lowest ISO setting possible considering the available light. The more light you have, the lower the ISO setting can go. Select aperture priority mode so you can control the depth of field, and shutter burst to take lots of frames per second.
- To unify the photograph and create a visual sense of togetherness, try to co-ordinate what the family are wearing. A conventional take might be white tops and denim bottoms but, if you want to do something a bit different, how about encouraging everyone to wear 70s-style ski jumpers or Hawaiian shirts?
- If you're photographing a family indoors, be careful not to position them in front of a window, as this can create backlighting problems. Instead, choose a plain wall and ask the group to stand a couple of feet in front of it to minimise any tricky shadows.
- Ask the family to huddle in closely together too – big gaps between people can look awful.
- Remember, you're the boss. If someone in the family is being a little too domineering, don't let them take over the shoot. Try to remain confident and in control.

- That said, it's important to be open to the family's suggestions and to sometimes just go with the flow. It's a tough balancing act, but the skill lies in recognising which ideas will work and which are likely to be a waste of time.
- If getting everybody to pose isn't working, then embrace the alternatives; unconventional compositions can add energy and individualism to a picture. So, if the family just want to bundle on top of one another, let them – and keep pressing the shutter button.

You'll know if your family portrait project has been a success if your photos make it into the family album or – even better – into a photo frame that takes pride of place on their mantlepiece.

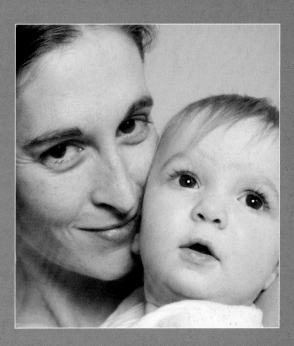

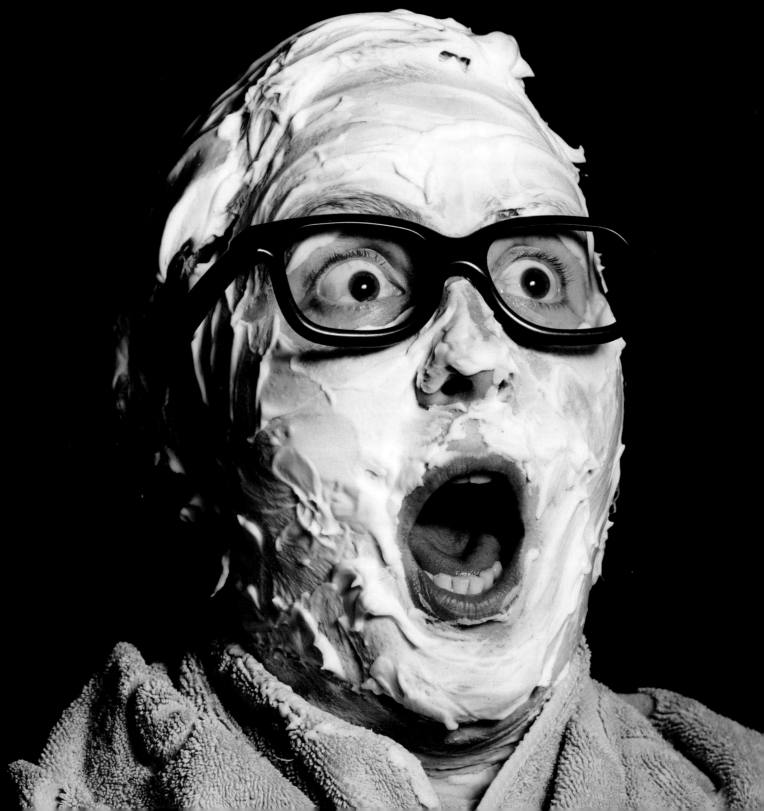

SELF PORTRAIT

kit

- DSLR
- You!
- Tripod
- Shutter release cable (optional, as you can use your camera's timer instead)
- Different lenses (optional)
- Props (such as make-up and disguises)
- Flash unit (optional)

The trouble with being a photographer is that you spend almost all of your time behind the camera, instead of in front of it. Well, now it's time to stop hiding and give yourself some quality lens time.

All the great painters managed to capture something of themselves in a self portrait at some point during their careers, with famous ones including those by Vincent Van Gogh, Rembrandt and Frida Kahlo. Photographically, there's a long legacy too: Andy Warhol, Nan Goldin and Cindy Sherman, to name a few. So, when it's your turn, you can be safe in the knowledge that you're joining a long line of artists who've done the same.

- All you need is a camera, a tripod and a shutter release cable (or just use the timer setting on the camera). You can use natural light or the flash. If you have different lenses, use them to experiment with the various effects that they can create.
- When I shoot portraits, I like to set the camera to aperture priority mode and select a low f-stop number for a nice shallow depth of field. Remember: the lower the f-stop number, the smaller the depth of field, and the higher the f-stop, the larger the depth of field.
- It's important to get your eyes in focus in the picture, so spend some time checking that this is right. If you have a decent amount of light available then you can just use auto focus. However, if the lighting's too low to work effectively, you'll need to set the focus to manual. Getting manual focus right will involve a lot of fiddling around, especially if you opt for a shallow depth of field.
- Before you start taking the photographs, try to generate ideas for images that you might like to take. Think outside the box – what would you do in front of the camera if no one was looking? What are your passions and pastimes? Be playful, and don't be afraid to let your loony side loose.

- It's also a good idea to use props: dress up your face with glasses, hats, make-up or whatever else you can lay your hands on. This will not only add some visual intrigue, but will also make you feel more relaxed in front of the camera. If you're short of ideas, try experimenting with conveying different emotions: shock, sadness, laughter and thoughtfulness make for beguiling shots.
- If masquerading as someone else isn't quite your thing, then maybe you can use this project as an opportunity for a bit of personal introspection. What's on your mind? And how can you express it visually?
- Try gazing in different directions within the photographic frame. Looking directly at the camera can sometimes create a 'police mug shot' of a photo, so try directing your gaze slightly to one side of the camera; or up, down or even over your shoulder.
- Once you're ready to snap, set the camera timer, hold your pose and wait for the shutter to click – or else just press the button on the shutter release cable whenever you like.

Another popular approach to creating photographic self portraits is to record your reflections in shiny surfaces. This could be anything from a full-length mirror to the back of a spoon. Just keep your eyes peeled and your camera at the ready…

> **Self portraits are great because:**
> - You can take them all alone, so there's no need to feel self conscious in front of the camera.
> - You can do them whenever you want, because you're the model.
> - You can take your time and enjoy the creative process.

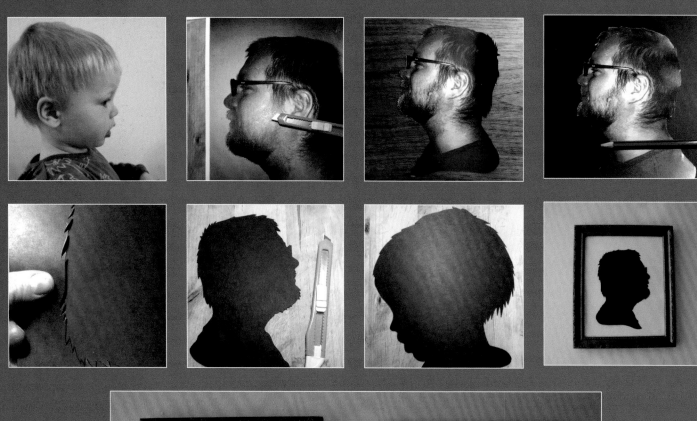
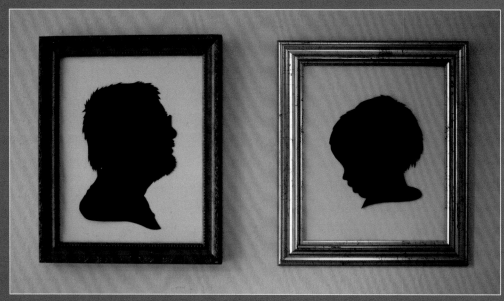

VICTORIAN SILHOUETTES

kit

- DSLR
- Side-on subject
- Colour printer and paper
- Black paper/card
- Graphite/white pencil
- Scissors or craft knife and cutting mat
- White/cream display card
- Picture frame

In the olden days, travelling silhouette-makers would go from town to town with mobile studios creating bespoke portraits for a penny. Some makers would cut a likeness directly into paper without drawing it out first, while others painted the sitter's profile using soot from fires. But when photography became popular, the silhouette became obsolete – well, almost.

The fundamental requirement for a nice, clear silhouette is a nice, clear profile picture (just the flat outline of a subject, without a hint of 3D form). So, you'll need to take a sharp snap of your subject in perfect profile.

- Ask your model to sit or stand – side-on – against a plain background of contrasting colour. This will make it far easier to see the profile in detail when it comes to cutting it out later.
- If you use the flash to light your sitter, watch out for shadows: if your subject is too close to the wall behind, then the flash will leave a dark shadow around him or her, and you won't be able to see where the person ends and the shadow begins. To avoid disastrous dark shadows, simply position your subject so that he or she is further from the wall, and you'll see the shadow will just drop away behind them.
- When you take a 3D portrait it's usually best to go for a shallow depth of field – but not in this case. To ensure that your sitter's profile is nice and crisp (not shallow and blurry), you'll need to select aperture priority mode and use a high f-stop number: f11 or above.
- Once you've positioned your sitter correctly so that you're happy with the lighting and his or her side profile, just press the shutter button.
- Now you've got the profile picture, print it out to fit in the frame (see opposite). Use a colour printer to enhance the detail in the image; black-and-white can be a little confusing.

- Next, carefully cut out the silhouette using scissors or a craft knife and cutting mat.
- Place your colour cutout on a piece of black paper or card. Using the cutout as a stencil, carefully draw around its outline using a graphite or white pencil to show visual contrast.
- Once you've drawn around it, take a look back at your original image, scrutinising it to see if there's any detail that you can add to the tracing. Taking that little bit of extra time to embellish something here or pop in a little more detail there will make your final silhouette all the more spectacular. This is also the time to perform some cosmetic enhancements to your subject's profile – a chin-tuck, perhaps? Rhinoplasty, anyone? Oh come now, you can't tell me that those Victorian artists didn't do it to ensure payment?!
- When your drawing is finished, cut it out carefully with scissors or a craft knife and cutting mat.
- Once the fiddly stuff is over, it's time to mount your masterpiece on some white or cream card and then frame it. The Victorians favoured oval frames to show off their silhouettes, but you don't have to spend a fortune – check out your local charity shop for a bargain buy. My frames were old cast-offs…

Grouping together framed family members on a wall looks great – like the father and son silhouettes opposite. Or you could experiment with silhouettes of pets or children's favourite toys.

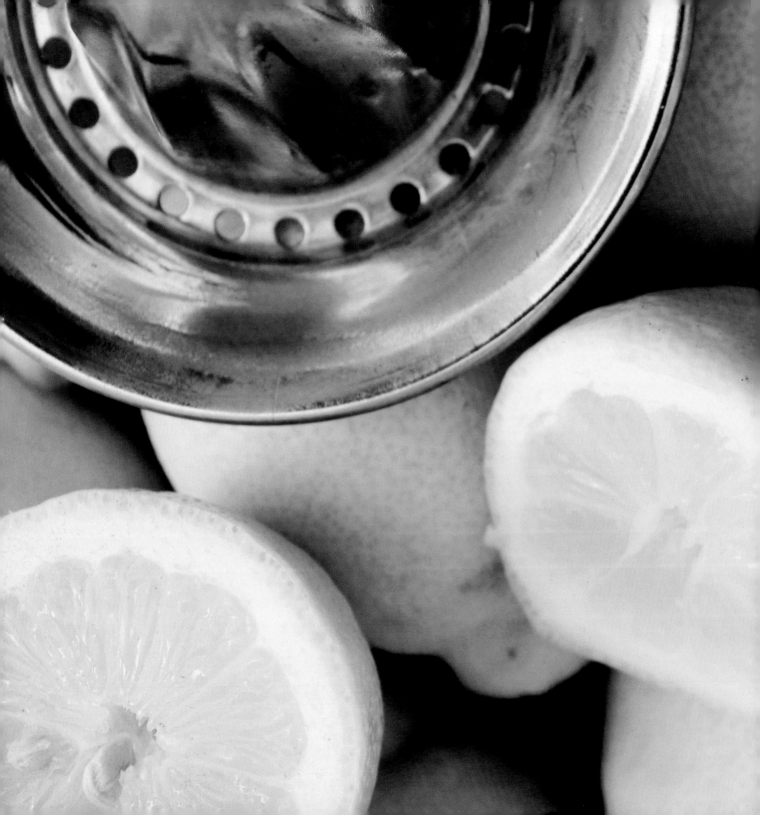

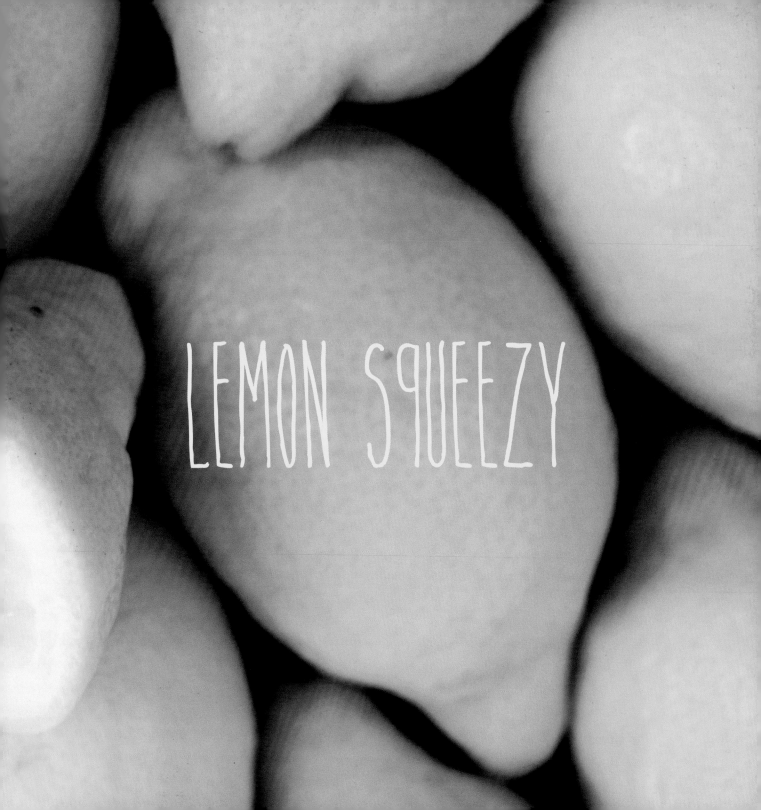

STILL LIFE

kit

- DSLR
- Interesting objects and a table for your still life scene
- Reflector
- Tripod

Still life has existed as an artform for thousands of years; from the days of the ancient Greeks and Romans, artists the world over have been perfecting the skills required to depict a visually enthralling scene. And some even say that a still life is a more demanding task for photographers than landscape or portrait photography because the composition and lighting is all down to them (and you!). So, are you ready to show off your skills?

- For starters, you need to pick some really fascinating objects to set your scene — things comprised of interesting texture, colour or form will work well. Think about objects that complement one another. For the examples on these pages, I thought that the greens of the fruit and vegetables harmonised with the wooden browns of the bowl and the table. And, form-wise, the contours of the pears and the incredibly bizarre spikes of the artichokes created different but equally arresting images.
- You might prefer to compose a more stylised scene for your still life, such as spectacles on a reading book, fruit in front of a jam jar or a pen lying adjacent to a word puzzle. Whatever your subject matter, though, you'll probably need to experiment with the composition. Don't be afraid to mix it up a little; arrange the objects in various positions and situations. Try to think about symmetry as you go; as well as asymmetry and the rule of thirds (see p16), creating triangles, lines (see p18) and depth in your composition also works very well. See — there's a lot to think about.
- As you're composing your scene, pay careful attention to the available lighting. The photos on these pages were all taken in natural light. For the best results with natural lighting, compose your still-life scene near a window — bearing in mind that the kind of light you need is the soft, diffused type (see p163). Hard lighting won't work as well because it gives too much contrast and leaves big, ugly shadows. So, if your window has harsh, bright light coming through it, use a net curtain or put up a muslin sheet to diffuse it. You can also control the light by using a reflector (stocked at all photography shops), or you could just use a piece of white card or paper to bounce a bit of light into the shadowy areas.
- Use a tripod to ensure that your final images come out looking sharp.
- Before you press the shutter button, check your frame to make sure it is just so.

Happy? Now press the shutter button!

Buy three

Three is a magic number. Compositionally, it gives you plenty of options with which to experiment. If you want even more variation, try using five objects — that's a pretty nifty number, too!

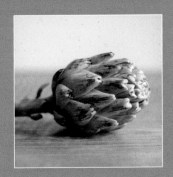
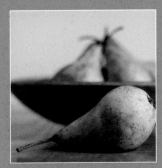
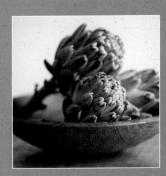

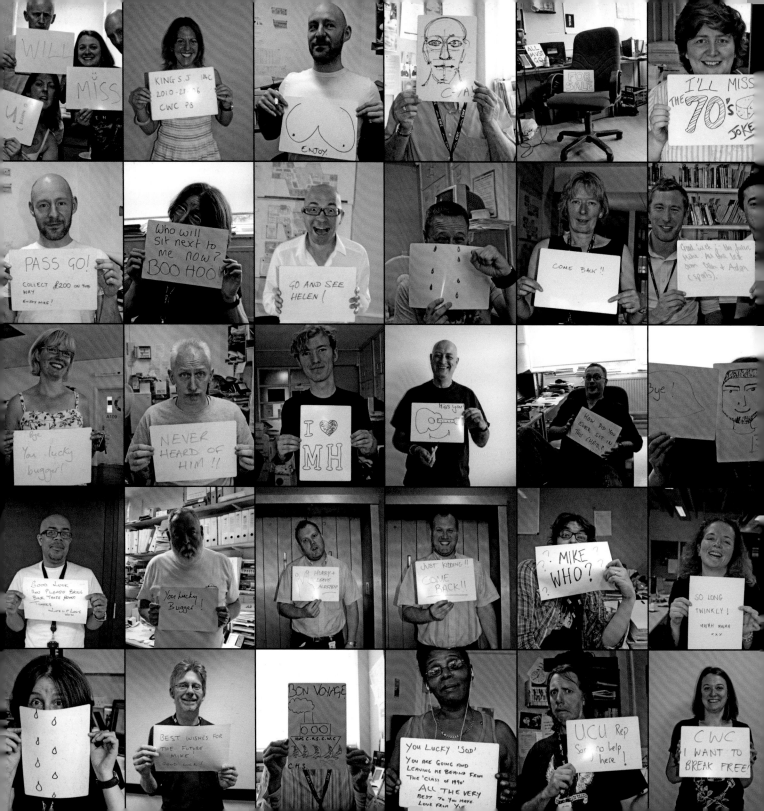

PHOTO MESSAGE

kit

- DSLR
- Mini-whiteboards (or A4 paper) and a marker pen
- Computer
- Free software from the Internet/Adobe Photoshop (optional)
- Colour printer and paper
- If you're making the card and creating the grid of thumbnail images, you'll need some glue and card to stick them to
- The finest folder your stationery cupboard can supply!

This is a great photo project to get you out of a 'leaving present' fix. You'll need little more than your camera, a small whiteboard and a marker pen. If you don't work in the type of environment that has these tools in abundance, then just nip out to a pound shop (buying a set is still cheaper than the cost of a card and present!). If you want the super-budget option, you could just use sheets of A4 paper.

- Once you've got your equipment at the ready, you need to do the office rounds, visiting your co-workers and asking them to write a short message or draw a little something on the whiteboard/paper. It's such a win-win situation; you're being the compassionate and supportive colleague and getting to have a bit of a giggle with everyone who's writing messages along the way: beats actual work hands down!
- Be lateral in terms of the people you're asking to contribute: invite everyone you can – from the boss downwards. They'll all enjoy being involved in the fun. Ask people to write two or three different messages, so you're left with plenty to choose from.
- Take a picture of each person holding his or her message and then head off to the next.
- Once back at your desk, you need to go through all the photos to pick the best ones from the bunch.
- If you want to create a grid of images like the one opposite, upload your images onto your computer and download one of a number of free software programmes from the Internet (try searching for terms like 'mosaic maker'). Or, if you have Adobe Photoshop,

then just use that. I think that rows of tiny thumbnail images make for a great and super-original leaving card.
- In order to create a whole book of messages as a leaving gift, you're going to need to abuse your office's colour printer before finding a nice folder in which to display the photo messages. The boss won't mind – it's for good old Mike, who's been working there for more than 15 years...
- If you have a little more time – and money – on your hands, you could have a professional book made out of the images (search 'photo books' online for options).

Either way, the book is going to be so filled with love it's bound to bring a tear to dear old Mike's eye.

> If you need a little inspiration for your project, check out artist Gillian Wearing's photo project, 'Signs that Say What You Want Them to Say and Not Signs that Say What Someone Else Wants You To Say'.

PLAY SNAP

kit

- DSLR
- A keen eye

If you love looking at fishing boats, doorways, sheds, post boxes, dogs waiting for their owners to come out of shops, black cats, garden gnomes, abandoned bicycles, lost gloves – or anything at all, for that matter – then play snap by taking a picture every time you see a different version of (or setting for) your favourite subject, just like I've done with this series of colourful shutters.

If you're not sure what subject you'd choose, then initially just take pictures of things that you think would make for an interesting collection and, before long, you'll discover a suitable 'snap' subject.

Next thing you know, you'll be breathless with panic if you see the subject you're collecting but don't have your DSLR with you. So make sure you're always carrying a trusted camera when you're out and about.

This project isn't a photographic quick fix. To accumulate a collection of images to be proud of, you need to lovingly build one up over time. But the pay-off will be amazing; a unique and original photo series.

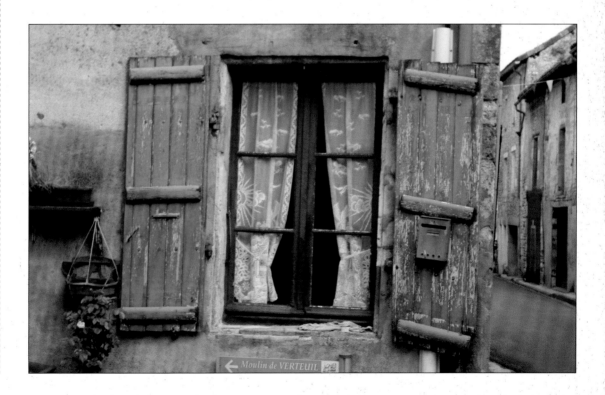

REFLECTIONS

kit

- DSLR
- Tripod (optional
 –but handy for low-
 lighting situations)
- Shiny surface

For this project all you have to do is focus on one thing: reflections. Every shiny surface is capable of making a reflection. So keep your eyes peeled for some really unusual glimpses of the world that could be bouncing intriguingly off a reflective surface.

You don't need the sunshine for this kind of project, either; if it's been raining all day, grab your camera and pop out to your town centre when it's dark. The wet pavements will have been transformed into large mirrors reflecting the orange glow emanating from the streetlights. These watery reflections offer an alternative glimpse into your surroundings.

To mess with the viewer's mind, try turning your final image upside down, so that the reflection is the right way up. This acts as a visual riddle, as the viewer tries to figure out what's going on.

Visual Layer

Reflections can improve the quality of an image because they add another visual layer to it. The reflection of the road ahead in the driver's sunglasses (see opposite) gives us a sense of what they are seeing. The image is also framed within the glasses' frames, which makes for an even neater shot.

You don't have to live near this amazing mirror of a lake in New Zealand to be able to take mind-bending inverted images of your environment. Any pool of water will do, from large ponds to puddles on the road. Look at the pool of water from different vantage points; when you find the correct angle, take your shot. The images often have a great contrast in texture, as the gritty surrounds are juxtaposed to the smoothness of water. Experiment with shaking up your images a bit by stirring the water in the puddles to create some ripples. This will further distort your images.

letter litter is mesmerising

PHOTOGRAPHIC A–Z

kit
- DSLR
- Zoom lens
- Letters!

Sharpen your visual skills by scouring your local environment for individual letters to photograph until you've got the full alphabet.

This is a good project to do with a friend who lives nearby. If you're anything like me, though, it could get quite competitive as you each strive to find the best shot.

Once the images have been taken, it can be fun to invite a few other friends around and test their observational skills by asking if they can tell where any of the letter photos come from.

The A–Z examples here were taken in Hackney, London, so, marks out of 26 for recognising and naming the locations of each of the letters correctly…

Never been to Hackney? Don't worry. Here's how to create something similar from your local area:

- You will need a zoom lens (unless you're blessed with extremely long arms) so that you can get good close-up shots of the letters.
- When taking each shot, aim for the letter to be as centred as possible within the frame. If you see a sign bearing several good letters, it might be worth taking a photograph of each so that you can select the best ones in the edit.

I guarantee that you'll start to notice some amazing typography – right on your doorstep. If you want to take this project one step further, how about gathering a collection of words from your letters and constructing some short verse poetry?

Mosaic-maker
When you're happy with your A–Z, you can create this rather attractive mosaic by downloading (for free) software from Big Huge Labs (www.bighugelabs.com) to organise all the photographs.

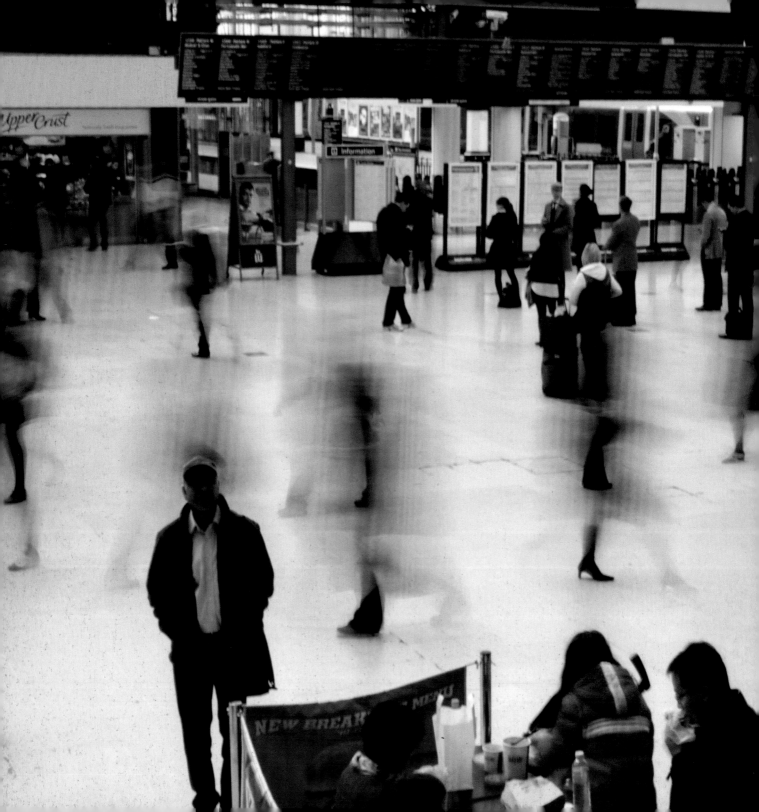

BLURRED MOTION

kit

- DSLR
- Moving subject(s)
- Tripod (or a sturdy surface to keep your camera steady)
- Neutral density filter (optional)
- A pair of sunglasses (optional)

Nothing conveys movement better than a blurred image – particularly when there's a contrastingly crisp stationary subject in the frame.

In order to capture blurred movement, your camera needs to be rock-steady and the shutter speed very slow. So keep your movements smooth and certain, with a shutter-speed setting of 1/50 of a second, or slower.

Review your images and remember to PEE (Practice, Experiment and Enjoy) as you go. A common problem with taking this kind of photo is that the images can be over-exposed due to the slow shutter speed allowing too much light to flood the camera's sensor.

If your images are over-exposed, you can try one or more of the following remedies:

- Choose a higher f-stop number to reduce the amount of light coming into the camera.
- Choose a faster shutter speed.
- Try reducing the ISO setting.
- Place a neutral density filter over the camera's lens – every camera shop sells them. This acts like a pair of sunglasses for the camera. If you don't have a neutral density filter but do have some sunglasses with you, experiment by putting them in front of the lens .
- As a last resort, try moving your camera to a spot where there's less ambient light.

Another common problem you many encounter is the stationary subject looking blurry in the image. This is because the shutter speed is so slow that the photos suffer from even the tiniest camera-wobble, so use a tripod and make sure that the blurred bits in your photograph are intentional rather than accidental!

The slower the camera's shutter speed, the greater the need for a tripod. If you use a setting lower than 1/50, you probably won't be able to hold the camera still so, if you don't have a tripod with you, make sure you find something sturdy to put your camera on.

Choosing the right shutter-speed will depend on the speed of the moving subject. For example, if you're using 1/50 of a second shutter speed to photograph an elderly person shuffling along the road, there will probably only be a small about of motion blur. However, if you use the same setting to take a shot of a moving taxi, the motion blur will be much more pronounced. So, depending on the amount of blur you're after, use a slower shutter speed to increase the amount of motion blur and, conversely, choose a faster shutter speed to decrease the blur.

Just because something is whizzing through your frame, don't lose sight of your composition. If you can, try to plan your shot in advance so that when you press the shutter button, you'll know what image to expect.

Once you've got to grips with using a slow shutter-speed for this project, why not try your hand at light trails (see p178), night shooting (see p198) or stargazing (see p200)?

Choose your subject carefully; moving subjects that make great photos are:

- Trains
- Waterfalls, waves or other running water
- Playgrounds: merry-go-rounds, slides, swings, and so on
- Fairgrounds
- Cyclists
- Birds
- Anywhere where there are moving people!

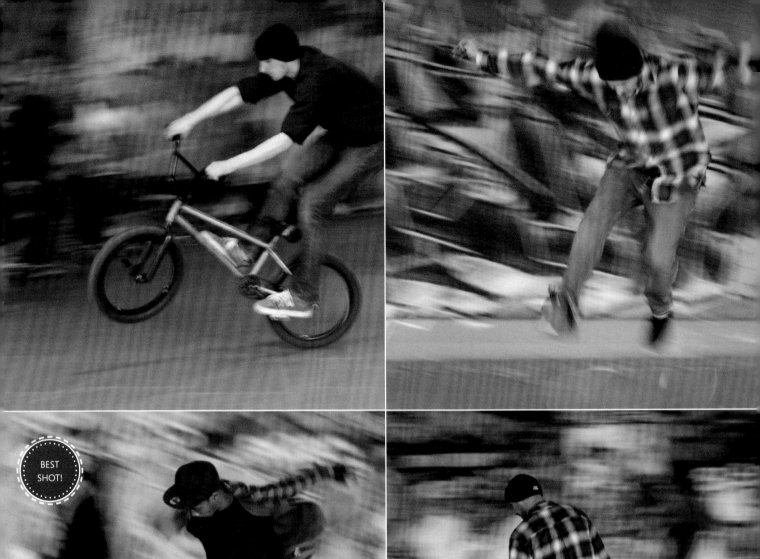
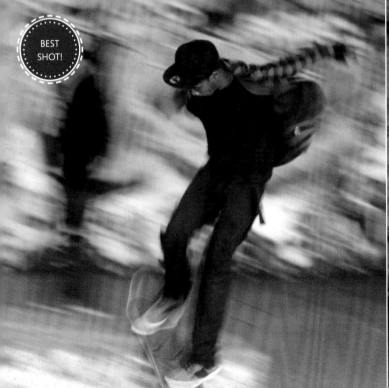

BEST
SHOT!

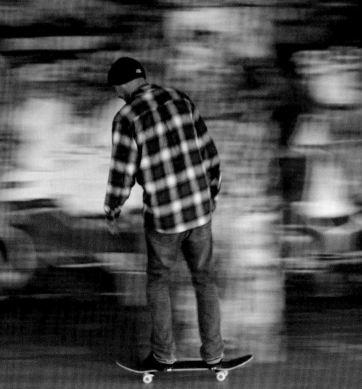

PANNING SHOTS

- DSLR
- Moving subject(s)

A great panning shot is easily recognisable: a moving subject is in focus while the background is a blur – the juxtaposition of these two elements creates real drama as well as a sense of speed and dynamism.

The key to taking a good panning shot is to ensure that your camera follows the moving subject at *exactly* the same speed. So you have to be physically moving the camera as you press the shutter button.

- Before you start panning, you need to set your camera to shutter priority mode and select a slow shutter speed; less than 1/50 of a second works well.
- Taking a shot with a slow shutter speed will destabilise the image just enough so that, as you pan the camera in sync with your moving subject, the subject will remain in focus while the background blurs. (This is the opposite to the rock-solid super-fast shutter speeds that photographers normally aim for.)
- Some DSLR cameras have a continuous focus mode, which is very useful for photographing a moving subject. If your camera doesn't, just use manual focus and be sure to focus your lens on the right part of the scene before you take the shot. For example, if you're shooting a moving car, focus on the road just at the point where the car will pass; this way, as the car enters the frame and you bring the camera up to take the photo, you'll know that the vehicle will be in focus.
- You need to be tracking the moving subject through the camera's viewfinder like a marksman uses the gunsight to follow his prey. It's vital to be moving continuously before, during, and after you take the shot; so definitely don't try this project if you're feeling a bit uncoordinated that day.
- To increase your chances of getting a good shot, try using shutter burst mode. Check your camera settings to see if it has this option. Shutter burst enables the camera to take several frames per second – the number

of frames depends on the spec of your DSLR, but the general rule is the higher the spec, the more frames per second. To use this mode, simply hold down the shutter button and the camera will keep firing frames until you're ready to release it.

- To increase the amount of background blur in your shot, you could try the following tactics:
 1. Decrease the shutter speed.
 2. Use a zoom lens, otherwise known as a telephoto lens (the really long one). The lens compresses the image and therefore augments the amount of background blur.
 3. Increase the distance between the moving subject and its background. The greater the distance, the more background blur you'll create.
- Don't be surprised if you end up discarding the majority of the images you take after a panning-shot shoot. The important thing is that you're left with a few amazing ones.

The best panning shots are usually taken when the moving subject is travelling in a straight line, parallel to where you are standing. This leaves you with plenty of interesting potential subject matter: cars, cyclists, running children, racing llamas – or anything else that moves in a linear direction… You could also, of course, take a panning shot of a rotating subject, which would entail rotating the camera at the same speed.

SHOOT 50 SHOTS

kit

- DSLR
- Interesting subject matter
- Plenty of imagination
- Tripod (optional)
- Flash unit (optional)
- Diffuser (optional)
- Different backgrounds (optional)
- Timer (optional)

It's not just cowboys who need to sharpen their shooting skills... Photographers need practice too!

All you need to do for this project is to find an interesting subject and shoot the life out it (with your camera; I'm not still talking about guns...). Just keep moving, keep thinking and keep firing the shutter until you have a set of 50 unique images.

This type of project is a fantastic way to push your visual thinking skills. You'll find that, as you're taking all the different kinds of shots, you enter a 'flow', in which the left side of your brain turns off and your right side (which powers creative thinking) switches on.

If you find yourself worrying too much about each shot, why not set a timer so you're working against the clock? The extra pressure might be just what you need to move your shots on.

There's no need to overthink the shots you're taking once you've found something cool to photograph – just keep taking them. When you have exhausted every type of shot in your visual arsenal, it's time to put down your camera and step away...

Edit your images carefully, re-cropping where necessary. I shot about 100 frames before adjusting them (using different crops, exposures, contrast and saturation) in basic editing software. Then I selected my top 50 – okay, so there are actually 54 here, but it was difficult to stop once I'd started – and created a contact sheet (opposite). From that I chose my top three images (to the right).

You think that 50 shots is a lot? Worried you might run out of ideas? Turn the page for some helpful hints...

The top image stood out because of its dreamy, painterly feel, which happened totally by chance when I used the reverse macro technique (see p82). The middle image was shot against a white sky to create this blown-out white background juxtaposed with the detail and form of the petals. The bottom image has a fabulously soft depth of field in contrast to the prickly leaf texture.

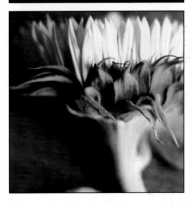

SHOOT WITH A SHALLOW DEPTH OF FIELD (F5.6 OR BELOW)	SHOOT WITH A LARGE DEPTH OF FIELD (F8 OR ABOVE)	**SHOOT FOR FORM (THE SHAPE OF THE SUBJECT)**	SHOOT FOR TEXTURE (HOW DOES THE SUBJECT FEEL?)	FOCUS ON WHATEVER LIGHT MIGHT APPEAR ON THE SURFACE OF THE SUBJECT	SHOOT THE SHADOWS
CONCENTRATE ON ANY ABSTRACT SHAPES YOU MIGHT SEE	SHOOT FROM ABOVE	SHOOT FROM BELOW	SHOOT TO SHOW HOW UNIFORM IT IS (ARE THERE PATTERNS AND LINES IN YOUR SUBJECT?) OR ORGANISE YOUR SUBJECT/S IN A UNIFORMED WAY.		SHOOT WITH A WI ANGLE (ZOOM OU WITH THE LENS)
SHOOT CLOSE-UP (ZOOM IN)	SHOOT MACRO	CHANGE YOUR ANGLE	NOW CHANGE YOUR ANGLE AGAIN	THROW THE SUBJECT YOU'RE SHOOTING INTO THE AIR (IF THAT'S POSSIBLE)	OR SQUASH IT (AGA IF THAT'S POSSIBL
SHOOT TO SHOW VOLUME (THE WEIGHT, SIZE AND FULLNESS OF THE SUBJECT)		BREAK THE RULE OF THIRDS (SEE P16)	USE THE NEGATIVE SPACE AS THE SUBJECT OF YOUR SHOT	SHOOT USING SHUTTER ZOOM TO SHOW DRAMA (SEE P24)	SHOOT TO SHOW SCALE
SHOOT TO SHOW *ACTION*	SHOOT SO THAT COLOUR IS THE MAIN SUBJECT	SHOOT WITH A DIFFERENT WHITE BALANCE SETTING	USE SHUTTER BURST MODE WHILE YOU MOVE AROUND THE SUBJECT	SHOOT TO SHOW HUMOUR (TRY TO FIND A FACE IN THE SUBJECT; MAKE I LOOK LIKE SOMETHING ELSE; TURN IT UPSIDE DOWN, AND SO ON)	
FILL THE FRAME WITH THE SUBJECT	SHOOT SO THAT THE FRAME IS VIRTUALLY EMPTY BUT THE SUBJECT IS STILL RECOGNISABLE	USE THE FLASH TO CREATE HARD LIGHTING	DIFFUSE THE FLASH'S LIGHT SO IT'S SOFT	SHOOT WHEN THE SUBJECT IS ONLY PARTIALLY LIT	USE ONLY DAYLIG TO ILLUMINATE THE SETTING
LOOK FOR LINES (SEE P18)	SHOOT TO HIGHLIGHT THE CONTRAST IN YOUR IMAGE (AREAS OF DARKNESS AND AREAS OF BRIGHTNESS)		SHOOT IN BLACK-AND-WHITE	OVER-EXPOSE YOUR IMAGE SO THAT ONLY THE DARKEST AREAS OF THE SUBJECT ARE VISIBLE	UNDER-EXPOSE YOU IMAGE SO THAT ON THE BRIGHTEST AREA OF THE SUBJECT ARE VISIBLE
USE A HIGH ISO SETTING	USE A LOW ISO SETTING	VARY YOUR FOCUS	BACKLIGHT YOUR SUBJECT	SHOOT TO SHOW CHAOS – DIFFERENT TEXTURES COLLIDING OR THE SUBJECT/S LOOKING DISORGANISED	SHOOT FOR SYMMETRY
SHOOT FOR ASYMMETRY	SHOOT AGAINST A CONTRASTING COLOUR	USE THE RULE OF THIRDS (SEE P16)	SHOOT THROUGH THE SUBJECT	SHOOT A LONG EXPOSURE (USE A TRIPOD)	ADD A TWIST OF YOUR VERY OWN!

MACRO

kit
- DSLR
- Lens
- Tripod (optional, but recommended)

Macro photography is typified by 'up close and personal' images. These shots are taken at a ratio of 1:1 or, like a magnifying glass, even bigger than life size. A previously hidden world is dramatically revealed in new levels of texture and detail.

- If you can't afford to buy a macro lens, don't worry – you already have one... Simply take off your existing lens and carefully reverse it before holding it up to the camera again (so that the end that normally attaches to the camera faces out towards the subject you want to photograph). The images on the opposite page were taken using a reversed prime 50mm f1.8 lens.
- Ensure that you get the exposure right by setting the camera to shutter priority mode. This way you can change the shutter speed to suit the amount of available light. If the image is too bright, choose a faster shutter speed; if it's too dark, slow the shutter speed down. Experiment as you go along.
- To focus your image, all you need to do is alter the distance between the subject and the camera. It's important to only make very small movements, though, as the depth of field created by your new macro lens can be very shallow indeed! Wait until the image is sharp before pushing the shutter button.

- It can be a real balancing act as one hand holds the camera and clicks the shutter while the other gently holds the lens up to the camera, so it's worth using a tripod to help with stability.
- When you get up close to nature using your 'new' macro lens, you'll see how complex and weird it is. For this reason, nature makes a great subject matter for macro photography. Start by exploring freaky flowers before moving onto intriguing insects. (But remember, these little critters can move fast.)
- Once you've got the hang of this project, why not have a go at experimenting with different lenses? The wider the lens can go, the more 'macro' the image will be.

If you find yourself well and truly bitten by the macro bug, you could buy a reverse lens mount. This clever metal ring screws on to your camera to allow the 'wrong' end of the lens to be attached and is relatively inexpensive when you consider the cost of a macro lens.

Be oh-so careful:
Make sure your reversed lens is free from dust before you put it up to your camera. Dust can easily get on your sensor and cause your pictures to look a bit lumpy.

Vintage camera

This image shows a normal shot taken with a 50mm prime lens. The images opposite demonstrate the dramatic macro effect that has been created by flipping the lens. If the images are coming out a little blurry, try upping the ISO setting so that you can use a faster shutter-speed.

PHOTOJOURNO

kit

- DSLR (or two)
- Tripod or monopod (it's one-legged as opposed to three)
- Spare batteries
- Spare memory cards
- Zoom lens (optional)
- Wide-angled lens (optional)
- Camera bag (if required)
- Pen and pad (it's useful to jot down notes if you're going to write about the event afterwards, and you'll probably need the names and details of the people you've photographed)

The role of the photojournalist is to research and capture images to accompany a story. In many ways the photographer acts as the 'eyes' of the viewers, taking them to the event and revealing, through their pictures, how the story unfolded. Have a go yourself…

To get the best, most emotive shots, photojournalists have to know their camera like the back of their hand. They also need to have brilliant people skills, as it's essential for them to be able to win the trust of their subjects. Are you able to mix with the homeless as well as the rich and famous? Sometimes you might be welcomed with open arms but, at other times, you might have a clenched fist (or worse!) waved at you.

It's also necessary to have an inquisitive mind and a 'nose' for a story that readers will care about. Photojournalists have to be quick thinkers, too, as some of the stories they cover can put them in dangerous situations. But, to have a go yourself, you don't have to risk life or limb – just pick an event you'd like to cover. It might be a fête, a fun run, a family celebration or a carnival… It doesn't matter what, just try to think about how a photojournalist would cover it.

It's important to take lots of photographs to document the story, which is easily achieved as pixels are free in this digital age. It helps to have a think about what the story or theme is going to be before you arrive, so that you already have in mind the type of photos you'd like to take. Planning and visualising beforehand means you'll be able to recognise photographic opportunities as and when they present themselves.

What shots should you take?

You need a range of shots to cover the event:

- Make sure you get a wide shot that covers the whole scene or event – find a high spot from which to take the photo, if you can.
- Take peopled portraits. Wherever possible, try to capture the extremes of human emotion – tears or elation – as these make the most compelling images.
- Also take plenty of close-ups of any relevant objects and surroundings to add to the story and scene.

Before you press the shutter button, remember to think about the following:

- Check your photo's composition – good composition can make all the difference between a mediocre picture and a great one.
- Fill the frame – pictures in newspapers and on blogs have to grab the viewer's attention.
- Watch your background – distracting backgrounds can ruin a shot.
- Eye contact – check where your subject is looking. A person's eyes are the first feature to be sought out by people, in real life or in a photo.
- Look for a shot that tells a story.

If you have two different types of lenses and cameras, wear them both around your neck. That way you can be a quick-draw snapper and take the shot with the appropriate lens in good time, instead of having to waste time changing lenses.

The shots are in the bag – now what? Contact the organisers of the event; your images might be just what they're after. Or you could create a free blog (see p216) and upload your images for the world to see.

SHOOT FROM THE HIP

kit

- DSLR
- A nice busy scene
- Neck strap (optional)

As with anything, it's all too easy for photographers to get stuck in a rut when it comes to taking their shots, resulting in a portfolio of images with an all-too-similar style and composition. This project provides a great little trick for shaking up your approach and letting go of any boring habits you may have developed.

There's nothing new about the 'shooting from the hip' technique; in fact, many vintage cameras were made with the viewfinder at the top of the camera so that taking shots this way could be a comfortable and natural approach.

Reportage photographers often use the technique because their subjects don't notice they're being photographed; when you aren't bringing the camera up to your eye, it's a lot easier to take candid shots.

Choose an interesting location with lots going on: markets can make for a great kind of street theatre, with plenty of action above and below eye level.

- Shooting from the hip is super simple: just extend the neck strap of your camera so that it's at waist-height or lower – or hold the camera by your side (firmly) with one hand – and take shots as you walk along.
- The key is to angle the camera slightly, so as to capture the interesting action. You will be amazed at how much more you notice at waist-height than at eye level.

- Set your camera to shutter priority mode and select a fairly fast shutter speed, because both you and your subject might be on the move while you are photographing. Start at 1/160 of a second and increase the speed if your shots are blurry.
- For an averagely bright UK day, select an ISO setting of about 400. If you want to increase the creativity of the shots, lower the shutter speed to show motion blur. Just make sure you stay still, otherwise the whole shot will come out blurry!
- To add yet more interest to your images, use the full range of your lens – zoom in for detail and zoom out to show the bigger picture.
- When you first use this technique, the desire to keep checking what you've taken is really strong – but try to overcome it. Constantly checking your shots will not only draw attention to you, but will also spoil the whole random nature of the images you're capturing; so checking counts as cheating!

Take plenty of shots, as this technique has a very low hit rate; out of every 100 shots you might get three or four fairly decent ones. But resist the urge to delete any images before you get home. As the saying goes, delete in haste – repent at leisure! Hopefully those three or four good images will be dramatically different from what you would normally take and will also have captured people acting in a natural, unselfconscious way.

ACCESSORISING

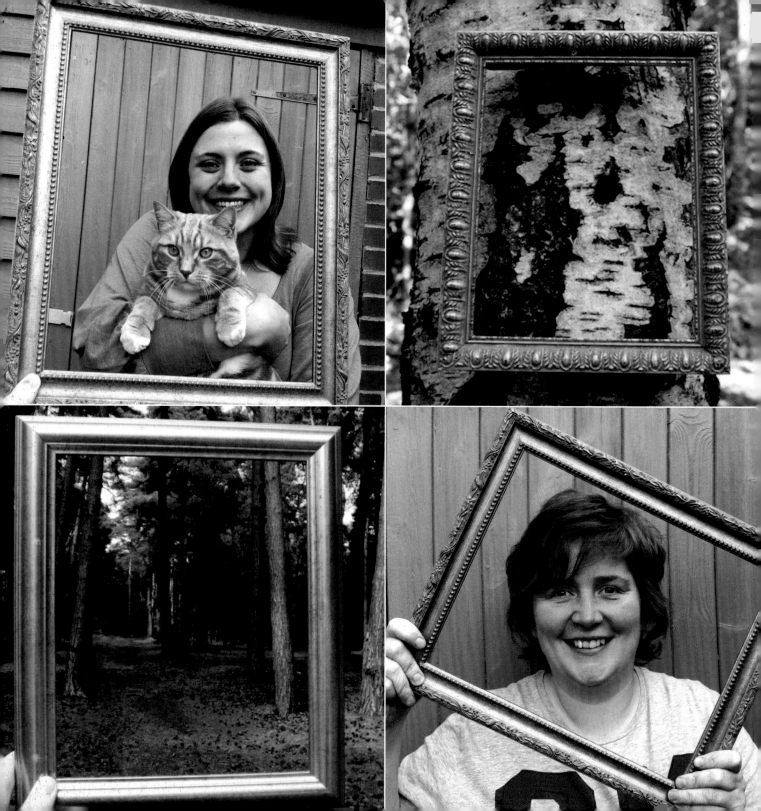

FRAMED!

kit

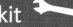

- DSLR
- Picture frame
- Interesting subject matter, such as friends and quirky locations

Take a frame off the wall, empty it of its usual boring contents (glass, picture – the lot), then go and take some photos with it. Easy!

Okay, so you don't want to use the frame displaying your prized swimming certificate? No problem. Just head to your nearest charity shop and somewhere in there you'll find a big box of pictures and frames.

Aim to buy one (funky, classical – whichever style you fancy) that's not too big or too heavy, so that when you hold it at arm's length you can still see its edges in your camera's viewfinder; and not too small, as you'll need to be able to fit your head through it (yes, these are important technical requirements!).

Once you've got your frame, you'll start to see your surroundings in a totally different light.

Framing is easy to get the hang of – just go for a walk and, literally, 'frame' your shots. Or take the frame to a party to use it as the ultimate fun photographic prop.

- Put your camera in aperture priority mode and select a high f-stop number – f11 or above – to ensure that the foreground (your frame) and the background (its subject) are both in focus.
- Take the frame in one hand and your camera in the other; use your frame to frame the subject.
- Check the image on the back of your camera – does it look sharp? If parts of the picture look soft, then you need to up the f-stop number to increase the amount of the image that's in focus.
- Check that your camera and picture frame are all in line (generally you want to avoid any wonky-looking pictures).
- Press the shutter button!

The joy of this project is that, once the photos have been printed, there's no framing required! You've pre-framed your pictures.

Props help to relax your (human) subjects. So, whether you're at a party or a picnic, a picture frame is a great way to encourage your friends to pose for you.
Mix it up: break the illusion of the frame by asking a subject to poke their head or arm through it. You could also try using the frame to take a mini still-life shot of the environment to help give the event a sense of narrative.

YOUR BUBBLE

kit

- DSLR
- Glass dome
- Interesting subject matter

We all exist in our own little world, so there's something amazing about making our individual universes even smaller. Glass domes (available to buy online) refract the light around them to create an inverse image inside. Looking into one is a little like watching a magical snow globe work its wonders in the palm of your hand.

Take your glass globe out and about with you for a photographic adventure. Watch panoramas become pocket-sized in the dome – like a mini city in a snow globe – while flowers and animals appear to be set in solid glass, like a Victorian paperweight. Because the images you take will be engendered with these qualities,

go with it; try to take photos that fit into the snow globe/paperweight/world-in-miniature themes.

- Hold the glass dome with one hand (between your forefinger and thumb).
- Simply start snapping it with the camera (held in your other hand) – experimenting with shallow and large depths of field to vary the sharpness of the background. (Remember that the lower the f-stop number, the shallower the depth of field will be – and the higher the f-stop number, the larger the depth of field.)

You can also try flipping the photo so that the image inside the globe is the right way up (see the photos below). Portraits can be fun, but tend not to be flattering!

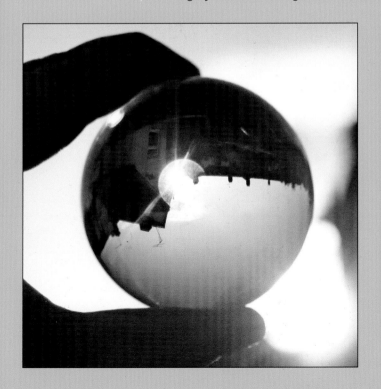

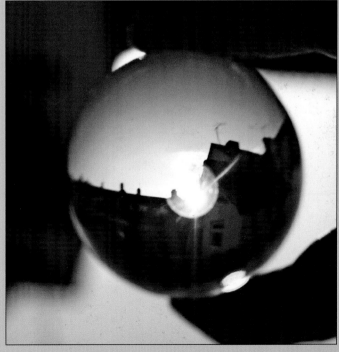

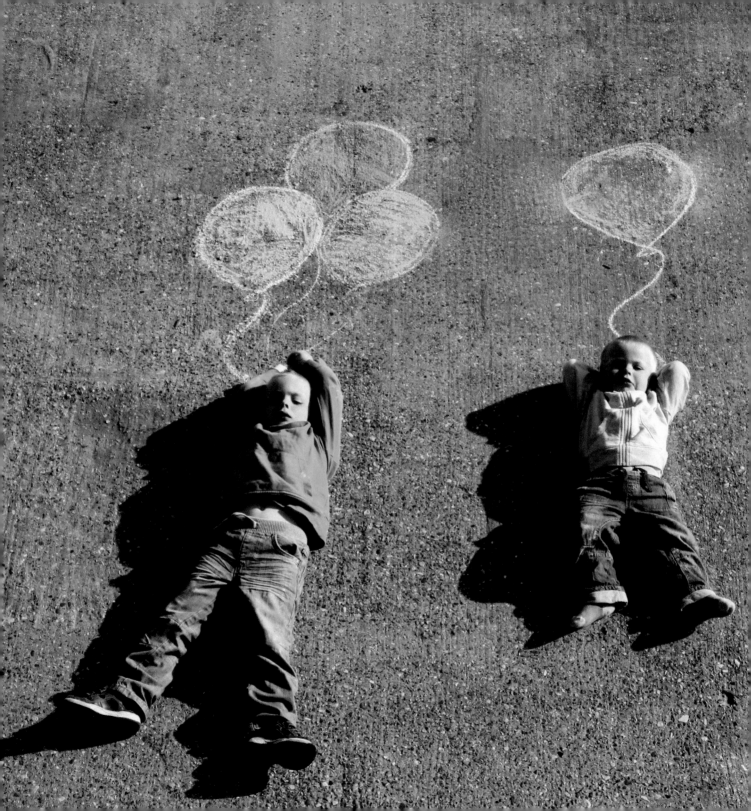

DRAWN TO PHOTOGRAPHY

kit

- DSLR
- An interesting background with a flat surface to draw on and a high vantage point
- Chalk
- Props to add life to the photo (optional)
- Model(s) (children, animals, and so on)
- Ladder (optional)

Sometimes photography can be a little hands-off – a photographer usually just points, shoots and leaves – which doesn't make for a lot of interaction with the environment that's being photographed.

This project allows you to get well and truly hands-on as you create some arty images in an old-fashioned way. It should also get you thinking about layering your images with information. Kids will love getting involved in the fun and, even better, the rain will clean it up for you.

For this series of photographs, I tried playing with perspective: using a high camera angle and an engaging hand-drawn background so that the horizontal plane becomes vertical in the final image.

To create your own hand-drawn photography:
- Begin by brainstorming some ideas for your background. Atli (the older child in these shots) came up with the great idea of drawing a parachute; while August (Atli's younger brother) just liked snapping the chalk sticks in half and then putting them in the bin saying 'broken'! Hopefully you'll come up with an excellent idea for a background and so won't need to chuck your chalk in the bin...
- Then you'll need to gather any props that might come in handy. (The small red cape really helped to bring the Superman images below to life.)
- Choose a location with a high vantage point to shoot from (such as the ground beneath a bedroom window, some steps, or somewhere where you can use a ladder).
- Now it's time to get drawing. To start, roughly sketch out your design and then colour it in using some chalks. (Atli was very good at colouring in; he's studying this at school.)
- Encourage your model(s) to interact with the background scene while you direct him, her or them from on high.
- When the scene below is looking brilliant from your vantage point, take the shot. There's no need to use any special settings; you can just use auto, if you like. Just make sure that your depth of field isn't too shallow so that you don't end up with a blurry chalk drawing.

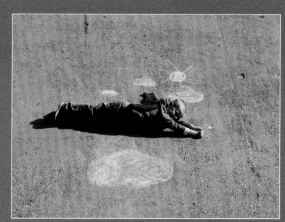

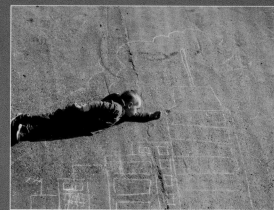

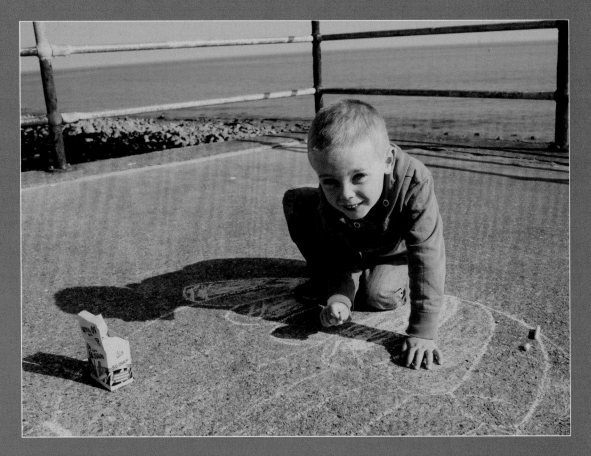

Other ideas:

Using a chalkboard in an image can be a good tool for communicating important information in a portrait – whether you are documenting a happy couple announcing their wedding date or a toddler's first steps.

To create a cute family photo, draw a big '+' sign on a wall between each parent, then an '=' sign between the second parent and their child, or children.

If you'd prefer to use a four-legged friend in the shot, try drawing a thought bubble on a wall above his or her head – perhaps containing a quote by Socrates…

With just a little imagination you can create some superbly interesting shots.

Adding a dash of drawing to your image creates an interesting visual layer. It can insert a little wit or give additional information to the viewer.

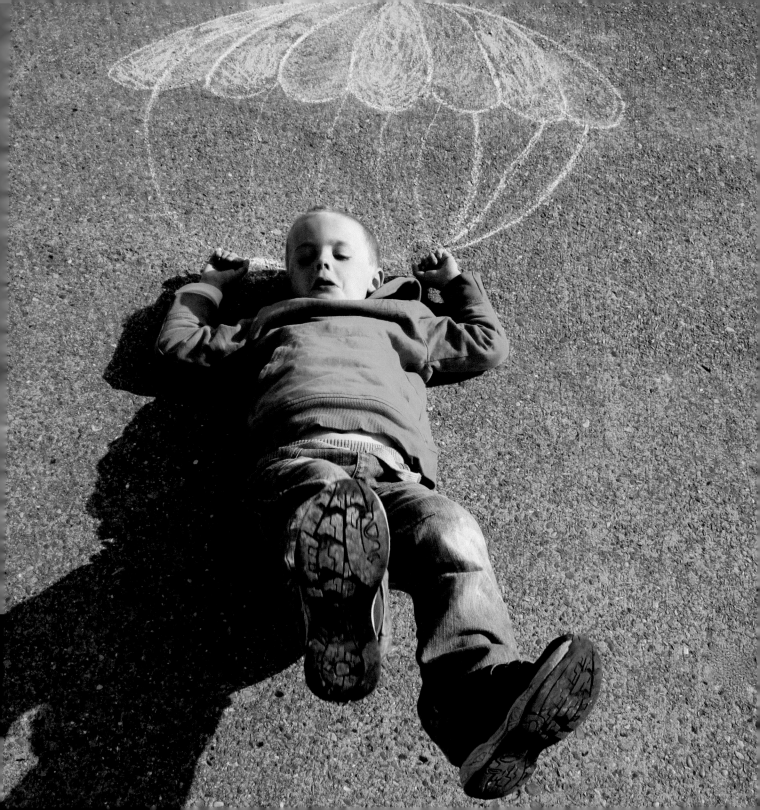

The making of the shot

Lighting: I used natural window light, as the light in the original poster was soft and even.

The model was positioned against a plain wall. The camera was set to an ISO of 400, with an aperture of f5.6.

Props: the headscarf was a piece of square material purchased from eBay for £2.99. The blue shirt was the model's own, as were the eye make-up and bright red lipstick.

Once I had *the shot*, I opened it in Adobe Photoshop on the computer. I removed the photo's background using the 'magic wand' tool, then used the 'fill' tool to create a plain yellow background to match the original poster. The blue mast at the top of the image was created using the 'pen' tool and then filled. Finally, I adjusted the contrast and saturation on the layer that the model was on. And there you have it...

DIGITALLY REMASTERED

kit

- DSLR
- A copy of an original picture to recreate or reinterpret
- Relevant props
- Relevant location
- Relevant lighting
- Photo-editing software (optional)

Classical artworks can be a great source of discovery and inspiration. Observe an old painting and you're likely to learn all sorts about composition, lighting, colour, narrative, drama and staging. So why not take a leaf out of an old hand's book and try recreating a work of art or, in this case, a vintage poster?

The original poster – entitled 'We Can Do It!' (see below, left) – was created by J Howard Miller. Its intention was to encourage American women to take up traditional male roles during the Second World War.

- Preparation is key for this project. Take a close look at the picture you'd like to recreate and write a list of costumes, props and locations that you'll need to use. (At this point you'll have to make a creative decision as to whether you wish to faithfully recreate the image or use some artistic licence of your own. It's your call.)
- Study the lighting in the original picture carefully: think about the direction of the light and whether it's harsh (creating dark shadows) or soft (hardly any shadows). Also think about the light source in the original: is it fluorescent, like the lighting in Edward Hopper's 'Nighthawks' painting, to create a play between light and shadow? Or perhaps the scene is candlelit, as found in a Rembrandt self portrait? You could experiment using these original sources of light, or try to recreating it using electric lights and modifiers (see p162–165).
- If you're going to shoot a portrait, pay careful attention to the eye level of your subject. In the original picture, in which direction is the model looking? These little details will give your digitally remastered image the 'wow' factor.
- Don't forget to take a copy of the original picture with you to the shoot so that you can faithfully reproduce – or reinterpret – it as you wish.

If classical paintings or vintage posters aren't really your thing, why not take some inspiration from a renowned photographer? Seeing your world through the eyes of another can be a really uplifting experience. To explore form, you might want to examine images by Edward Weston; to explore landscape, works by Ansel Adams are worth a look; or, for reportage, Martin Parr is pretty inspirational. Further ideas are given below...

COUPLE'S SHOT	ONE FOR THE BOYS	ONE FOR THE GIRLS	GROUP SHOT
Dress up in Puritan costumes, find a pitchfork and stand in front of a wooden cottage to recreate the classic Grant Wood painting, 'American Gothic', of a farmer and his spinster daughter.	Dig out your best suit and a large shiny green apple to recreate the 'Son of Man' painting by Surrealist René Magritte. The subject wears a bowler hat, suit and tie – looking perfectly normal – but his face is obscured by a huge apple!	Recreate the beautiful but haunting portrait of 'Girl with a Pearl Earring' by Dutch painter Johannes Vermeer. Very few props are needed, and it provides the perfect excuse to get yourself (or your model) some pearl earrings!	Gather a bunch of people together and re-enact French painter Georges Seurat's 'A Sunday on La Grande Jatte'.

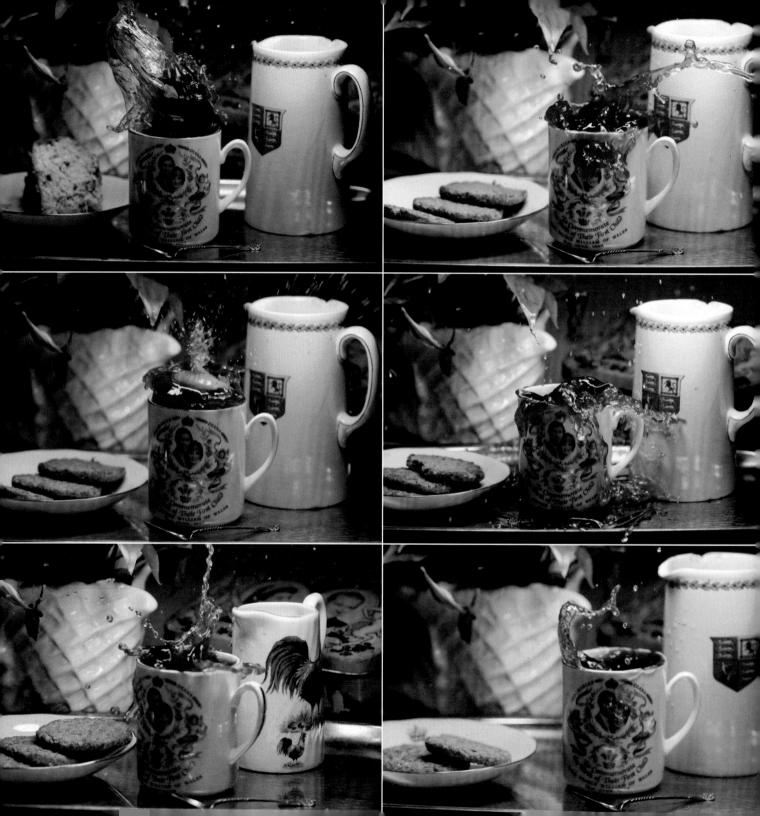

SLAM DUNK

kit

- DSLR
- Tripod
- Table lights (or a flash unit or strong light from a window)
- Objects for the still-life scene, including cups of tea and perhaps a cake (or two to eat if you get peckish)
- Missile, such as an egg or plasticine
- Shutter release cable with long lead (optional)
- Beautiful assistant (optional)
- Biro
- Plenty of paper towels

The big storm in a fine bone-china teacup is a compelling photographic story – full of drama, energy and intrigue. Get ready to make a splash...

For this fantastically fun project you'll need your camera, a tripod, a table light or two (or a flash unit), a cup of tea, a hard-boiled egg or lump of plasticine, and some other objects to dress this (not very) still-life scene.

Please take care with the electricity near the liquid if you are using a table lamp to light the scene, though; it can get very messy and somewhat dangerous...

To create images similar to the ones here:

- Compose your still life and make some tea for the cup.
- Select shutter priority mode on your camera before placing it on a tripod or firm surface. To give the sense of 'frozen motion' the shutter speed has to be very fast – over 1/250 of a second makes a good starting point – the images here were taken at 1/800 of a second, with an aperture number of f4.
- Once you've filled your cup with tea, it's time to make a big splash: drop the egg/plasticine into the liquid and – just a fraction of a second later – take the shot. (It's tricky to get this kind of quick-fire timing right, so you'll probably need to take quite a few shots before you have something you're happy with.)
- If you have a shutter release cable, do use it. Depending on the length of the cable, you may be able to simultaneously drop the weight into the tea while taking the shot. If you don't have a shutter release cable then you will need someone to help at this point. You will need to communicate with each other and develop a well-timed system of releasing the weight and taking the shot.
- Select manual focus and, to get the best shots, I suggest you focus on the middle of the cup to capture the central point of the action. If you have an assistant, ask them to hold a biro (or something else small) in the centre of the cup, so that you can manually set the focus before the action starts.
- If the tea tippings and splashings come up looking blurry, you'll need to increase the shutter speed. (Check your camera's screen after each shot to make sure the shutter speed is correct.)
- If, when you're checking the images on your camera's screen, the liquid's 'motion' looks sharp but the image itself is dark, it's because the high shutter speed is not giving enough time for the sensor to be exposed to a sufficient amount of light. To improve the image quality, you need more light on your still life, so either add another table lamp or, if you're using a flash, increase the amount of flash on the subject area. If this doesn't help, then try upping the ISO setting a little.
- Have plenty of paper towels to hand, as this wet 'n' wild project can get incredibly messy. After each shot, mop up your scene, refresh the props and repeat. Such fun!

To up the drama, try using perishable objects, like biscuits, slices of cake and fresh table linen. There is something very naughty about purposefully ruining things!

If messiness simply isn't you, take the project outside where you'll have more light and won't leave such a mess.

GOOD VIBRATIONS

kit

- DSLR (ideally with a macro lens)
- Old speaker (attached to a music source)
- Cling film (or latex from a rubber glove)
- Modelling clay
- Cream and food dye
- Tripod
- Flash unit with connecting cable (or daylight/table lamps/pop-up flash)
- An object to focus on
- Music!

The trouble with music is that it's normally difficult to photograph, not being a visible entity and all that, but the joy of this project is that it allows you to capture those banging beats and phat tunes visually using a colourful and creative technique.

1. Grab yourself a speaker (keeping it attached to a music source); it doesn't have to be good quality – I took apart a set of ancient computer speakers for this project.

2. Carefully remove the speaker from its outer casing and wrap the whole thing in cling film or the latex from a rubber glove (so as to avoid any disasters with liquid meeting electricity).

3. Use some modelling clay to fix the speaker in position and ensure that the liquid you will be pouring on top doesn't just run off the speaker.

Next, set your camera up:

- Ideally you will have a macro lens that you can use to zoom into the liquid on the speaker (if you don't have one, just get as close to the speaker as possible and zoom in, then crop the image later). A tripod is also necessary and, preferably, a flash unit and connecting cable to illuminate the vibrations.
- Remember, the closer the flash unit is to the dancing globules created by the speaker, the less power you will need. So if your flash is very close, put it on the lowest setting, and only increase it if your images look dark.
- Position the flash so that it's off camera and just to the side of the speaker. Don't panic if you don't have a flash unit – use bright window light, a couple of table lights or your pop-up flash instead.
- Select shutter priority mode and set the camera to a fast shutter speed (I used 1/200 of a second) to freeze the motion of the super-speedy droplets.
- Choose a low aperture number (I used f5.6) to give a shallow depth of field, which is generally more in keeping with a still-life set-up. You might need to choose different settings according to the available light. As a rule of thumb, if the globules look blurry you should increase the shutter speed. If your images are dark, you'll either need to use a stronger light source or try increasing the ISO setting.
- Use manual focus, and ask an eager helper to place an object in the centre of your speaker (before you pour the liquid on) to help you set the lens focus.
- Now it's time to pour on some liquid (just a little at first) and play your favourite tune. Pump up the volume, get those globules jumping and then push the shutter button!

Take lots of shots and carefully crop the shots to improve the compostion. I love the fact that the droplets look like they're from another planet, so I cropped the speaker out of the shot to enhance their weird, abstract forms.

Keep your eyes peeled for shapes within the splashes – I noticed that one of the droplets looked like it had arms, so cropped the shot to highlight this.

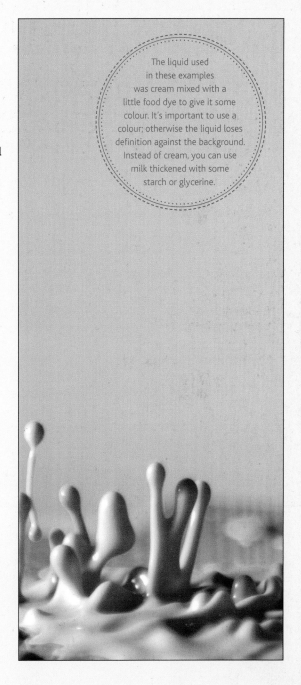

The liquid used in these examples was cream mixed with a little food dye to give it some colour. It's important to use a colour; otherwise the liquid loses definition against the background. Instead of cream, you can use milk thickened with some starch or glycerine.

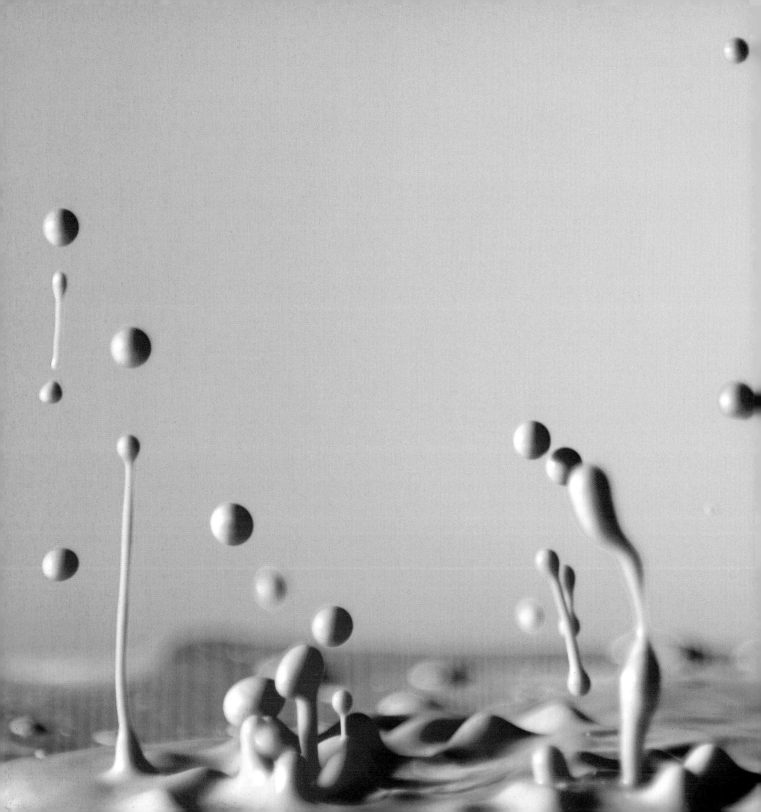

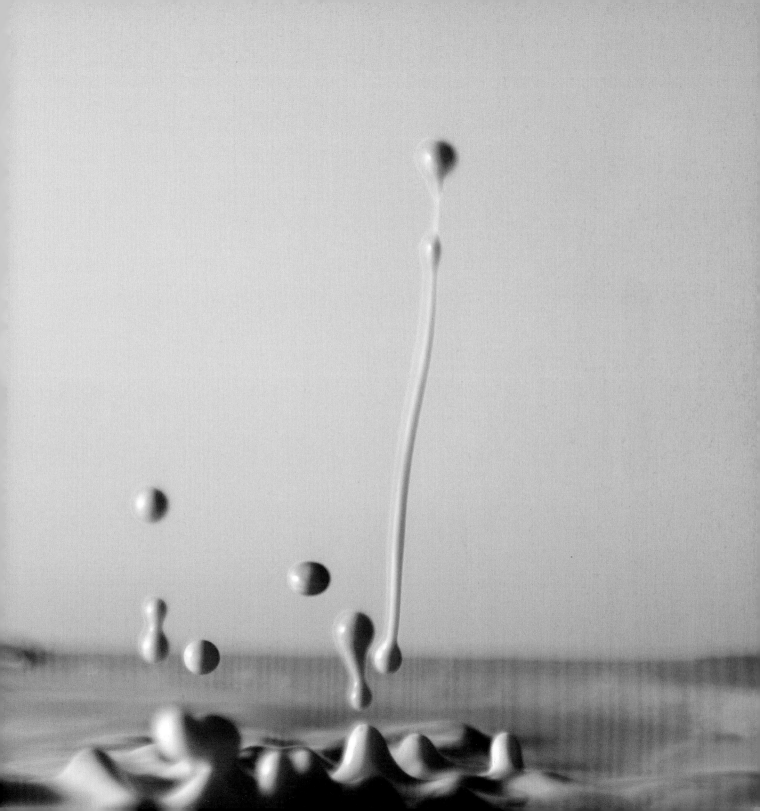

SHADOW PLAY

- Sun print paper
- Object(s) with an interesting shape, such as leaves or flowers
- Sunlight!
- A tray with water

If you haven't experimented with camera-free photography before now, then this is a great project to get you started. Gone are the days of having to convert your bathroom or the cupboard under the stairs into a light-free chamber with litres of chemicals at the ready... All you'll need for this project is some Sun print paper (search the web for good supplier), a pretty object or two, sunlight and a tray of water. The fun-to-funds ratio is most agreeable!

Photograms – what the results of this process are known as – are produced when an object is arranged on light-sensitive paper and then exposed to light. It was the American artist, painter and photographer Man Ray who introduced this technique to the world, rather modestly calling it the 'Rayograph'. And the process hasn't changed much at all since he published the first collection of images made using this process back in 1922.

1. Choose an object with an interesting form and then simply arrange it on a sheet of the light-sensitive paper before exposing the sheet to light for a couple of minutes. A replica image of this object is then captured on the paper as a result of the exposure to light.

2. To 'fix' the image onto the Sun print paper, submerge the sheet in water for a minute.

When the paper enters the water, the areas that were dark (those that were beneath the object, and not exposed to light) go white, while the rest of the paper, which was a pale blue/white, turns a beautiful dark blue.

3. Once out of the water, the paper needs to be dried flat; I recommend setting the sheet up against a flat, vertical surface to allow any water to run off.

> While you're waiting for the sheet to dry, you can decide how you're going to display your beautiful images.

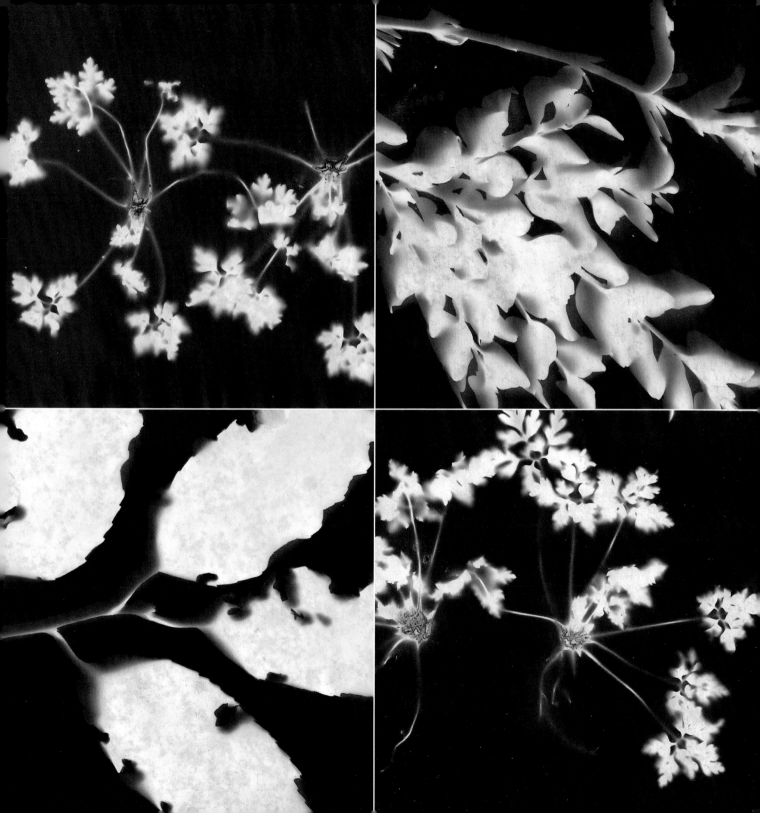

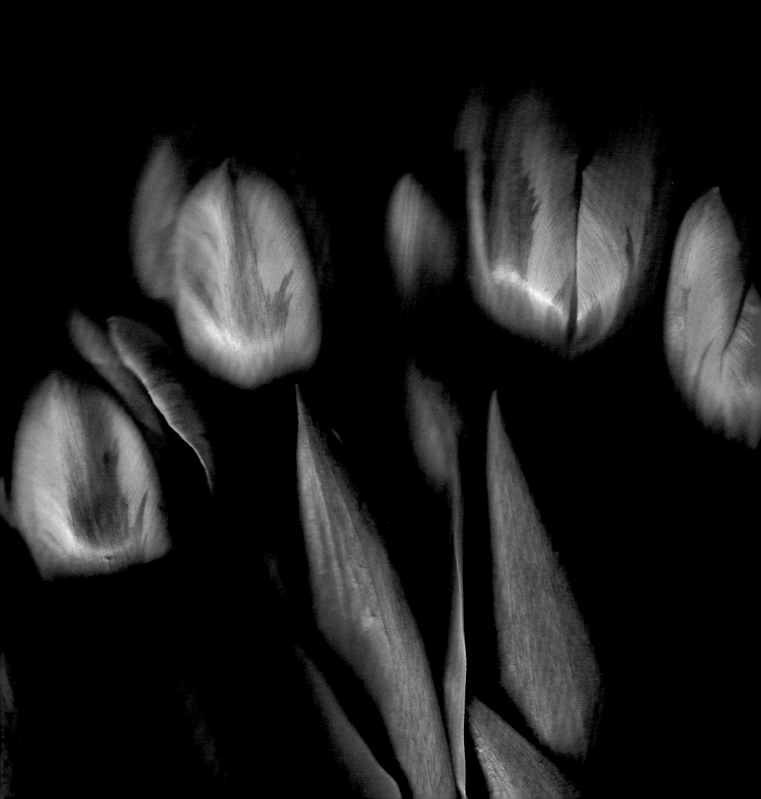

SCANOGRAPHY

kit

- Scanner
- Various interesting objects
- Background of some sort, such as a sheet of black paper
- Computer
- Post-production software
- Printer and paper (optional)

'Scanography' is just a catchy name for scanner photography (see what they did there?). The images that a scanner can produce are really interesting. This is because the scanner has an extremely shallow depth of field, so any 3D objects you try scanning quickly become out of focus if they aren't in direct contact with the glass bed. The light from the scanner means that parts of the objects come out looking super sharp, often with beautiful highlights (see the chillies, below left). The colours can also be wonderfully rich and saturated.

You'll need access to a computer, a scanner, various interesting objects (raid your fridge or garden if you're stuck for ideas), some post-production software such as Adobe's Photoshop Elements, or Aperture, and a printer and some paper if you want to display your finished work.

- Arrange the objects on the glass of your scanner.
- Think about your background. I used a sheet of black paper to contrast with the colourful objects, but if you're scanning darker objects, you might want to use a lighter backdrop.

- When you're happy with your arrangement, press the scan button. This should generate a low-resolution preview. If you need to make any changes to the arrangement, here's your chance to do so.
- Check that the scanner is set to scan at 300dpi. This will enable you to reproduce the image at actual size. If you wish to print it on a larger scale, it's necessary to increase the dpi so that your images don't become blurry.
- Press the 'accept' button, and the scanner should generate a high-resolution image.
- Tweak your image using post-production software. I increased the saturation and contrast and also made the background a solid black.
- Try to remove any dust or dirt on the image, as this can be a real distraction. It shouldn't take too long.

Don't forget to save your image before printing it out, or uploading it.

FRAME-OSAURUS

kit

- Photos you want to display
- Plastic dinosaurs (or other similar four-legged toys)
- Cutting tool (sharp knife or hacksaw, depending on the toys' material)
- Scraps of paper
- Wood-filler
- Strong adhesive (superglue or a hot glue gun)
- Strong magnets
- Paint and small paintbrush

Everyone has a few old photos languishing in a forgotten drawer in the house that really deserve to see the light of day. The 'frame-osaurus' is just the solution for displaying those photos without having to go to the effort and expense of having them framed. As well as providing you with a funky new photo-holder, this project repurposes old toys – which means you'll have an excuse to play with them once more!

1. To create some hip new frames you'll need a few cool plastic toys. It's not essential to use dinosaurs – if you were into My Little Pony as a kid then it's fine to use these figurines – as long as the toys in question are sturdy. Creatures with four legs tend to work best, and dinosaurs are particularly stable because of their tails!

2. Once you have your toy(s), decide where to cut each one in half. The cut line is crucial; it needs to be vertical when the toy is in its normal stance. This is so that your photo will be in an upright – and therefore easily viewable – position.

3. The cutting tool required depends on the material of the toy(s). If it's a soft, pliable rubber substance, you'll probably be able to use a sharp knife; if it's hard plastic, using a small hacksaw is advisable.

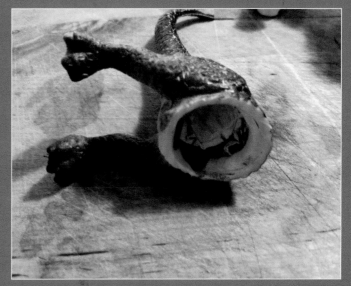

4. Once you have carefully cleaved the toy(s) in two (bet you felt like a total weirdo!), you need to stuff the hollow in each of the halves with scraps of paper. Pack the paper in as firmly as you can, but leave roughly 0.5cm of space from the top.

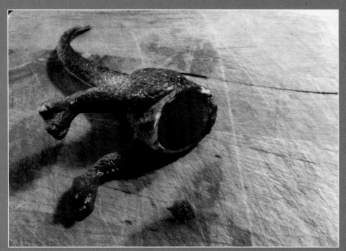

5. Fill this remaining space with wood-filler (it appears brown in the photos as my wood-filler had a dye in it), which shouldn't shrink, so gives you something solid to stick your magnets to later on.

6. Allow the filler to dry.

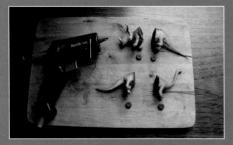

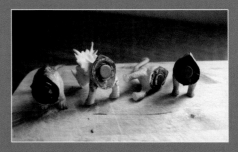

7. When the wood-filler is dry, attach some strong magnets (available from most craft shops) to each half of the toy(s) using a strong adhesive like superglue or a hot glue gun. Be sure to check before you glue the magnets onto each half of every toy that they pull together rather than repel — otherwise the toys won't join back up.

Well done! You have completed the funkiest frame(s)! Now find those pictures and put them on display. Little clusters of marauding dinosaur photo-holders look brilliant together. They make great gifts, too.

8. Finally, paint your toy(s) — I chose gold to make blinging frame-osauruses — and leave to dry before popping a picture between each one and joining the two halves of each toy together again. What a roaring success...

POP-UP CARDS

kit

- Computer
- Digital images
- Printer and photographic/plain paper
- Blank cards or plain A4 card
- Glue
- Pencil
- Scissors/craft knife and cutting matt
- Envelopes (optional)

Add some childhood magic to the next homemade card you send. These little beauties burst open with impromptu theatre.

The first thing you need to do is to find images that will make an interesting subject. A pop-up card is comprised of a series of layers, so you'll need the first image to act as a backdrop to the foreground that is the second image.

Rummage through your digital archive to find pairs of images that will work well together (or you could go out and take some specific shots). It doesn't matter if the two images were taken at the same location or totally different ones, but selecting images from the same shoot often means that they automatically fit together. This is largely to do with the lighting, and is an important part of making the scene feel 'real'.

Print out your images on photographic or plain paper. If you're using plain paper, you might just need to mount your foreground image onto card to give it a little more structure and ensure that your finished card is a 'pop' and not a flop. (To save some pennies, I purchased a huge pack of blank cards and envelopes from a craft shop for a fiver. As the average shop-bought card costs around £2.50, I'd already covered my costs by the time I started making my third card. But you could always just use a sheet of A4 card and fold it in half to form your card.) Fold your card in half horizontally.

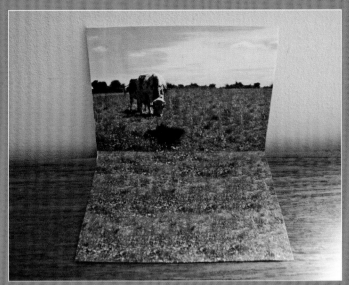

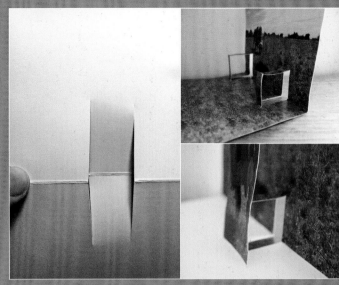

1. Keep your card in landscape format in front of you and open it up so that you can glue your background image to the top half of the card. Make sure that the bottom of the image lines up with the central crease. If you want to get really fancy, stick a corresponding image on the bottom half to act as the 'ground' for your pop-up (for instance, I added another photo of grass here).

2. Then you'll need to make the hinge (or bracket) to stick the foreground object to:
- Locate which area of the card you want your foreground object to 'pop-up' into.
- Fold your card closed.
- Mark two parallel horizontal lines along the spine of your card.
- Cut along the lines (the longer you make the slits; the further the foreground object will pop-up from the spine) with scissors or a craft knife.

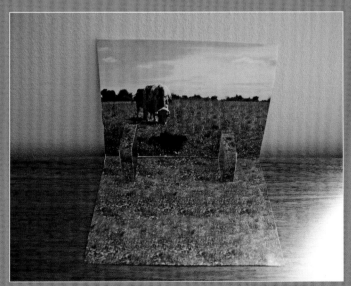

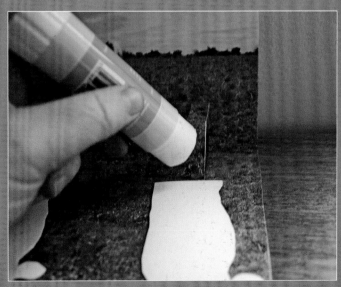

3. Open up your card again and poke the hinge in from behind so that it forms a right angle when viewed from the side.

4. Glue the vertical outer face of the hinge and attach your foreground cutout image before leaving it to dry.

5. Close the card and glue another card (or a sheet of A4 card) to the back of your pop-up card to hide the hinge holes. Write your personalised message on the back of the card.

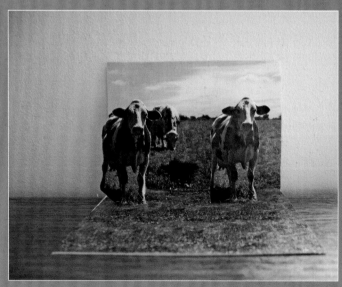

6. Hey presto – it's a pop-up card! Seal the card in its envelope and enjoy the awed gasp from the recipient and a round of applause on opening.

Photo-editing software

Most photo-editing software has a 'clone' tool, which enables you to clone areas of a photo and replicate them in different places. For example, I duplicated the image of the cows in the field twice so that I had three copies of the same image. I kept the original and just cut out the cow using scissors. I removed the cow in the second image by cloning the grass and bushes over her. And, in the third image, I cloned the grass to cover everything else in the frame.

If you don't have photo-editing software, you could just take your camera out and take several individual photos – bearing in mind the different layers you'll need. To replicate this cow card, for instance, simply take a single shot of a cow in a field, then a wide-angle shot of a cow with the herd and, finally, a wide-angle shot of just the grass. When you get home, you can just print the images out and assemble them.

For an even more low-fi approach, you could cut out pictures from magazines and make a collage out of these instead.

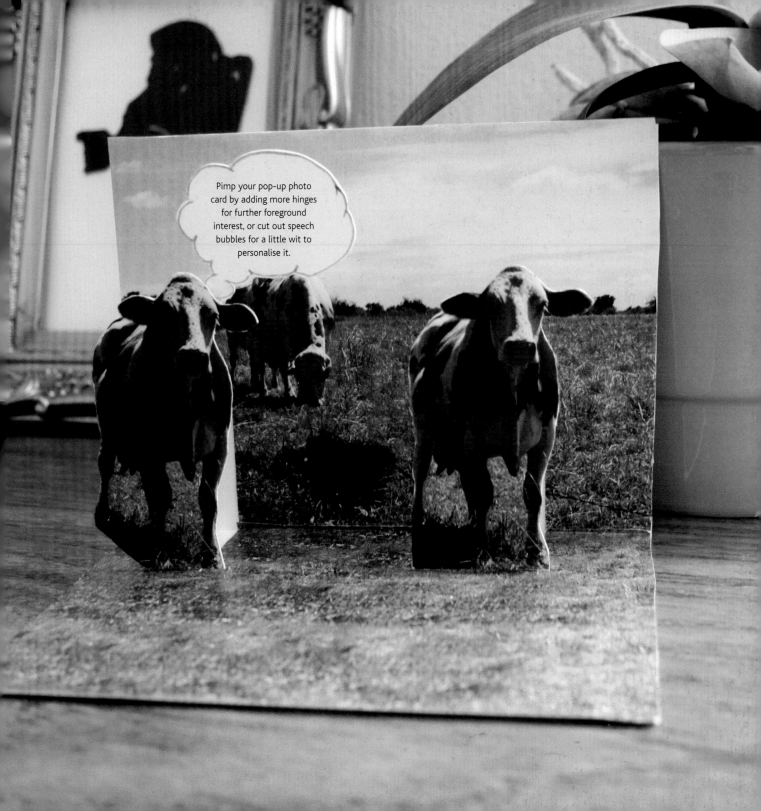

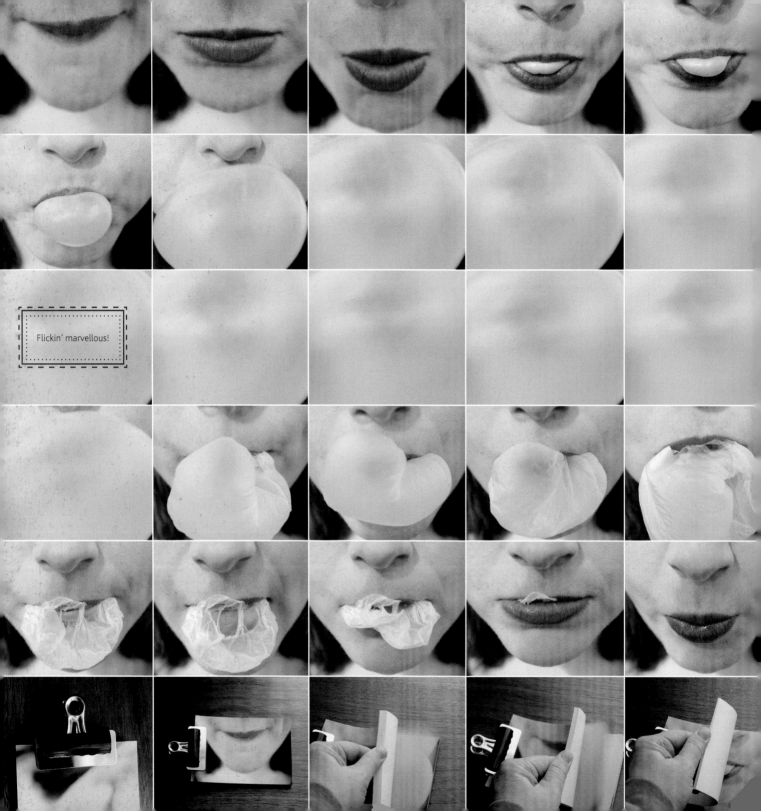

Flickin' marvellous!

FLICK BOOK

kit

- DSLR
- A compelling story for you to capture
- Thin card/ photographic paper (optional – you might prefer to use a photo lab for your printouts)
- Stapler/glue/ bulldog clip

There's something magical about seeing a story unfold in the palm of your hand. This little 19th-century invention bridges the gap between the photograph and the moving image. By creating a booklet of sequential images you can simulate motion when you flick through the pages.

The principle of the flick book (as it's known in Britain) or flip book (as it's called in the US) was used to create another 19th-century device called the mutoscope. This was more commonly referred to as the 'what the butler saw' machine (which, presumably, was a reference to Victorian butlers peeping through keyholes).

The mutoscope acted as a kind of giant mechanical flick book, containing a circular drum with hundreds of sequential images around the inside. To use the mutoscope, a viewer would pay a penny to peer through a viewfinder and crank a handle to 'flick' the images in front of their eyes. These machines caused outrage at the time, and were even banned in some places, as 'what the butler saw' could be mildly risqué!

A flick book can be comprised of anything from a few pages to over a hundred – the length and size of the book is up to you. Just remember that you need to be able to physically flick through it (if you have massive hands then this may be less of an issue!). I'd recommend a length of around 30 pages.

- Think of a suitable 'story' for your flick book.
- Once you have your story, try to compose your frame (looking through the camera's viewfinder) so that the action takes place on the right-hand side of the frame. This is because, when you flick through the book, you won't be able to see anything near the book's spine (on the left). Try also to capture an image for the front of your flick book before you stop shooting (this shot can have the action in the centre of the frame).

- Now for the maths part: to record your action, it's best to use the shutter burst setting on your camera; it makes things nice and easy – you just hold the shutter down and pictures will be taken continuously. The specification of your camera will dictate the number of frames it will take in a given time. My camera takes about 3 frames per second, so to take 30 images for my pages I needed to record an action for 10 seconds. If you have a fancy camera that records at about 6 frames per second, then you'll only need to record for 5 seconds for the 30 snaps. (The rest of the camera settings are up to you, as it depends on what your flick book is going to be about.)
- After you have captured your action with the correct number of images for your book, you need to print them out. I had mine processed at a photo lab, but you could print them out at home on some thin card or photographic paper.
- Arrange your printed images in sequential order on top of one another (the first image you took should be at the top of the pile). Tap the stack of images down to make sure that all the pictures are perfectly aligned to the edge that is going to be flicked – if one image is sticking out too much it will ruin the smooth momentum.
- Now all you have to do is to fasten your images together. The traditional method uses staples, but you could use glue or a giant bulldog clip.
- It's time to start flicking!

What's better than a flick book? A double-sided one of course! To make your flick book even more amazing, stick another sequence of images to the reverse of your first set, then you can turn the book over and flick the other side. Those Victorians knew how to have a good time.

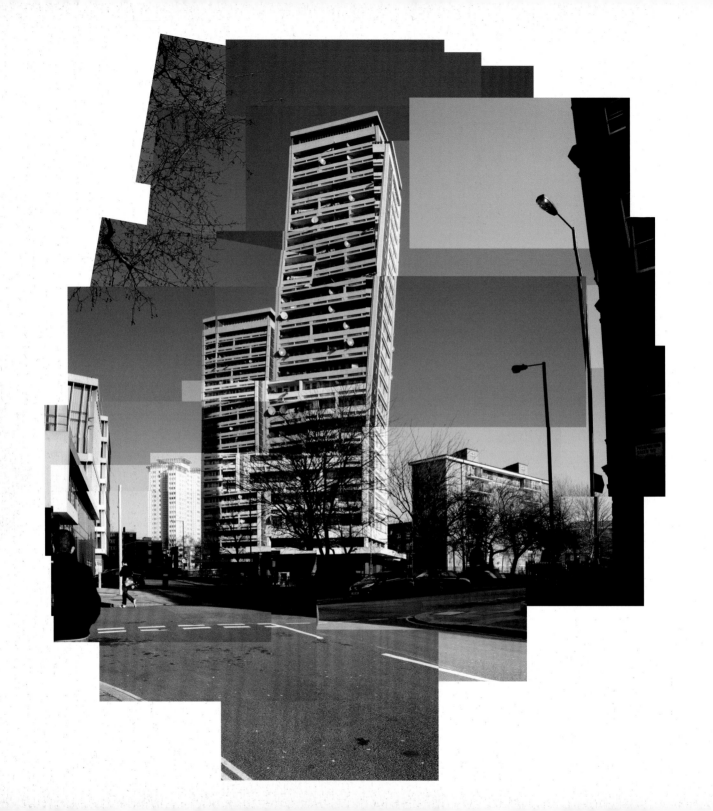

DOING A HOCKNEY

kit

- DSLR
- Interesting view
- Tripod (if the lighting is poor)
- Computer (optional)
- Colour printer with photographic/plain paper (or use a photo lab)
- Glue
- Backing card
- Frame for mounting

David Hockney is the Granddaddy of Pop Art, and one of the most influential artists of the 20th century; he's best known for his paintings of Los Angeles swimming pools in the sixties. But you don't have to be a dab-hand with a paintbrush to complete this project, because Hockney is also pretty nifty with a camera. He is a huge fan of collages, whether they're made from different paintings, such as his 'A Bigger Grand Canyon' (1998) – a single work constructed from 60 separate canvases – or a single mosaic made from a montage of photographs.

Hockney calls his photo collages 'joiners'. He discovered the technique when he was photographing the interior of a house and took lots of separate shots as a visual reference for a painting. When he got back to his studio he stuck all the images together and rather liked the effect it created and, since then, he has gone on to produce many joiners.

Creating your own joiner is a super-simple project, but the effects can be really mesmerising. You're not just capturing a moment in time, but several. As time elapses, it brings with it its own narrative: people passing through the frame, clouds moving, light changing and all sorts of other, subtler, alterations to a scene.

- Head off in search of an interesting location* with your camera. Although this technique will add a layer of visual intrigue, it will not be enough in itself to make a great stand-alone image; so aim to photograph something that you love or a scene that really interests you – that way you won't tire of looking at the final results. The photo collage also works best with large-scale subject matter: think epic landscapes or cityscapes – views that aren't easily contained within a single shot.
- Firstly, take a wide-angle shot of your chosen location. This will act as a handy reference (like the image on the lid of a jigsaw puzzle) when you're trying to piece all the smaller images together later on.
- Once you have the wide-angle shot, it's time to zoom in slightly to capture small sections of your scene. It's best to set your camera to auto and keep your feet firmly planted in the same position. You don't need to use a tripod unless the lighting is poor enough to require ultra-steady shots.
- Try to imagine a grid in front of the landscape before you, and then systematically snap away at each 'square' so that every part of the landscape is covered.
- Make sure that each shot overlaps with the previous one, both vertically and horizontally: you don't want any gaps when it comes to joining the images together.

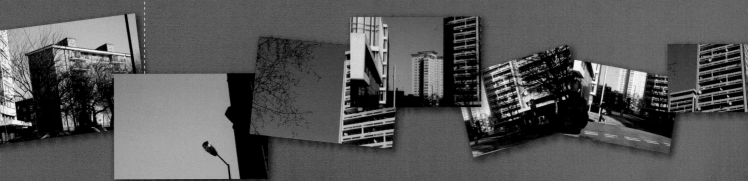

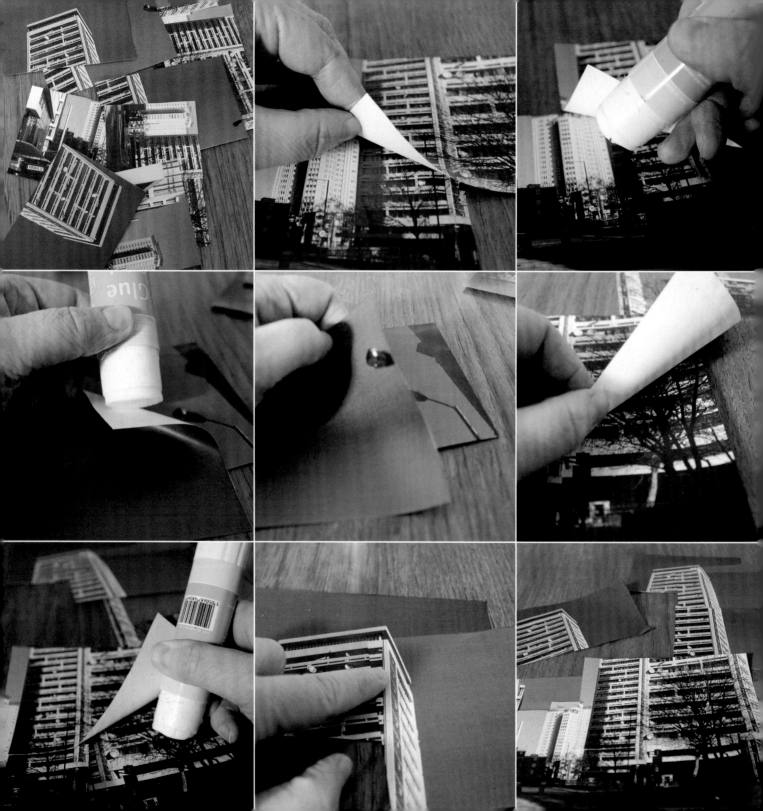

- Remember: it's better to take plenty more pictures than you need as opposed to too few.
- When you've taken all your images, print them on photographic or plain paper or take a trip to a quality photo lab. (Mr Hockney has his printed at a photo lab, in case you were wondering.)

Then, using your wide-angle shot as a reference photo, get ready to start glueing the images to backing card. Always double check that the images really do go together beforehand, though: you don't want to come unstuck! I find it easier to stick the images to one another rather than straight onto the backing card as, that way, you have the choice of putting each image either in front or behind the previous one – depending on what you think looks better.

Once your visual puzzle is complete, and stuck on the backing card, you're ready to display it. Hockney frames his and hangs them in the world's best galleries or sells them for a fortune – so you could try doing that too!

*Of course, you could make a digital collage out of the images already on your computer, but it wouldn't be as much fun and, besides, it isn't the way the great man himself does things!

You could also apply this technique to capture 360-degree panoramic views.

I photographed the tower block from the corner to give the image a sense of depth, as the viewer's eye is led to explore both the front and the side of the building. This wouldn't have been possible if I'd photographed the building face-on. I like the pristine whiteness of the tower blocks juxtaposed against the solid blue sky.

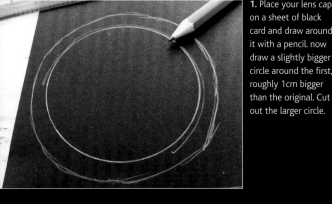

1. Place your lens cap on a sheet of black card and draw around it with a pencil. now draw a slightly bigger circle around the first, roughly 1cm bigger than the original. Cut out the larger circle.

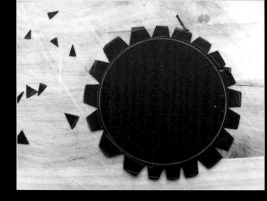

2. To create the tabs around the edge of the larger circle, use scissors to cut out small triangles of card at 1-cm intervals, with the point of each triangle just touching the inner circle.

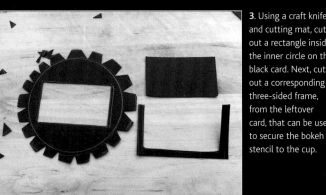

3. Using a craft knife and cutting mat, cut out a rectangle inside the inner circle on the black card. Next, cut out a corresponding three-sided frame, from the leftover card, that can be used to secure the bokeh stencil to the cup.

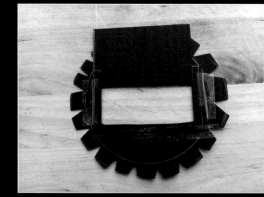

4. Stick the three-sided frame onto the centre of the black card circle with sticky tape and check that the black card rectangle slides into it easily.

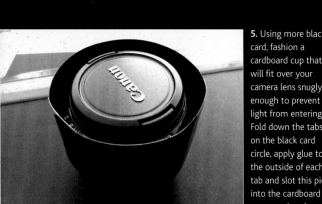

5. Using more black card, fashion a cardboard cup that will fit over your camera lens snugly enough to prevent the light from entering. Fold down the tabs on the black card circle, apply glue to the outside of each tab and slot this piece into the cardboard cup, pressing the tabs

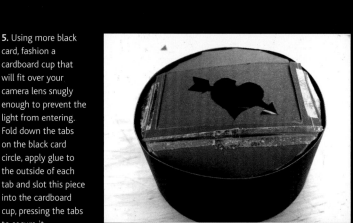

6. Finally, using the craft knife and cutting mat, cut a shape from the black card rectangle to create your bokeh stencil, then slot the stencil into its frame holder.

BOKEH LOVE

kit

- DSLR
- Black card/ transparent plastic
- Pencil
- Scissors
- Craft knife and cutting mat
- Sticky tape
- Glue
- Black marker pen (if you use transparent plastic)
- Lights

'Bokeh' is the Japanese word for the area of a photo that's out of focus. When you're taking photos with a normal camera lens, any background or out-of-focus lights that feature in the picture will have a polygonal outline or shape, created by the contours of the camera's aperture blades. But with some plain black card and a little crafty cutting, it's possible to create some funky new shapes all of your own.

First you'll need to construct a cardboard 'bokeh maker' – a cup that fits onto the front of the camera with a hole cut out of it. To do this, complete the step-by-step stages opposite while referring to the photos.

The great thing about this project is that once you've got your bokeh maker ready, you can try as many different bokeh shapes as you feel like making. The frame ensures that the bokeh stencils (cardboard cut-outs) fit snugly over the lens and can be easily removed and replaced by a different cutout.

If you aren't too adept with a craft knife to cut out your stencils from the card, you could use a black marker pen on transparent plastic instead (draw your shape and simply shade in the background). Be sure to leave the area where you want your bokeh shape clear then slot the card into the stencil frame.

Once you've created your bokeh contraption, it's time to adjust some basic settings on your camera:

- Select aperture priority mode and set the lowest f-stop number to enable a maximum amount of light to enter the lens, which will create a shallow depth of field.
- Crank up the ISO setting so that the shutter speeds are fast enough to capture sharp bokeh images (or use manual mode to set the shutter speed and aperture).
- Choose a location with a sparkly light, and make sure that the light is out of focus in your frame (focus on something in the foreground instead).
- Experiment until you get the correct camera settings for your location.

You can also try varying the light sources: fairy lights and car lights – at a distance – provide excellent lighting for great shots. I mixed it up a bit and used sparklers (stuck in potatoes!) to get the cascading love hearts below.

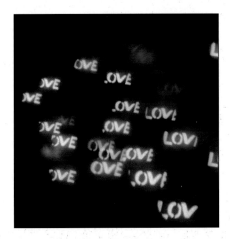

DIGITAL PINHOLE

kit

- DSLR (with body cap)
- Drill and a small drill bit
- Foil, card or section of a tin can, or similar
- Scissors
- Sticky tape
- Pin or needle
- Fine-grade sandpaper (if you use a tin can)
- Adhesive tack

A camera is essentially a simple piece of kit. Light travels through a hole and, by the power of physics, the outside world is inverted and projected onto the back of the box.

The hole that you'll make in your camera's body cap is where the light will enter your DSLR. As the light only has to travel a short distance between the hole and the sensor, your 'new' digital pinhole camera will give a wide-angled image and, as all pinhole cameras have a constant focus (even if it can look a bit soft), your images should always be in focus(ish).

The beauty of digital pinhole photography is that your world suddenly becomes simplified. You no longer have to concern yourself with the quality of the lens glass: whether prime is better than zoom or which brand offers the best value for money; because the moment you drill through your camera's body cap you are on the way to making a totally unique lens – one created by you. The fundamentals of photography are under your control and you can produce some amazing shots too.

To fashion a digital pinhole for your camera, you'll need a camera body cap, a drill and a small drill bit, a piece of foil, card or tin can, scissors, sticky tape, a pin or needle, sandpaper, adhesive tack... and luck! Then just follow the step-by step instructions, opposite.

It's best to buy a new camera body cap; you could use the one that came with the camera, but there's a great risk that doing so will let dust and dirt onto your precious camera sensor later on, so it's probably not worth the risk.

Before you head out to shoot some digital pinhole images, cover the pinhole with a piece of adhesive tack to prevent dust getting on the sensor while you're moving.

Select shutter priority mode and experiment with different exposure times. Practise, experiment and enjoy!

1. Make a hole in the centre of your camera's body cap using the drill and a small drill bit — this isn't the hole that the light will come through, so the size isn't that important.

2. Cut a small piece of foil to cover this hole, affixing it to the back of the cap with sticky tape. Alternatively, you could use some black card or a bit from the side of a tin can.

3. Push a pin or needle through the material, into the hole in the body cap. This makes the hole that the light will pass through before it gets to the censor. To produce a sharp image, the hole should be as round and smooth as possible. (If you're using a piece of tin can, remove any burrs along the edges with fine-grade sandpaper.)

4. Make sure that the body cap is free of dust before screwing it onto your camera, and cover the hole with a piece of blue tack to protect it during transportation. Now you're good to go!

BROADEN YOUR HORIZONS

kit

- DSLR (with lens cap)
- Security door-viewer
- Pencil
- Black card
- Scissors/craft knife
- Glue

This is a fun and inexpensive way of experimenting with a fish-eye lens. A DIY 'hack' will transform a simple piece of home security into an amazing 180-degree lens for your digital camera.

You'll need to lay your hands on a security door viewer, which is normally used to spy on unwanted visitors (I bought mine on eBay), a pencil, black card, scissors or a craft knife and some glue.

The idea is to create a cardboard cup that fits over the end of your camera (in fact you could probably use a real cardboard cup – why didn't I think of that?!). The card adds some protection between the metal and your precious camera lens – you don't want to scratch it.

- Place your lens cap on the card and draw around it, and then repeat this on a separate section of card so you're left with two circles with space in between them.
- Draw a slightly bigger circle around one of the circles (roughly 1cm bigger – you can just freestyle it). In the centre of the circle make a small hole (this will allow you to look through the door viewer later on).
- Cut both of the circles out of the card with scissors.
- Take the smaller cardboard circle and draw, then cut out, a hole in its middle that is roughly the same size as the diameter of your door viewer's shaft.

- To create the tabs on the outside of the larger circle that will be used to secure it to the cup, use scissors to cut out small triangles of card at 1-cm intervals, with the point of each triangle just touching the inner circle. Then fold down the tabs from the inner circle.
- Apply glue to the outside of each tab and stick a 3cm-wide strip (that's just longer than the circumference of your lens) around them to create a sleeve. You've created a cardboard cup with a hole in it – yay!
- Align the door viewer's flat end with the hole in the top of your cardboard cup and slot the other end of the door viewer through the hole in the middle of the smaller cardboard circle (you'll need to unscrew the door viewer in order to do this). When the smaller circle meets the top of the cardboard cup, glue them together; so you've essentially made a door viewer sandwich, with card on either side of the door viewer.
- Check that the holes align and that you can still see through the door viewer before the glue dries!
- Select a centre-weighted focal point on your camera before gently placing your door viewer sandwich over the end of camera. Welcome to 180-degree vision!
- Before you take your camera and new fish-eye lens out to start snapping, remember to select the highest image-resolution setting, because you'll need to crop the images later...

Great Shots

Fish-eye lenses are great for photographing landscapes, extremely interesting portraits, tall buildings and trees. The distorted 'barrel' effect created by the thickness of the glass adds drama and intrigue to an image.

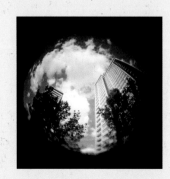

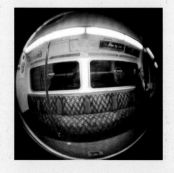

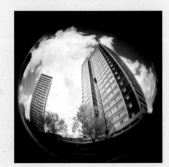

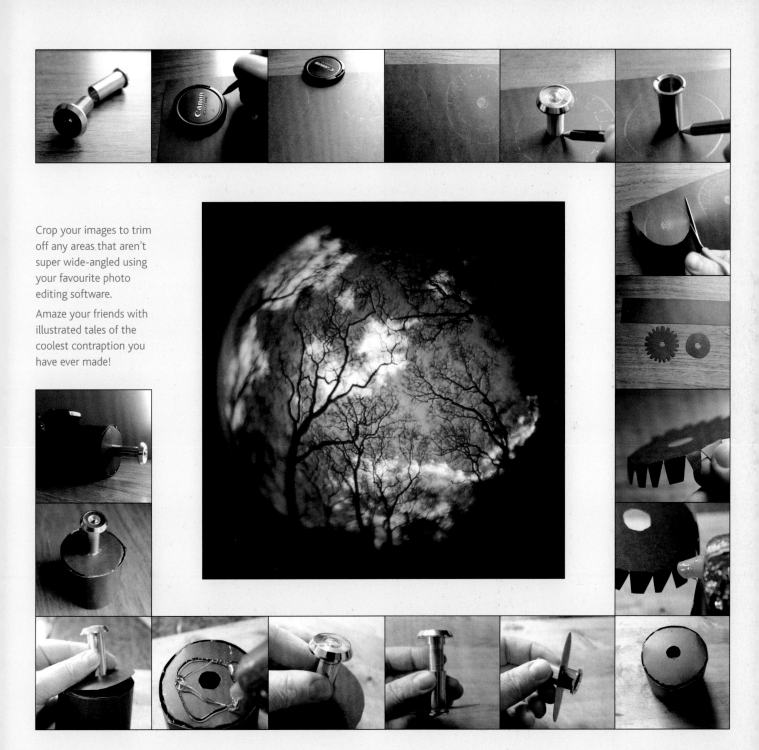

Crop your images to trim off any areas that aren't super wide-angled using your favourite photo editing software.

Amaze your friends with illustrated tales of the coolest contraption you have ever made!

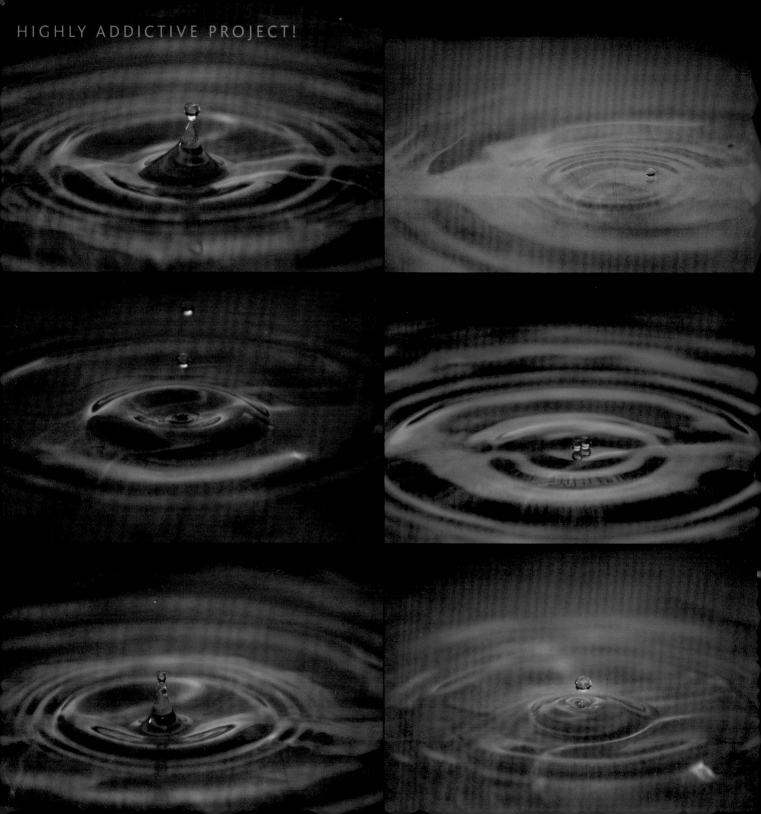

DRIP

kit

- DSLR
- Small plastic bag filled with water
- Pin
- Tray
- Table lamps
- White backdrop
- Tripod
- Two high-backed chairs and a broom (or something from which to hang the bag of water)
- Table
- Macro lens (optional)
- Pencil

The camera can see things that the human eye can't; so taking motion shots is a fascinating way of 'freeze-framing' a moment. Capturing those fractions-of-a-second of movement can get very addictive.

This project is perfect for a rainy day. Simply get together the following: a small plastic bag filled with water, a pin, a tray for the water droplets to fall into, table lamps, a white backdrop to reflect light and a tripod to keep your camera steady. You'll also need a means of suspending the bag of water (I hung mine on a broom handle suspended between two high-backed chairs over a table).

- Once you've elevated your bag of water, put the tray on the table beneath it.
- Set up the white backdrop behind it and shine a table lamp on it so that it bounces light towards the action.
- Prick the bottom of the bag with the pin.
- Set up the tripod and camera so that the lens points at the part of the tray (at about a 45-degree angle – not too near the splashes) where the droplets are landing.
- The photographs will come out best if you use a macro lens; if you don't have one, just get in as close as you possibly can without getting the camera wet. You might just need to crop the image afterwards.
- Set the camera to manual focus and, to ensure top results, place an object in the exact same place as the drops are landing (I used a pencil). Once you've focussed on that object, remove it and check your screen – the droplets should be in sharp focus.
- Now for the hard part... Getting a good clear shot involves quite a lot of trial and error. The drips should be falling from the plastic bag fairly rhythmically, enabling you to swiftly figure out when you need to be pressing the shutter button. To increase your chances of getting a sharp image, you could use the shutter burst setting if your camera has it. This will keep firing frames while your finger is on the shutter button.

- Once you've taken a few shots, carefully review them on the camera (if you knock the tripod as you're doing this, remember to set the focus again). If the water globules are looking blurry, you need to increase the shutter speed; if the image is too dark, add more light to the scene with another table light, up the output from your flash, or increase the ISO setting. (If you increase the ISO setting, just remember that you're decreasing the image quality by adding digital noise.)

Colour

The different colour effects in the photographs opposite were achieved by experimenting with the white-balance setting for the shots. Different sources of light have different colour temperatures and if you leave your camera in auto white balance it will select what it thinks is the appropriate white balance for the given situation. If you manually select the 'wrong' white balance it will give your image a coloured tint. You could, of course, use food colouring or different-coloured trays to get a similar effect.

Want to do more? Find a flat-sided glass container (such as a fish tank or a vase), fill it with water, throw objects into it and shoot this.

Still want more? How about trying to photograph a balloon or a soap bubble as it bursts?

Hoofing around

Edward Muybridge was the first photographer to experiment with high-speed photography. He set about trying to settle the debate (yes, there was one!) as to whether all four of a horse's hooves left the floor at once as it ran, or not. His findings were first published in 1878. (All four hooves do leave the floor at once, by the way.)

kit

- DSLR
- 4 x A4 sheets of mirrorcard
- Ruler
- Compass (or use a cup that's a little larger in diameter to that of your lens)
- Pen
- Detachable flash unit
- Scissors or craft knife and cutting mat
- Sticky tape or hot glue gun
- Duct tape

The ring flash is the go-to piece of kit for fashion photographers. It creates a beautiful circle of light that will flatter any model – making us swoon! Unfortunately, its price tag will also leave you weak at the knees. So it's time to introduce the 'ghetto' ring flash...

Buy at least 4 sheets of A4 mirrorcard from a craft shop.

2 Measure the diameter of the thickest part of the camera's lens, adding an extra 0.5cm to this measurement so that the lens will be able to move freely when the ring flash is in place around it.

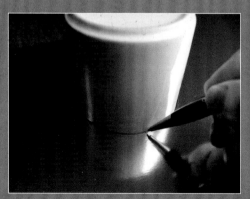

Use a compass (or a cup that's a little bigger than your lens) to draw a circle with the recorded diameter measurement on the mirrorcard.

Then draw another circle around this first circle (roughly 5cm larger, so that you have a 'doughnut' shape).

5 Measure from the bottom of your flash unit to the centre of your lens. We'll call this the 'master measurement' – it's important to get this measurement correct before you brandish the scissors (as my uncle would say, 'measure twice and cut once').

6. Draw the master measurement onto the mirrorcard doughnut, starting from the centre, going upwards (see photo 7, right). Then measure the width of the flash unit and draw this along the top of your master measurement marking (see photo 7).

7. You should end up with a big symmetrical 'T' shape starting from the centre of the doughnut.

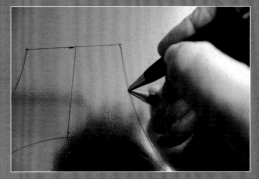

8. Next you need to draw a freehand curve from each end of the 'T' down to the edges of the doughnut to make a shape that resembles a really wide-handled table-tennis bat.

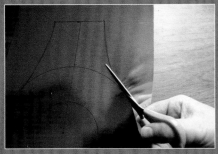

9. Use scissors or a craft knife and cutting mat to cut out the entire table-tennis bat shape – this will form the back panel of the ring flash.

10. Use this back panel as a stencil to draw around the handle part only on another sheet of the mirrorcard. Remove the back panel stencil and just draw a freehand arc from the end of one side of the handle you've just traced to the other. This arc will form the bottom of the ring flash's front panel.

11. Measure the height of your flash unit and add this measurement to the top of the stencilled handle.

12. Cut out this handle (which should be longer than the one on the back panel) – this will form the front panel of the ring flash.

13. Then cut out the centre of the doughnut on the back panel (now you'll have a table-tennis bat with a hole in the middle) so that you can fit your camera lens through it.

14. Cut a strip of mirrorcard (about 5cm wide) to make a cuff, and fasten it, shiny side outwards, around the edges of the central hole in the back panel to form an inner wall for the lens. You can use strong sticky tape or hot glue to keep it in place.

15. You'll need another long strip of mirrorcard (again, 5cm in width) to fix all the way around the edge of the back panel (apart from at the very top, where the flash unit will go), shiny side inwards, to form an outer wall. To do this, you might have to cut more than one strip of card and stick them together.

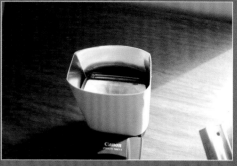

16. Make a 10cm-wide cuff of mirrorcard to fit around the flash unit, shiny side inwards, fastening each end together with sticky tape or hot glue. Move the cuff forwards by 5cm so it looks like the flash is in a cardboard tunnel.

17. Once the flash cuff is in place, snip down along the two bottom corners to form a handy flap for easy assemblage later.

18. Now fix the front and back panels of the ring flash together, the mirrored sides facing one another (including the cuff around the flash unit) using sticky tape or hot glue.

19. Slot your finished ring flash onto your camera – sticking the lens through the centre. Do a test shot in front of a mirror, using your flash unit, to ensure that the light circulates around the mirrorcard ring flash without any blockages. You are looking for a solid ring of light to be shining back at you.

20. Check that the front panel isn't too low down and blocking light from coming out – trim it back if it is. If you notice any light leaks, cover the source with card and duct tape.

Your ring flash is ready!

Experiment using different flash exposures; getting a correct exposure will depend on the distance between the subject and camera and on the aperture and ISO setting. For the self portrait opposite, I used an ISO setting of 200, an aperture number or f3.5 and kept the flash power at ⅛.

3D RETRO

kit

- DSLR
- 2 sheets of black A4 card
- Ruler
- Scissors or craft knife and cutting mat
- Stapler with staples, or strong glue
- Old reading glasses (any old prescription – so long as they magnify objects in the near distance)
- Pencil
- Clear sticky tape
- Colour printer and plain paper
- 3D subjects to photograph
- Computer

Our eyes are about 6.35cm apart; so the left eye sees a slightly different image to that seen by the right eye. It is this difference that creates a 'three-dimensional' effect when we look at objects in the near distance (when an object is further away, the difference between what each eye sees is not sufficiently significant to create the 3D effect).

To transform boring flat images into fresh 3D shapes that appear to jump out of a photo, you'll need to construct a stereoscope. This super-cool invention plays on the difference between what each eye sees close-up, so is able to create 3D effects on your photographs. And, once you've built your stereoscope, you can use it over and over again with different images from your collection.

1. Take a sheet of A4 card and fold it in half lengthways. Then fold each side back on itself, 1cm away from the central crease, so that when you open the card and place it flat-side down, it has a pleat (or spine) of 1cm in height along its entire length.

2. Measure 7cm from the edge of the card and fold this section up towards the centre. Give it a good push to fold it right over.

3. Open the fold out again and use your scissors to snip into the pleat where it crosses the centre pleat.

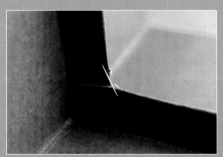

4. Fold the card back up again to form a right angle, and fix it in place with a staple or strong glue. This end will form the viewing part of your stereoscope.

5. Repeat this process with the other end of the card – but this time only fold 4 or 5cm over. This end will help keep your images upright.

6. VANDALISE THE READING GLASSES: RELEASE THE LENSES FROM THEIR FRAMES.

7. Place the lenses on the viewing end of your stereoscope (one on either side of the crease) eye-width apart, and draw around them using a pencil.

8. Use your scissors or a craft knife and cutting mat to cut a little rectangle inside each lens shape so that you can see through each side.

9. Stick two bits of clear sticky tape at the top and bottom of each lens and fasten the lenses to the inside of the card over the rectangular holes (make sure they are the right way round: so that when you turn the card upright you're looking through the lenses as if the glasses were on your face).

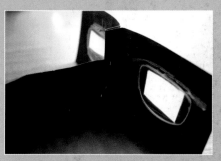

10. Fasten a strip of card (around 5 or 6cm high) all the way along the top of the stereoscope's spine. This will act as a separator to keep each of your eyes looking in the correct direction – with no sneaky peaks to the other side of the contraption.

11. To make the 3D images for your stereoscope, it's necessary to mimic what your eyes see by taking two pictures of the same subject several centimetres apart with your camera. A good technique for achieving this difference is to stand up and take the first shot, then transfer your weight onto one leg to take the second shot. The slight shift in body weight should result in the right amount of distance between the shots taken.

12. Using this technique, take several sets of photographs of different 3D subjects. Get some depth to your image and have the main focal point only a couple of feet away from the camera for maximum effect.

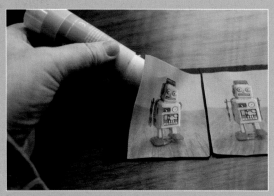

13. When you're happy with your images, upload them to your computer and print them out, then stick them onto another piece of card, side by side – leaving a space of 0.5cm between each image.

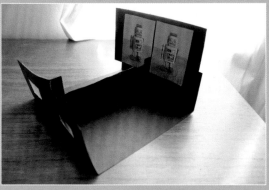

14. Make a small incision at the bottom of the image card, halfway between the images, so that you can place it at the back of the stereoscope and it will happily straddle the central spine. You can now adjust your images by moving them up and down the centre pleat until they are in focus when you look through the eye pieces.

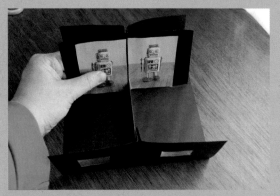

15. Look through the eyepieces and – *voilà*! You might need to go a little bit cross-eyed if the 3D effect isn't hitting you between the eyes. But don't panic – it will. You've just created your very own 3D vision – what phantasmagoria!

Digital version

You can create an online version of this 3D Retro project by making an animated gif. Just upload your pairs of images to free computer software such as www.makeagif.com or www.gifninja.com, which enable you to flick from one image to another; tricking your eyes into thinking that the two images are, in fact, a single 3D image. Experiment with the timing until it looks unmistakably 3D. You can then embed this on your blog (see p216).

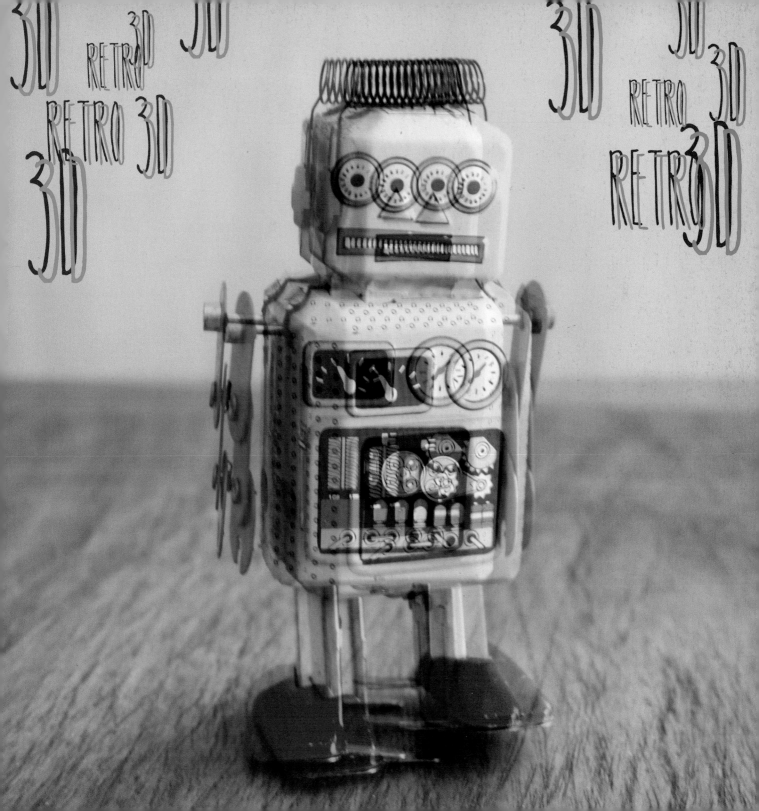

VINTAGE VISION

kit

- DSLR
- Vintage camera with viewfinder on top
- Object
- Ruler
- Cardboard (from a rectangular cardboard box)
- Pencil
- Scissors or a craft knife and cutting mat
- Duct tape
- Interesting subjects
- Computer

Through-the-Viewfinder photography provides a great excuse to have fun with gorgeous vintage cameras, without the hassle of using film or having to pay for processing costs.

First things first: you'll need to get hold of an old camera – the kind with a large viewfinder at the top. The Kodak Duaflex is a popular choice for this type of photography (known as TTV). You can buy one for just a few quid second-hand – I bought my Kodak Duaflex II for £5.50 from eBay. Other cameras worth searching for are the Argus Seventy-five, Kodak Brownie Reflex and the Ansco Rediflex.

When you're searching for a vintage camera for this project, look for one with a fairly clear viewfinder. However, it shouldn't be completely clear: a bit of grime or mould adds to the atmosphere. The chunky bevelled glass on these cameras is what distorts your images (because you're taking photos with your DSLR looking into the vintage camera's viewfinder) to give a retro look.

When you're in possession of a lovely old camera, you need to make a light, tight sleeve to go around it. This stops the light reflecting on the old viewfinder, which could ruin your shots.

To construct the sleeve, you need to take some measurements, starting with the minimal focal distance of your lens. To find this:

- Set your DSLR camera to auto and place it on a flat surface with any object directly in front of it.
- Gradually move the DSLR physically closer or further away from the object until you find the minimal distance at which your camera will happily focus (if you are too close the camera won't find focus).
- Once you have this 'happy' focus, physically measure the distance between the DSLR's body and the object: this will be your minimal focal distance.
- Add to this distance the height of your vintage camera, and the resulting figure is the length of the piece of cardboard that you require. (It's better to be generous with your measurements – you can always shorten the cardboard.)

Follow the intructions, opposite, to construct your sleeve, and then you'll be ready to start snapping.

1. Measure the width and depth of your funky vintage camera.

2. Mark these measurements (width, depth, width, depth) on the shorter side of the card with a pencil from left to right, then use a ruler to extend these marks along the length of the card so that you have four parallel lines. Make sure that the lines are straight, as these will form the sides of your sleeve.

3. Score along the lines you have drawn with scissors or a craft knife and cutting mat, using your ruler, making sure to avoid cutting the cardboard all the way through (you just want to be able to bend it easily). Trim away any excess card.

4. Fold the cardboard sleeve around the vintage camera and mark on it with a pencil where the lens and viewfinder (the two glass discs on the side of the camera) sit. Cut away a window for them (and anything else that sticks out on the camera) using scissors or a craft knife and cutting mat.

5. Fold the cardboard sleeve along the scored lines and fit the jointed sleeve around the camera. (If some of the joints split, secure them with some duct tape.)

6. Secure the sleeve around the camera using duct tape. For extra hold, you can also stick the sleeve to the retro camera itself (the tape shouldn't harm the camera).

To take the shots:

- Select auto-focus mode on your DSLR.
- Move the selective point focus to the centre of the screen.
- Select shutter priority mode and use a fairly fast shutter speed (around 1/160 of a second).
- Insert your DSLR's lens into the top of the sleeve.
- When you look into the digital viewfinder or LCD display you will see a square of in-focus retro image while the rest of the screen should be black (apart from a few minor light leaks).
- You're now ready to get shooting in full vintage vision!
- The retro camera might seem a bit back-to-front – when you want to go left, you have to move the camera to the right, and vice versa. But persevere and, with practice, your manoeuvring will improve.

When you've finished shooting your vintage vision TTV images, upload these onto a computer for cropping and straightening. You might also feel the need to add a few colour effects so enhance the vintage feel of your photos – totally retro!

And, once you've mastered regular TTV photography, why not try the underwater version (see p156)?

If you get into TTV
Why not join one of the many Flikr groups that focus entirely on this special way of creating images?

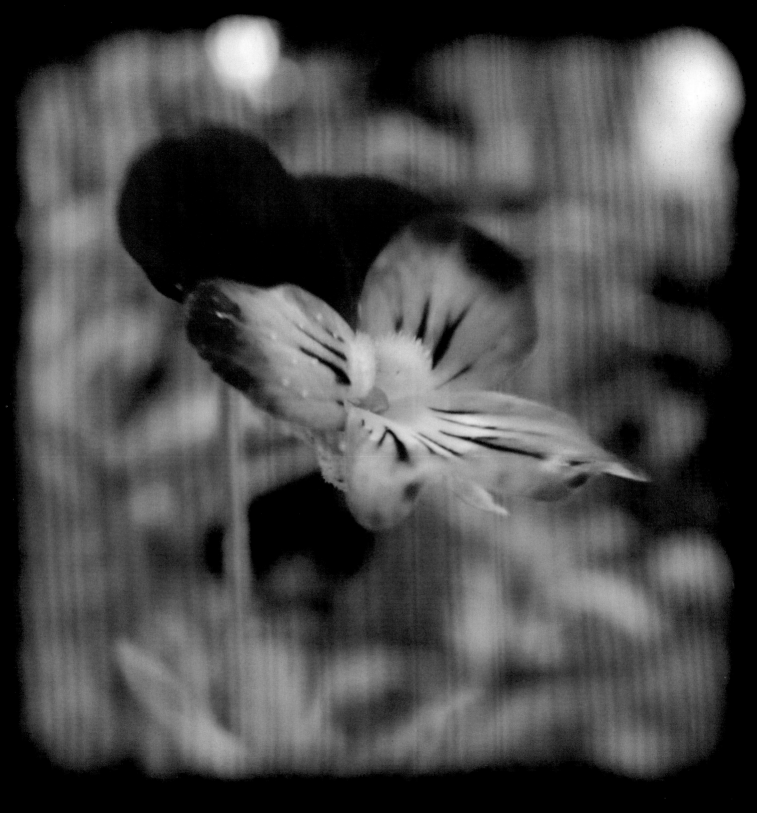

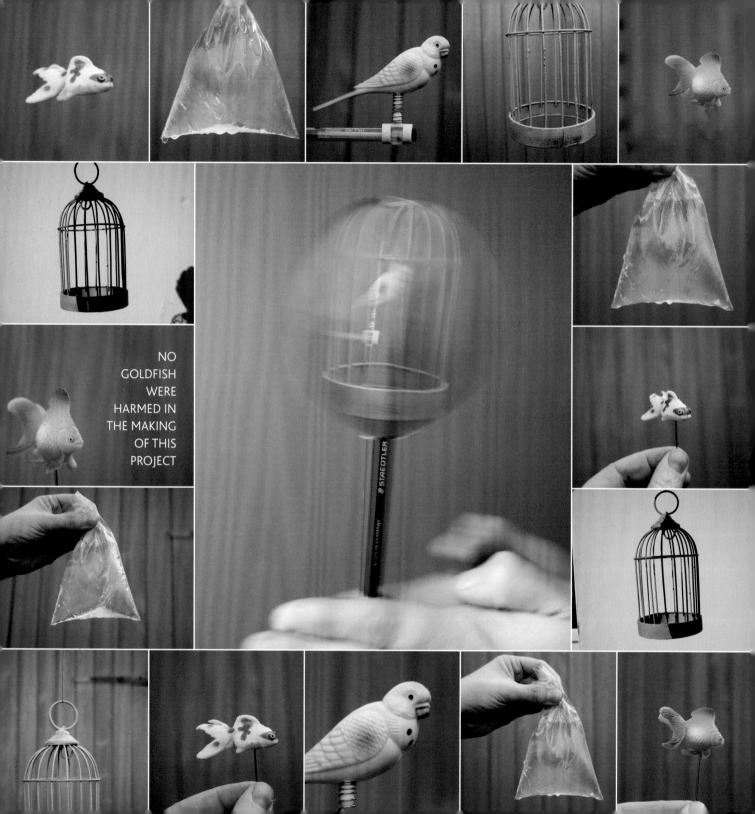

NO
GOLDFISH
WERE
HARMED IN
THE MAKING
OF THIS
PROJECT

THAUMATROPE

kit

- DSLR
- Two interesting subjects to photograph
- Computer
- Printer and photographic or plain paper
- Light
- A compass or something circular to draw around
- Pencil
- Scissors or a craft knife and cutting mat
- Sticky tape
- Glue
- Hands to make it spin

'Thaumatrope' comes from the Greek words *thauma* – meaning 'magic' – and *trope* – meaning 'turn'. By harnessing the fundamentals of animation, the thaumatrope causes two separate images to merge into one when its discs rotate. The images magically combine because of a phenomenon called the 'persistence of vision', in which it is thought that the retinas of our eyes retain an image for a fraction of second after we've seen it. So, as the thaumatrope turns, our eyes will see the previous image and the current one at the same time – got it?

You won't need to get yourself in spin to create this simple optical toy – you'll just need two images that are about the same size and are able to fit together. I opted for some pure Victorian kitsch with a photo of a bird and a photo of a cage; other classic couplings include a jockey and horse and a rather random smile and a cat. But you can let your imagination go wild: fish on a bicycle, Elvis and a hamburger or you and your other half.

- Both images need to have the same background, which will ideally contrast with the subject of your photo; this is to make sure that it has some added visual 'pop'.
- When photographing your subjects, scale is really important. You have to imagine the two images blending together as they will during the rotation of your finished thaumatrope. If you aren't sure of the scale, take photos of several different sizes to give you a variety of options when you come to assembling it.
- Print out your shots – on photographic or plain paper.
- Place your images on top of each other and then hold them up to a light bulb or well-lit window to see if they're lining up correctly.
- When you are happy with their positioning, use a compass – or something circular to draw around – and a pencil to draw a circle around the main action.
- Cut out your images using scissors or a craft knife and cutting mat.
- Set one of the images face-down and attach a pencil to the back of it using sticky tape.
- Glue the back of the other image to the back of the first image – so that the pencil is sandwiched between the two discs.
- Leave it to dry.

Now spin the pencil quickly between the palms of your hands and stare at the rotating discs. Behold – a wondrous sight – the two images appear as one!

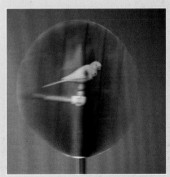

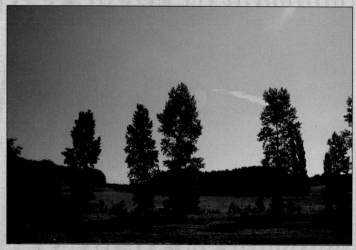

Inspirational

Have a look at artist
Abelardo Morell's work
for further inspiration.
He has made the camera
obscura an art form
and his life's work.

CAMERA OBSCURA

kit

- DSLR
- Room with small windows
- Black-out material (such as cardboard, foil or thick plastic)
- Masking tape
- Sharp pencil, scissors or craft knife
- Tripod
- Shutter release cable (optional, but highly recommended as you might get a sore finger from spending long periods of time glued to the shutter button, and there's potential for camera wobble without one)

A camera is simply a box with a hole in it. With this in mind, we're going to transform a room into the giant inside of a camera to capture an image from outside, and then take a picture of it inside the room with a DSLR. Confused? It's actually incredibly simple. This 'camera obscura' method dates back to 470 BC, when it is thought to have been discovered by Chinese philosopher Mo-ti.

For this project to work effectively, you need to black out a room in its entirety, so that it's impossible for *any* natural light to sneak in.

The choice of room is really important: ideally it will have small windows (the larger the windows; the more black-out material you'll need, and the more time you'll have to spend putting it up) and a light switch that's handy to locate in the dark. It's also worth bearing in mind that the view from the window is what will be projected into the room; so when it comes to choosing your room, make sure that its external view is more interesting than a flat, white cloud!

The material you use to black-out the room can be anything – so long as it prevents any light from entering – such as cardboard, foil or thick plastic. Whatever you choose to use, just make sure you have plenty of it.

Once you've entirely blacked out the room using your black-out material and masking tape to secure it (which shouldn't damage the paintwork on removal), you need to make the all-important hole in the material covering your chosen window, which will act as the lens to this giant camera of a room.

The hole's position is important. To get it right, try to visualise what is on the other side of the window and think of which spot will give maximum interest (as you would do when deciding where to position your lens). Just ensure that it's not too near to the windowsill – leave a gap of at least 30cm – so the light doesn't get blocked.

Make the hole using an appropriate implement. (If you're cutting into cardboard, for instance, use a sharp pencil.) Be careful not to make it too big – start off small and increase the size if you need to.

This is when the magic should happen. Give your eyes plenty of time to adjust to the extreme low-level lighting and you should see, projected on the wall opposite the hole, an upside-down image of the view outside the window. The image will be in colour and will wrap itself around the room, covering everything in its path.

Time for the camera bit: your DSLR will probably 'freak out' initially because of the darkness, but don't worry. Just crank up the ISO setting, use manual focus and select the bulb setting (see p218).

The camera will need to be on a tripod or solid surface so that it stays super steady over the long exposure time. (Make sure you don't set the tripod up in front of the source of light, or you'll have a big tripod-shaped shadow in your image.)

Now, fumbling around in the dark and straining to see through the viewfinder isn't a recipe for fantastic composition, but just because it's difficult it doesn't mean you shouldn't try!

Use a shutter release cable when it comes to taking the shots, or keep your hand particularly steady to eliminate any camera-wobble effects.

Experiment with different exposure times until you get your perfect shots. Check the image on your camera each time: if an image looks dark, you need to lengthen your exposure time (decrease the shutter speed); if it's too bright, reduce the ISO setting so that it's less sensitive, or else decrease your exposure time (by selecting a faster shutter speed). The pictures I took had a 3-minute exposure, on an ISO setting of 400, which can seem like an eternity when you're waiting in the dark. Have a radio in the room to stop you from going stir-crazy!

1. To make your waterproof periscope 'sleeve', you'll need to dismember an old plastic folder that's longer than your minimal focal distance (see Vintage Vision, p148) – a black folder works best, as it blocks out any light. Remove any internal plastic sleeves and then set the empty folder out flat.

2. Measure the width and depth of the top of your vintage camera (you need one that has a chunky bevelled glass viewfinder, which is viewed from above – see p148 for more info).

3. Mark these measurements (width, depth, width, depth) on the shorter side of the open folder with a pencil, from left to right, then use a ruler to extend the marks along the length of the folder so that you have four parallel lines. Make sure that the lines are straight, as these will form the sides of your periscope.

4. Score along the lines with a craft knife on a cutting mat (making sure not to cut right through the plastic), using your ruler, and then trim away any excess folder.

5. Cut out holes from the plastic where the lens and the viewfinder lens are, using a craft knife with a strong, thick blade and a cutting mat.

6. The jointed plastic folder should now fit around the top of your retro camera. Fold it along the scored lines. (If some of the joints split, secure them with some duct tape.)

7. Wrap the jointed plastic folder around your camera to form the sides of the periscope. Fasten the sides together and secure the camera in position using more duct tape.

UNDERWATER VINTAGE VISION

- DSLR
- Vintage camera with its viewfinder on top
- A4 dark plastic folder
- Pencil
- Ruler (ideally metal)
- Strong craft knife and cutting mat
- Duct tape
- Clear plastic bag – without holes!
- A body of water, such as a swimming pool, pond or bath containing something cool to photograph
- Flowery fifties swim hat (optional!)

Underwater photography normally involves expensive specialist equipment and a skilled scuba diver – but a watery shot doesn't have to be so complicated. In fact, you don't even have to get wet to produce amazing images. By harnessing the ground-glass magic of your vintage camera, the digital capabilities of your DSLR and some old plastic folders, you can create an underwater periscope that will give you a window into an unseen world...

You'll need to make your periscope 'sleeve' (see opposite) before the really fun part: taking the photos.

- Get your DSLR under control first: use single-point focussing and make sure the red dot is in the centre of your DSLR viewfinder before setting your camera to auto focus.
- Find a body of water (a swimming pool, pond or bath, maybe), in which to submerge your contraption.
- Lower the bottom of your periscope into the water until your vintage camera is submerged.
- Put the lens of your DSLR in the top of the periscope (don't put the periscope too far into the water or you might get your DSLR wet!).

- What you should see when you look through the viewfinder of your DSLR is a square of underwater image and a surrounding frame of black – zoom in so that the underwater image is as large as possible.
- Focus on the ground-glass frame of the vintage camera and press the shutter button.

Review your images to adjust the exposure as necessary. I found that my images were over-exposed, so altered my settings to manual and selected a shutter speed of 1/160 of a second, an aperture of f5.6 and an ISO setting of 400. But the exposure will depend on the amount of available light and the cleanliness of the water, so be prepared to make several adjustments before you get the image you want.

The periscope is a tricky thing to manoeuvre due to the way that the vintage camera works. It's all a bit back-to-front – when you want to go left, you have to move the camera to the right, and vice versa. But persevere and, with practice, your manoeuvring will improve.

Use photo-editing software to crop your images as you wish. I left the thick black frame of the vintage viewfinder in the image, as I think it frames each shot really well.

8. To make the periscope waterproof, and to help protect your vintage camera, securely fix a clear plastic bag to the bottom of it with more duct tape.

Congratulations, you have made your underwater periscope contraption!

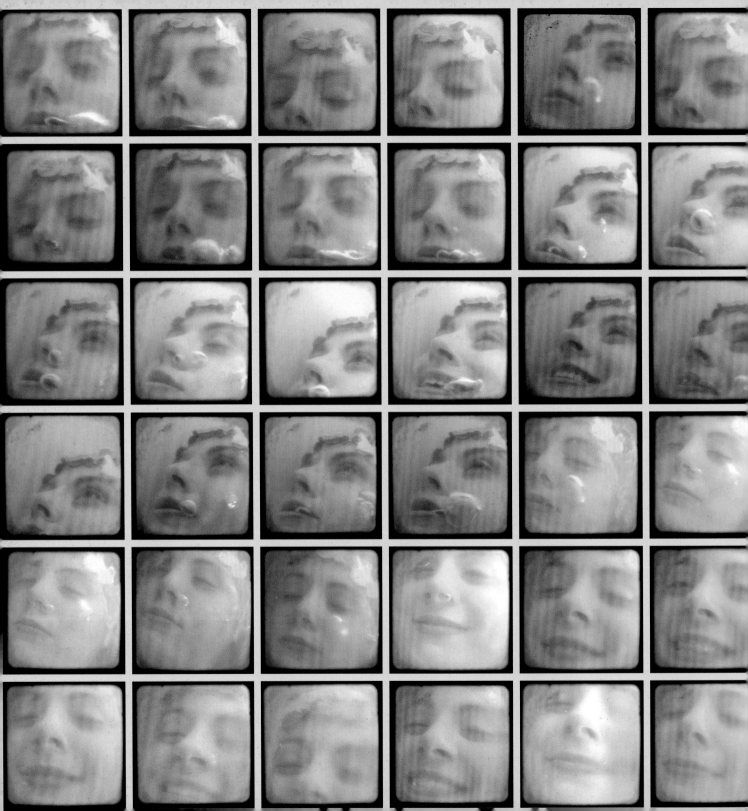

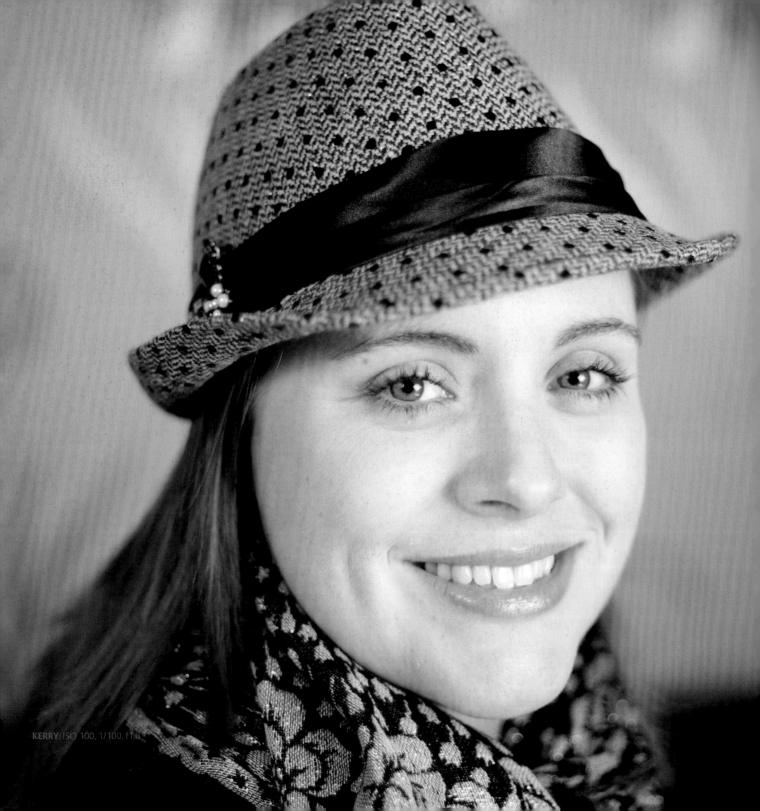

KERRY: ISO 100, 1/100, f1.8

SINGLE-LIGHT PORTRAIT

kit

- DSLR
- Model
- Light source (a flash unit, work light or any other light source, elevated on a stand)
- Softbox or umbrella (very useful for a soft lighting set-up, but not essential)
- Tripod (optional)

All studio photography starts with a single light source. Photographers call this the 'key' light because it's often the main source of light, and is usually positioned above the subject, at about a 45-degree angle to the camera. Its primary function is to light the model's eyes. Adding other lights (known as 'fill' lights) and using light modifiers helps to control the areas of brightness and shadow in the shot that are created by the key light.

The portraits on these pages were all taken using a single light source but, if you look closely, they have different qualities to them...

Light is often described as being 'hard' or 'soft':
The picture opposite demonstrates soft lighting; the light wraps itself around the subject without creating any hard shadows. There are three principal ways to create this kind of soft lighting:

- Using a big light: the larger the light source, the softer the lighting will be.
- Lengthening the distance between the light source and the subject: the greater the distance, the softer the lighting will be.
- Using a light diffuser, such as a softbox.

The soft light in the picture opposite was created using a softbox. A reflective surface inside the softbox bounces the light through a diffuse panel at the front to create a gentle, flattering light. An alternative method to using a softbox is to shoot through an umbrella. This kind of light is often used when photographing women because it creates a soft and flattering look for a 'feminine' feel.

Hard lighting is demonstrated by the middle and right images, below. This type of lighting is instantly recognisable due to the dramatic shadows it creates, which often make for an edgier image. Because of this, it's a popular choice for photographing men. Hard lighting is achieved by placing the light source closer to the subject, without a modifier to diffuse the light.

Remember that changing the position of the light source will alter where the light and shadows will fall, so you can have fun experimenting with different angles and lightings as well as using different camera settings as you snap away.

The best way to learn about lighting is through experimentation. If you're on a budget, just buy a work light from a DIY store that you might use to light your garage, and let the fun begin.

GWEN: ISO 100, 1/100 of a second, f3.5

PAUL: ISO 400, 1/200 of a second, f5.6

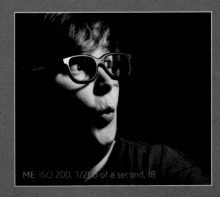

ME: ISO 200, 1/200 of a second, f8

TWO-LIGHT SET-UP

kit

- DSLR
- Model
- Lights (flash units, modelling lamps, domestic lights, and so on)
- Lighting stand (the best type of light stand is one that is voice-activated: ask an assistant to help, if you can!)
- Softboxes or light modifiers
- Backdrop, such as a brick wall, backdrop cloth, bed sheet or curtain (optional)
- Tripod (optional)

Once you've got the hang of using a single – or key – light, it's worth introducing a second light into your photography set.

This extra light can be used as:

A fill light
Used to brighten up areas of darkness within the set, for instance, lightening the shadows on a subject's face.

A hair – or 'rim' – light
Adds a little bit of light to a subject's outline, creating a 3D effect in the portrait. It can be used to make the person 'pop out' from the background.

A background light
Used to light the background. For example, when photographing models against a brick wall, you may want the light to just skim the wall for a dramatic, textured effect. To create this effect, simply place the light close to the wall and then shine it across the surface.

To alter the amount of light on the subject you can do two things:

- Adjust the power of the light.
- Move the light closer to, or further from, the subject. The closer the light source is to the subject, the more powerful the lighting will be; the further away the light source, the weaker the lighting will be.

Lighting is a question of taste – what you think looks great may not be everyone's cup of tea. But that's okay; just experiment and develop your own style.

The set-up
For this photo shoot, the model was fairly close to the black backdrop. I placed the softbox high above her head to create the soft lighting. The flash unit was at a low angle in relation to the model, acting as a 'hair light' to create the 3D effect. The camera settings used were: an ISO setting of 125, an aperture number of f2.2 and a shutter speed of 1/250 of a second. Experiment with your settings to see what works best for you.

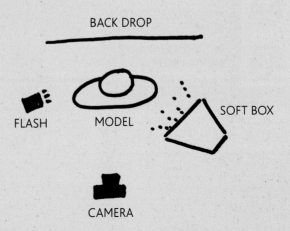

BACK DROP

FLASH MODEL SOFT BOX

CAMERA

CLAM-SHELL LIGHTING

'Clam Shell' might sound like a strange method for lighting a subject, but it simply refers to the positioning of the lighting softbox and reflector (a reflective material used to bounce the light in another direction; see left for information on the different kinds). It's extremely easy to set up and the resulting shots are a marvel to behold: truly professional-looking, flattering shots of any model.

Begin by positioning your softbox (which will form the main light source) just above your subject's head, and then place the reflector horizontally beneath his or her neck – ask your model to hold it at chest height – making sure that it can't be seen in the shot.

The success of clam-shell lighting lies in the fact that the light from the softbox bounces off the reflector and onto the model's neck. You may have to experiment with the angle of the reflector to ensure that it's reflecting sufficient light onto your subject. This light also brightens the dark shadows that can form under the subject's neck from the overhead lighting. Just take care not to over-illuminate his or her neck, as this can look a bit odd!

Check the composition on your camera (pointing the lens between the softbox and the reflector) and, when you're happy, press the shutter button. I used a fixed 50mm lens with an aperture number of f2.5 and an ISO setting of 100 to get a shallow depth of field and a soft, flattering image. When using shallow depths of field, always make sure that your subject's eyes are in focus. I used a fairly fast shutter speed of 1/100 of a second so a tripod wasn't necessary to get a steady shot, but it is recommended if you're using a slower shutter speed.

You can quite often tell what type of lighting has been used in a portrait shot by studying the reflections in a subject's eyes. Look closely, and you might be able to see the source of the light: whether it was natural or part of a studio setting, how many lights were used and even if a ring flash (see p140) was utilised. Softboxes come in different shapes and sizes: they can be square, hexagonal or long rectangular strips, and these shapes can be reflected in the model's eyes to give you a clue as to the lighting set-up. This information can be a handy starting point if you want to experiment and recreate similar lighting in your own images.

The shadows

Although the image below has a nice catch light (the attention-grabbing reflected light in a model's eyes), you will also notice dark shadows beneath her neck. This can be rather unflattering. Using the reflector has eliminated the shadows for a better look (see opposite).

SHOTS THAT ROCK

kit

- DSLR
- Fast glass lens (optional)
- A gig
- Normal piece of glass (optional)
- Computer (optional)
- Basic photo-editing software (optional)
- Digital-imaging software (optional)

You've tried taking shots of bands before? Did it go a little bit like this? You stood at the back of the gig and it was dark so your flash popped up; it illuminated the backs of the three rows of people in front of you, but the band was in total darkness. You decided to move in closer, but all you managed to take was a picture of the lead singer munching on the microphone. Or perhaps you decided to photograph the rest of the band – after all, it's not just about the lead singer – but the shots came out blurry. So you forgave your flash and decided to use it again, but the manager told you to go away and stop annoying the band! You returned to the bar dejected... We've all been there.

Gig photography is tricky for several reasons: firstly, bands tend to hang out in dark rooms with weird, coloured lighting flashing about the place; secondly, the performers can move about a lot. And let's not forget that there's also a crowd that jumps up and down between you, the band and your perfect shot!

Now, if we could all afford to buy a 70–200mm f2.8 lens (aka a nice piece of fast glass, which operates well under low-lighting situations and, additionally, can zoom in above the crowd), the challenge of gig photography would be a small one. In that single piece of smart glass, you're able to eliminate some of the biggest hurdles of photographing bands. But where's the fun in that? And where's the money for that lens...?

The most affordable piece of fast glass is a fixed 50mm lens, which goes down to f1.8. This little beauty retails for about £100 and operates very well in low-lighting situations (I recommend you add it to your Christmas list). But you will have to get right up close to the stage because it's a fixed lens, so it doesn't zoom in or out – you'll have to use your legs for that.

However, there are still plenty of ways to improve your pictures without fast glass:

- Use manual focus. All those variable lights will be too much for the auto setting to cope with.
- Try to get into the groove of the music: having an idea of what the performer will do next will help you to respond quickly to capture it.
- Forget about your flash: shoot without it. Use the lights that are available to light your subject. Get good shots by balancing slow shutter speeds with large apertures and a high ISO setting.
- A certain amount of motion blur is acceptable, and can capture the energy of the gig by conveying movement. Use shutter burst mode to avoid too much blur (see p219 for more information on this setting).
- If your aperture is wide-open and your shutter speed slow, but the images are coming out too blurry, then it's time to up your ISO setting. The trouble with doing so, however, is that it will add digital noise to your images, which is particularly noticeable when you shoot in colour. Digital noise is preferable to blur, though, and you can improve the image in post-production.
- To increase your chances of getting a great shot, move closer to the action (this rule applies to photographing anything and everything).
- Make the most of your close-up position by moving around the stage. Try to shoot from a 45-degree angle; this avoids any microphone-munching shots and will capture more of the other performers too.
- Look for an unusual vantage point to shoot from. Get up high, if you can, or try to shoot from behind the stage (see opposite top right – behind the guitarist).
- Shoot close-ups: hands, instruments, posters, microphones – they all help to tell the story (like the photo on the next page of the maracas and shoes).

- Take shots of the crowd as well as of the performers. Nothing captures the essence of a gig better than the crowd's reaction to the music.
- Experiment with lens flare. Lens manufacturers have spent a fortune trying to eliminate the effects of this. But these brightly coloured polygonal shapes, which sometimes burst across your image, can add a real sense of drama (see opposite bottom left). To experiment with lens flare, shoot into a bright light and review your images. To increase your chances of lens flare, attach a small piece of normal glass (without the special coating) in front of your lens.

When the ringing in your ears has stopped and your head has cleared, let the photo-editing begin!

There are a few things you can do to reduce the amount of digital noise in an image. You can just click to reduce the noise levels in digital-imaging software, or you can opt to change your images to black-and-white, either by shooting in this programme (if your camera has it) or in post-production.

Sometimes a high ISO setting can be real a virtue; when the colour photo (opposite top right) was converted to black-and-white (opposite, bottom right), the image noise gave the visual effect of film grain – I think this suits the sixties vibe of Mary Epworth and the Jubilee Band.

Making your images black-and-white is a great trick to remove those horrible coloured lights that venues often use to create ambiance. They might make the band look more appealing on stage, but it's a rare person who looks good coloured green in a photo (see top right)!

You should end up with a bunch of images that you're proud to share. Ask the band if they want any of the files to use as publicity shots. Would a local paper be interested in featuring them? Would the venue want a copy for their publicity materials? Before you know it, you'll be shooting for the *NME*!

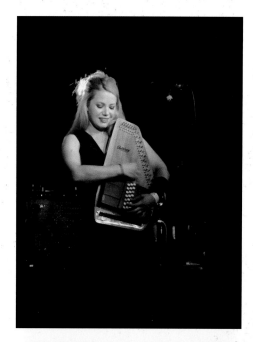

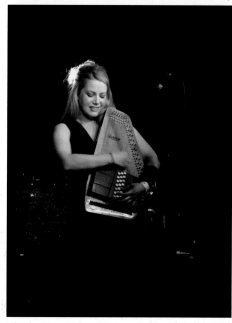

1.

2.

3.

4.

5.

6.

7.

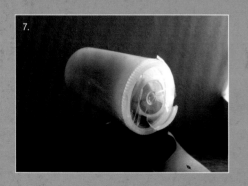

8.

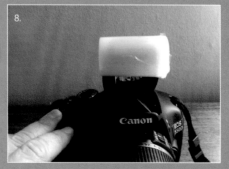

9.

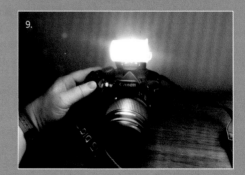

POP-UP FLASH MODIFIER

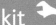

kit

- DSLR (with pop-up flash)
- Translucent film canister
- Ruler
- Pen
- Craft knife
- Sticky tape

Your camera's little pop-up flash can create harsh effects on your portraits, such as blown-out highlights and dark shadows. Stand too close when you're photographing your perfectly ordinary friend, and he or she could end up looking like an alien from *Cocoon*. But fear not – you don't have to be scared of your flash, or your friends, anymore.

The trouble with your pop-up flash is that it's small and powerful – producing harsh, unflattering light that creates too much contrast in your photos. When the pop-up flash modifier is mounted on the camera, the light from the flash has to pass through its translucent plastic, which acts as a diffuser to produce a softer and more flattering form of light.

Now you know that the difference between a good photo and a totally amazing one is often down to the lighting, you can use all kinds of things to tame the harsh light of your flash and produce fabulously flattering photos as a result.

To make this super-simple flash modifier, you need a translucent film canister (the kind used to contain a roll of film back in the days before digital photography was invented). If you don't have one lying around in a draw somewhere, then go to your local camera shop or photo lab and ask for an empty one. They tend to be nice peeps and may even give you a canister for free.

- Measure the approximate width and depth of your pop-up flash unit and mark these on the canister with a pen. Use these markings to cut out a rectangle from the side of the empty film canister (your flash unit will slot into this rectangular hole) with a craft knife, keeping your fingers well away from the blade.
- Check whether the canister fits over the flash's head, trimming it down a little more if necessary, but aiming to get a snug fit.
- If the canister's cap won't fit back on it, you might need to modify it. (Remove the inner contours of the lid but don't remove its outer edge, or it won't work as a lid anymore.)
- Put the lid back on the canister and fix it in place with some sticky tape.
- Now slip the modified canister over your pop-up flash, and you're good to go!

Although your pop-up flash modifier is most effective during the night, you don't have to wait until it gets dark before you use it; the flash modifier can work really well in daylight too. Using it during the middle of the day helps combat those nasty panda-eye shadows that can be created when the sun is directly above your subject. The flash adds some catch light in the model's eyes and also lightens any unflattering shadows.

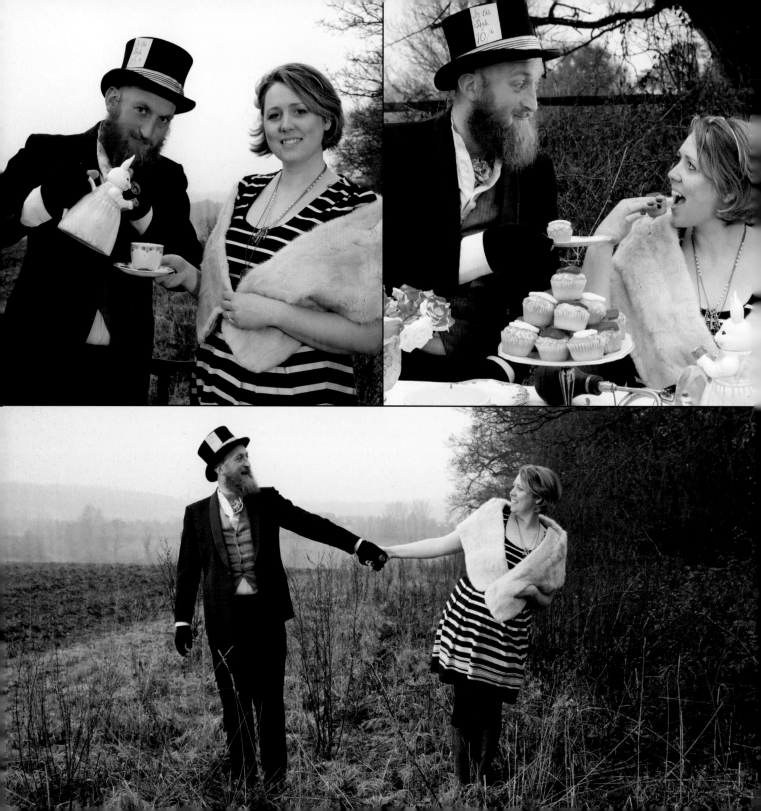

FAKE THE GOLDEN HOUR

The 'golden hour' is comprised of those magical 60 minutes before the sun sets or fully rises. The deliciously diffused light that it sheds during this hour has a wonderfully warm, orangey glow that many professional photographers agree offers the best lighting for photographs.

But if you don't fancy waiting around all day, or getting up early, this project provides an excellent 'cheat' to achieve this lovely lighting. The warm, glowing shots on these pages look like they were taken just before a stunning summer sunset but, in fact, were shot at two o'clock in the afternoon on a freezing, overcast February day.

Faking the golden hour is remarkably easy. You just need to get your hands on a coloured gel called Colour Temperature Orange (CTO) to fix in front of your flash unit or DSLR's pop-up flash.

You can buy packs of CTO flash gels fairly cheaply, and they can make a fun addition to your camera bag. The flash gels come in various densities, and you can experiment with getting the look you want in your photo by increasing or decreasing the number of gel 'layers' you use: the more layers, the darker the shade of orange light your flash will produce.

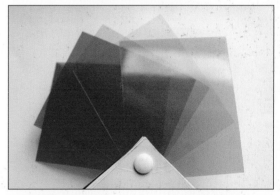

I recycled an orange gel from a variety pack of coloured gels that used to come with the old-style flashes, hence the irregular fit of the gel in front of the flash in the top right picture. However, modern packs of coloured flash gels fit much better and are available to buy online.

Once you've got your gels, attach them to the front of the flash with some duct tape.

Now you're ready to head off and start shooting using your magically modified flash.

Aah what a glorious golden light!

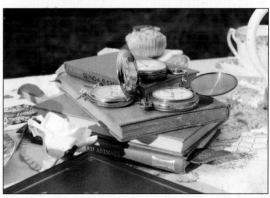

SPIROLIGHTS

kit

- DSLR
- Small torch
- String
- Tripod
- Shutter release cable (optional)
- Drawing pin
- Sticky tape (optional)
- Coloured gels/ recycled materials (optional)

Oh, the joy brought by the Spirograph plastic drawing toy! Can you remember putting your biro in one of its holes and rotating it around and around in the cog frame to create crazy geometric patterns? Did you sit for minutes on end, gazing in wonderment at the mind-boggling pattern that you created in seconds? This is a safe space – you can admit it here.

In fact, you can enjoy creating more spiro fun with this project... Just substitute the biro with a small torch and the paper with your camera, and you'll soon be able to gaze in wonderment once more.

To start with, tie a short length of string to the end of your torch (which should be switched on) and then secure the other end of the string to the ceiling or the top of a doorframe using a drawing pin.

- Set your tripod up with the camera on top of it pointing upwards, so that it's as low to the ground as possible and directly beneath the torch's beam.
- Select a low ISO setting for your camera – between 100 and 200 should be fine. Set your camera to shutter priority mode and begin with a 20-second exposure.
- Set your focus manually (on the torch) – yes, this will entail you having to lie on the floor to set the focus!
- Draw the curtains and turn the lights off – so that the room is dark – and you're ready to go.
- Use a shutter release cable or the camera's in-built timer settings to trigger the shutter before giving your torch a firm swing (preferably one with a circular motion to it).
- Check the image on the camera and adjust your timings as necessary.

To change the colour of the 'spirolight', attach a different coloured plastic gel (see Fake the Golden Hour, p175) to the end of the torch using some tape. Or, if you don't

want to splash the cash, you could use something from your recycling box: coloured sweet wrappers or a cutting from a plastic bottle or plastic bag will all do the trick.

Pimp your spirolight

For even prettier geometric patterns, use different coloured lights in one exposure. During an exposure, cover the camera using the lens cap while you swap the gel or recycled material, then swing the torch again and shoot. Repeat to build up a multicoloured spirolight.

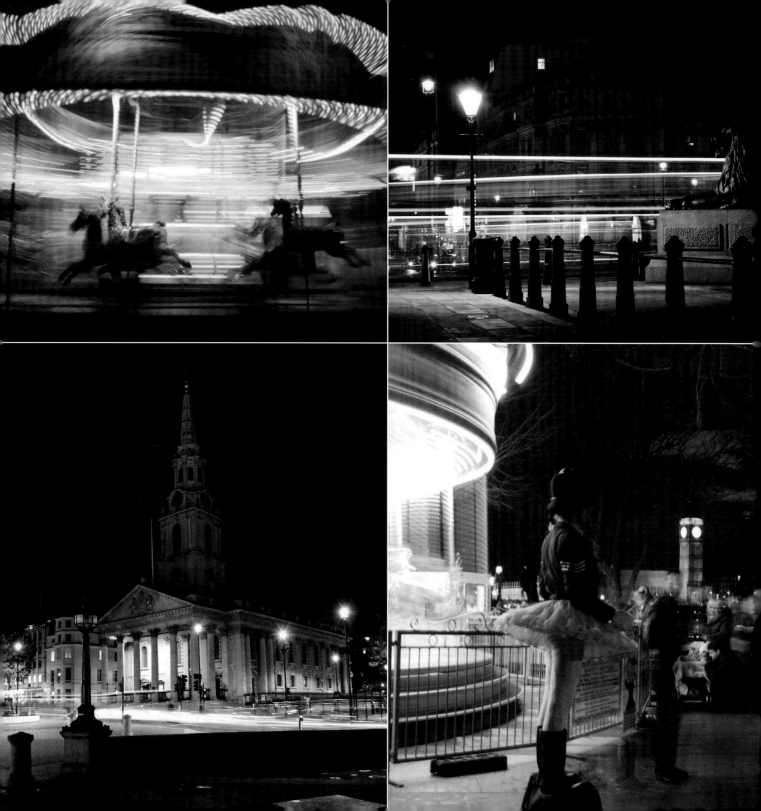

LIGHT TRAILS

kit

kit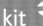

- DSLR
- Warm clothing
- Dark skies
- A location with moving lights
- Tripod (optional)
- Shutter release cable (optional)

Mastering this simple technique will bring you big, eye-catching rewards. If you've done any night-time photography before, you'll know that you have to keep the shutter open for longer because there is a lot less light available to you than in the daytime.

As a moving light passes the open shutter, a light trail is produced. The slow shutter speed also gives enough time for ambient light to be captured, so even small light sources leave a bright mark against the velvety darkness. These types of shots feature heavily in magazines and advertising because they look so cool.

The basic kit requirements for this project are your camera and some warm clothing. A tripod and shutter release cable would be handy, but are not strictly necessary if you have a flat surface to place your camera on, and a built-in timer setting.

Choose your location carefully. It's a good idea to scope one out in daylight rather than fumble around in the dark. The essential element for this project is movement, so pick somewhere like a fairground or busy road around an interesting landmark (take care when you're photographing near roads, though: wear something that's easily visible, and don't take any risks).

Once you've found a location with interesting moving lights it's time to set up the camera.

- Put the camera on a tripod or sturdy flat surface.
- Set the focus to manual and look through the viewfinder to find a bright area in your location (ideally in the middle of your frame) to focus upon – make sure it looks sharp.
- Select shutter priority mode and experiment with different exposure time durations – have a look at each image produced and adjust the shutter speed accordingly. The longer the exposure time, the longer the light trail will be in the image. So, if there isn't

much 'movement' in the image, this is probably because your shutter speed is too fast.
- Getting the right exposure will depend on how much available light there is and which ISO setting you use. (Try not to go above an ISO of 800, as this will add too much digital noise, which will have a negative effect on the quality of your image.)

Happy snapping!

Make your light trails go sky-high by experimenting with photographing fireworks. The basic principles are exactly the same, and the results can be a great way of documenting a New Year's Eve party or Bonfire Night, to last long after the fleeting embers and hangovers have disappeared.

Keep experimenting

The great thing about digital photography is that pixels are free! So don't be afraid to try out as many different settings as you like.

Don't lose focus!

The last thing you want is to come back to the warmth of home and realise that all your photographs look soft. In these low-lighting situations the camera can struggle to focus automatically, so it's best to select manual focus and use a bright object somewhere in the frame as your focal point.

Taking it further

Koyaanisqatsi is a film created using time-lapse photography (a series of still images put together in a sequence). Some scenes have fantastic light trails in them – take a look to gain inspiration.

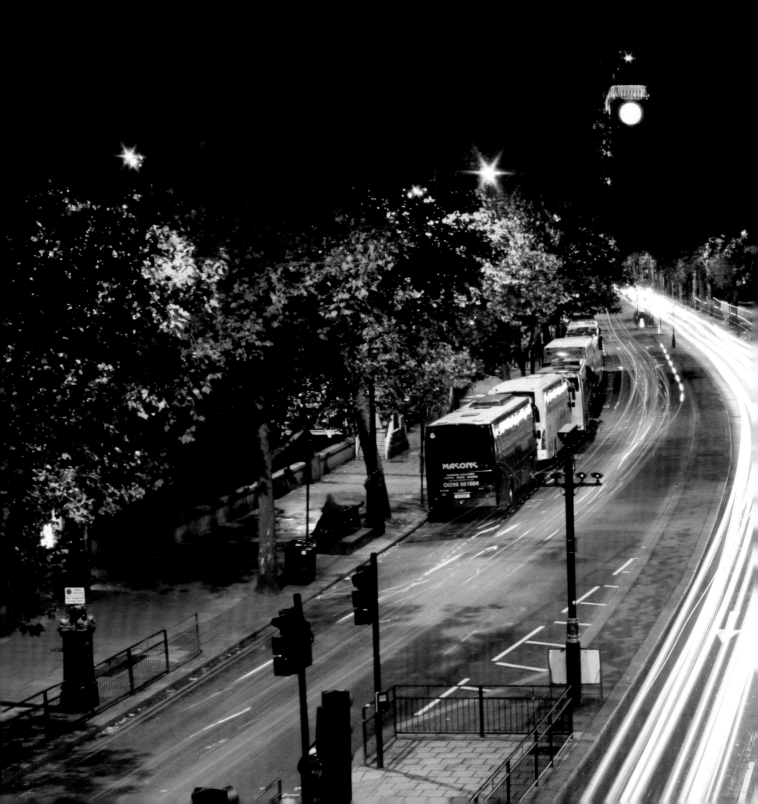

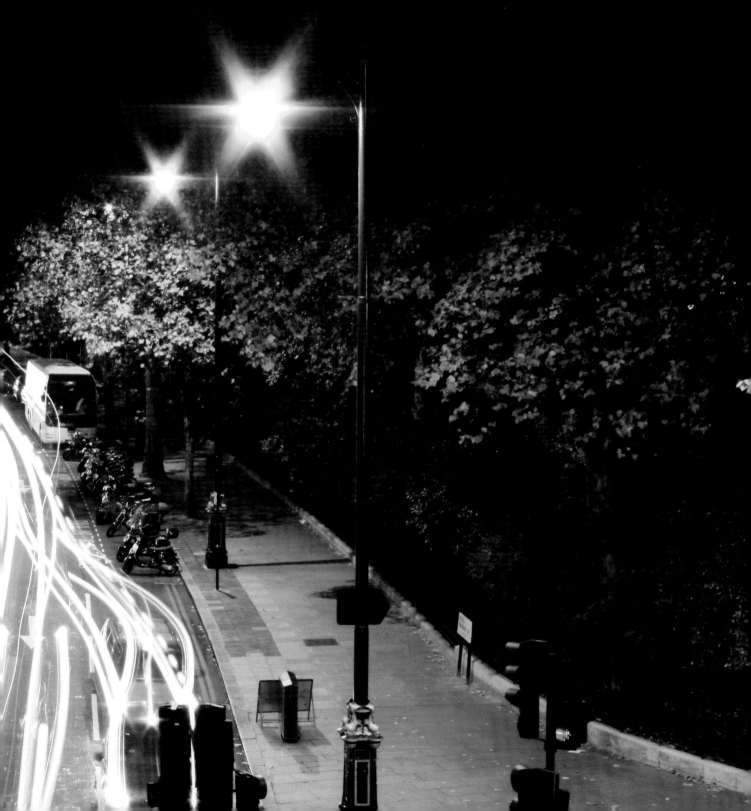

LIGHT GRAFFITI

kit

- DSLR
- Tripod
- Light-emitting devices
- Darkness
- Interesting location
- Coloured gels/ plastic (optional)
- A willing assistant (optional)
- Shutter release cable (optional)

Light graffiti – or 'light drawing' – is a fun way to get creative in front of your camera. All you need is a tripod and a hand-held light-emitting device (anything from a sparkler to a bike light) with which to 'draw' in front of your camera's open shutter – in the dark.

Simple it may be, but it can produce arresting images limited only by your imagination and a few inexpensive light tools. Pablo Picasso was a fan, and elevated this previously lowly art form when he created a series of images with a torch for *Life* magazine in 1950.

I think that light drawings look best when you can clearly see the location in the image. For example, drawing a silhouette of a ghost in a plain dark space looks okay, but is remarkably more impressive when it's beside a spooky building. So, have the shutter open for longer to allow sufficient time for the ambient light to register with your camera's sensor.

Be creative: think about the environment you are working in. Juxtaposition works well – can you think of something very unexpected for the surroundings?

Once you have your bright idea and a cool location in mind, you need to gather together a few torches, or other light-emitting devices such as mobile phones, Christmas tree lights, glow sticks, LEDs or sparklers. You will also need darkness so, if you can't wait for the sun to go down, pull the curtains now!

You might also like to use coloured gels (see Fake the Golden Hour, p174) to transform your plain white drawing light to colour. If you haven't got gels, any coloured transparent plastic will do: sweet wrappers, plastic bottles, and so on. Just hold one over your light, and you'll be drawing in colour.

You will need a tripod to ensure your camera is perfectly steady during the long exposure.

- Set the camera to shutter priority mode and find the bulb setting – select this and then use a shutter release cable to lock the shutter open, or just use the built-in timer to give you enough time to draw with your light tool in front of the camera.
- To set your focus, ask an assistant to stand in the position where you plan to draw your shape, and shine a torch towards the camera so that you can set your focus manually. If you don't have an assistant, place a torch on the ground facing the camera. When the focus is sharper than a shiny pin, tilt the camera up to reframe the shot as required.
- Be sure to aim the light towards the camera as you draw, so that the light is bright. Remember, if you don't want to appear in the shot – keep moving.
- Similarly to other projects in the book, you will have to PEE (Practice, Experiment and Enjoy) before you get a good shot.
- If the image is too dark when you check it, you need to increase the shutter speed or up the ISO setting. Be careful when increasing the ISO setting; if it's too high it will increase the amount of digital noise you get in the shot, which can have a negative effect on the overall picture quality.
- If the image is too bright or looks a bit burned out, then decrease your exposure time.

Gather together a bunch of friends. Light graffiti is a great project to do with mates, as several people can be drawing in front of the camera at the same time. Collaborative projects enable you to bounce ideas off one another before going to the pub afterwards to warm up!

Tip

If you're writing a message, remember to write it backwards! Or you can cheat a bit and mirror it in post-production!

LIGHT STENCILS

kit

- DSLR
- Detachable flash unit
- Cardboard box
- Pencil
- Scissors or a craft knife and cutting mat
- Aluminium foil
- Black tape
- Cardboard
- Coloured gels, tissue paper or plastic (optional)
- Torch
- Tripod
- Shutter release cable (optional)

Your mum may have used stencils to decorate her kitchen walls in the eighties, but infamous graffiti artists like Banksy have turned stencilling into a hip urban art form.

Light stencilling follows this rich tradition, but leaves a more fleeting impression on the environment. Whether you're interested in creating pithy political statements or something more decorative, the only limitation with this project is your creative vision.

The process for creating a light stencil is simple, so long as you have a detachable flash unit.

You'll need a cardboard box – I usually choose one with a bottom about the size of a sheet of A4 paper.

Before you set your camera up, it's important to choose a location in which the light stencil can interact with the environment: for example, I've photographed my bird shapes so that they appear to be sitting on the garden fence, so see what will work for your scene.

See opposite for how to make your stencil.

1. Position the flash unit on the top of the box (with the longer side of the flash over the longer side of the box), equidistant from the edges, and draw a line from the bottom corners of the flash down to the bottom corners of the box.

2. Do the same on each side of the box; then cut all the way along these lines (up to and including the box flaps) using scissors or a craft knife and cutting mat.

3. Cut out a 'window' at the bottom of the box, leaving a 3cm-wide edge – this is where your stencil will go.

4. Line the inside of your box-turned-stencil-holder with aluminium foil to reflect the flash's light, then seal the edges of the stencil holder using black tape to prevent any light leaks.

5. Now it's time to create your stencil: use your imagination to draw a simple shape on another piece of cardboard. If you're not a confident sketcher, then trace something instead.

6. Once you're happy with your drawing (or tracing), use scissors or a craft knife and cutting mat to cut out the shape(s).

7. You can add some colour to your stencil and diffuse the flash's light by using coloured gels (see p174), tissue paper (as above) or coloured plastics.

Once you have your stencil box, it's time to head outside (a torch is a necessary accomplice for night-time projects).

- Fix the camera on a tripod.
- Set the camera's timer – to about 30 seconds – or find the bulb setting in shutter priority mode and use a shutter release cable.
- Choose a low ISO setting (of about 100) to avoid any digital noise.
- Set the focus on your camera by standing behind it and shining a torch at the spot where your stencil will appear (in this shot I aimed the torchlight at the fence). Then use manual focus to get the area beneath the torchlight looking sharp.
- Set your flash to around 1/8th power to begin with, before putting it into the back of the stencil holder.
- Check your composition and then, when you're happy, press the shutter button.
- Move in front of the camera to the right location and aim the stencil towards the camera before triggering the flash (I used the pilot button to do so).
- Move about quickly when you are in front of the camera – if you stand still you will appear in the image and ruin the effect.
- Check the images and adjust your shutter speed so that the background is correctly exposed.

Once you have mastered the basics, take your images to another level by doing several different stencil flashes in one exposure, to build a scene. You could also experiment by adding some light graffiti (see p182) to enhance your lighting masterpiece.

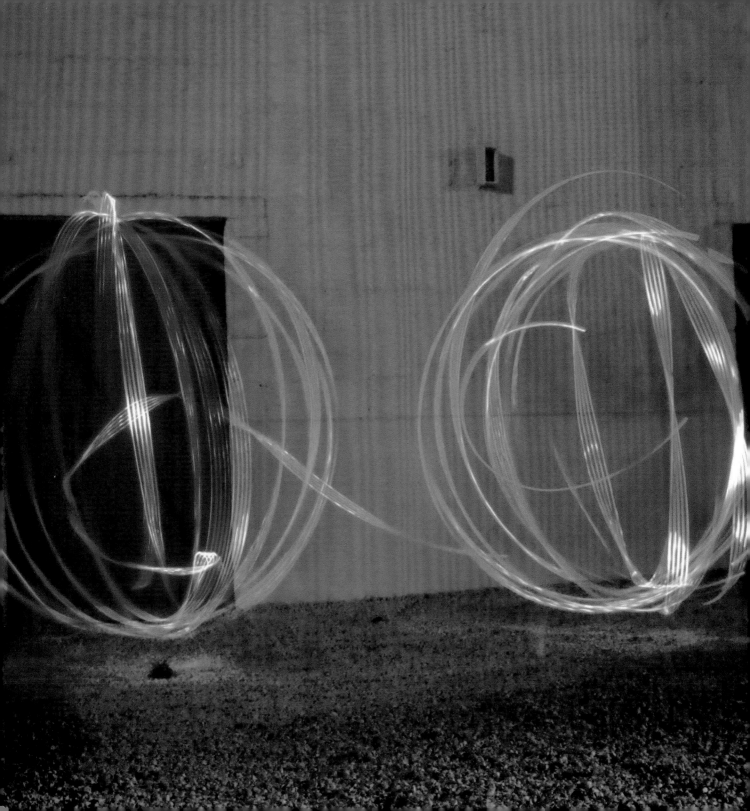

GOLDEN GLOBES

kit

- DSLR
- A fitting location
- Darkness
- Light-emitting device
- Cord (or string)
- Tripod
- Shutter release cable (optional)
- A fixed marker

Whether you can fool your friends into thinking these stunning light spheres are from outer space or not, they are really satisfying to create...

As with much nocturnal photography, it's important that you find an interesting location for this project. It's usually best to find a suitable spot in daylight to make for an easier set-up when it's dark.

Think carefully about composition when you're scouting for a location; infusing a sense of mystery into your shots by filming in an atmospheric setting — by derelict barns, a body of water or dead trees, for example — will give your images that extra edge.

Although the finished photo will look like a special effect, you don't actually need any fancy kit to create it: just your camera, tripod, a light-emitting device (such as a torch or bike light), some cord or string and a shutter release cable (or use your camera's built-in timer).

It's remarkably easy to achieve the globe shape, but it does require a bit of practice before you start shooting:
- Fix your light-emitting device to the end of the length of cord. (For the photo opposite, I used a bike light and attached it to garden string — so low-fi!)
- Then you need to swing the cord (with the light attached) in a full circle in front of you.
- Find a fixed point in the ground as a marker (anything will do — in the photograph opposite, I used a weed in the gravel).
- Shuffle in a circle around your marker, at a distance of about 50cm away from it all the while swinging the light in circles. This will take some practice, but keep taking small circling steps around it, while making sure that the swinging light keeps crossing your fixed point. You will probably find that you keep hitting yourself with the torch but keep at it! (If you don't move in a circle around the point then your body will be visible

in the image and the sphere won't have a 3D effect — it will just look like a ring of light — which isn't nearly as impressive!)

Now for the camera:
- Pop it onto a tripod.
- If you are using a shutter release cable, set your camera to shutter priority mode, find the bulb setting and select this. If you're using the camera's timer, set it to 30 seconds to start with.
- Use a very low ISO setting to avoid any unwanted digital noise in the images.

Don't get yourself into a spin if your golden globes aren't perfect the first couple of times you try this technique. Review your images and learn from your mistakes.

Once you have mastered the dark art of creating a singular orb, try doing multiple orbs in a single exposure. Pimp your light globes by using different light sources and coloured gels (see p174).

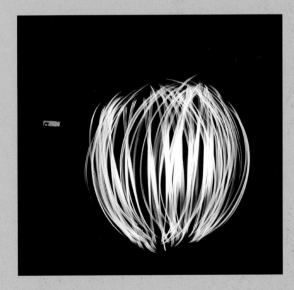

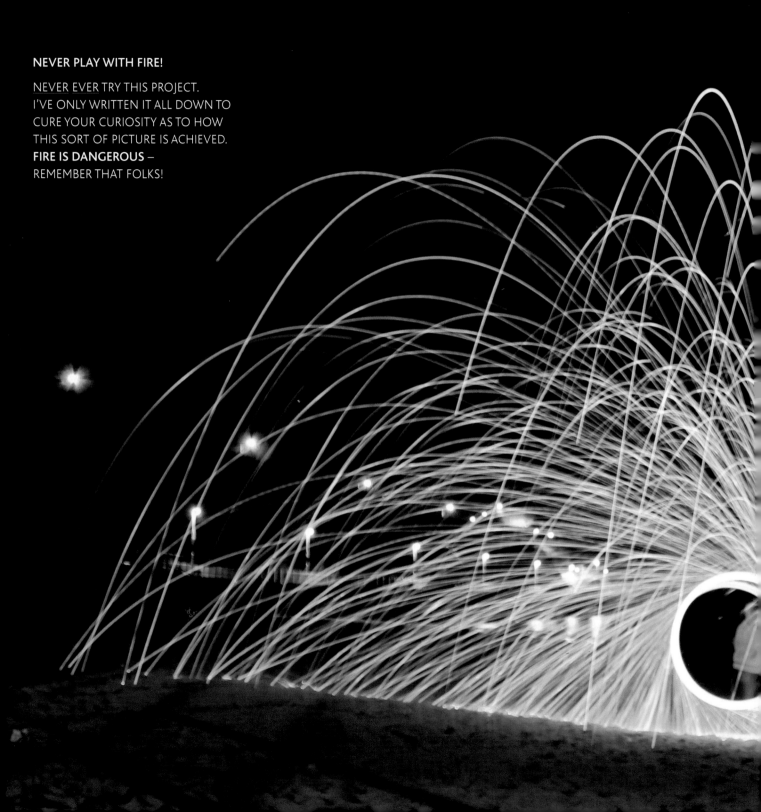

NEVER PLAY WITH FIRE!

<u>NEVER</u> <u>EVER</u> TRY THIS PROJECT.
I'VE ONLY WRITTEN IT ALL DOWN TO
CURE YOUR CURIOSITY AS TO HOW
THIS SORT OF PICTURE IS ACHIEVED.
FIRE IS DANGEROUS –
REMEMBER THAT FOLKS!

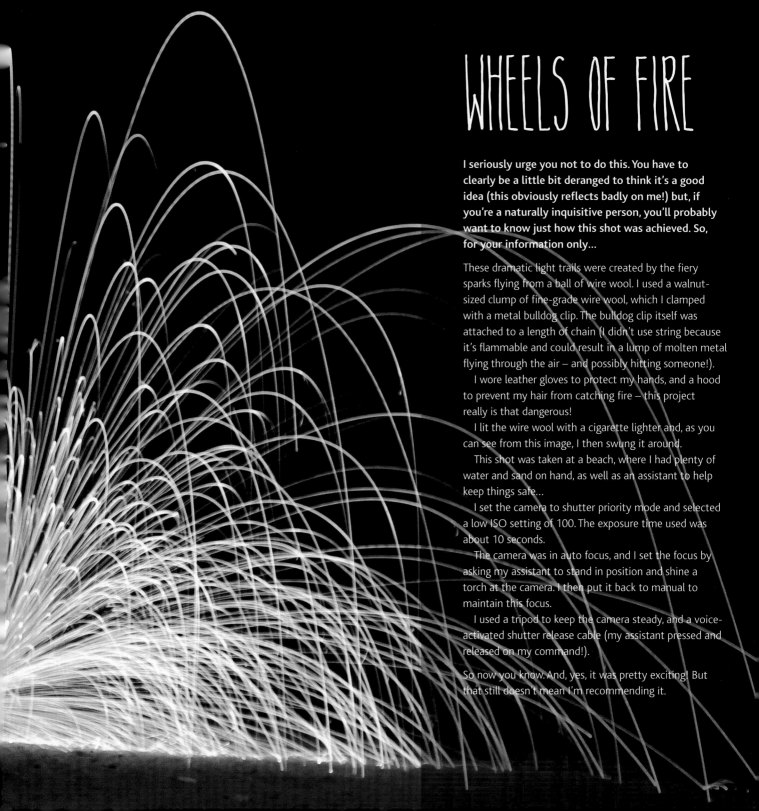

WHEELS OF FIRE

I seriously urge you not to do this. You have to clearly be a little bit deranged to think it's a good idea (this obviously reflects badly on me!) but, if you're a naturally inquisitive person, you'll probably want to know just how this shot was achieved. So, for your information only...

These dramatic light trails were created by the fiery sparks flying from a ball of wire wool. I used a walnut-sized clump of fine-grade wire wool, which I clamped with a metal bulldog clip. The bulldog clip itself was attached to a length of chain (I didn't use string because it's flammable and could result in a lump of molten metal flying through the air – and possibly hitting someone!).

I wore leather gloves to protect my hands, and a hood to prevent my hair from catching fire – this project really is that dangerous!

I lit the wire wool with a cigarette lighter and, as you can see from this image, I then swung it around.

This shot was taken at a beach, where I had plenty of water and sand on hand, as well as an assistant to help keep things safe...

I set the camera to shutter priority mode and selected a low ISO setting of 100. The exposure time used was about 10 seconds.

The camera was in auto focus, and I set the focus by asking my assistant to stand in position and shine a torch at the camera. I then put it back to manual to maintain this focus.

I used a tripod to keep the camera steady, and a voice-activated shutter release cable (my assistant pressed and released on my command!).

So now you know. And, yes, it was pretty exciting! But that still doesn't mean I'm recommending it.

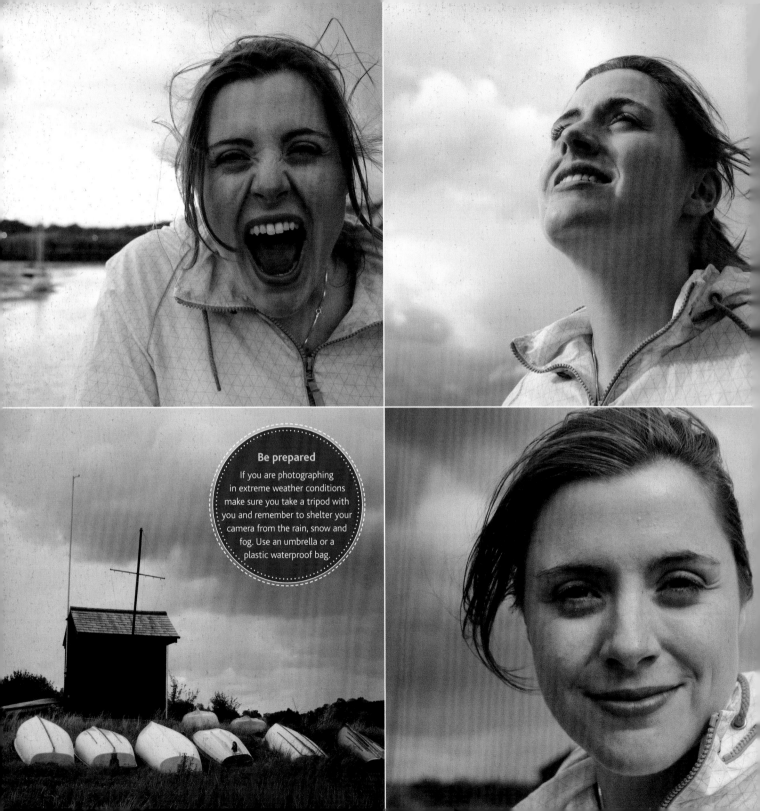

Be prepared
If you are photographing in extreme weather conditions make sure you take a tripod with you and remember to shelter your camera from the rain, snow and fog. Use an umbrella or a plastic waterproof bag.

STORM CHASER

kit

- DSLR
- Tripod (optional)
- Shutter release cable (optional)
- Protection (for you and your camera)

It's raining. It's snowing. It's foggy. It's cold... Stop being a fair-weather photographer who waits for the perfect auburn light. Get out in the elements or you could be missing the perfect shot.

If you live in a drizzly, overcast country, where you're not sure what the weather is going to do from one moment to the next – then count yourself lucky! Embrace the foreboding skies and, instead of running for shelter, run and get your camera. Below are 10 reasons why bad weather equals good photos:

1. Clouds act like giant softboxes in the sky, providing a wonderfully soft diffused light. This light wraps around a subject and doesn't leave any ugly dark shadows – perfect for shooting portraits.
2. Dark, rumbling skies can make for a dramatic backdrop for a portrait (see opposite) or landscape, and can be a fantastic alternative to a 'pleasant sky' shot.
3. There's no need for a wind machine to give your shots a bit of energy when it's blowing a gale outside. Harness the power of the wind and the dramatic effect it has on all who stand in its way by capturing it photographically.
4. Rain can make wet surfaces shimmer, in urban environments roads can suddenly become mirrors, reflecting the buildings around; rainfall provides a great opportunity to capture interesting reflections in the resulting puddles and shiny surfaces (see p70).
5. Rain can also add volume to waterways and waterfalls, turning a trickling stream into a torrent; the fast waters provide a good opportunity to experiment with a long exposure time.
6. To capture lightning, use a tripod and a very slow shutter speed to create a long exposure time. You'll need to find the bulb setting on the camera, so you can press the shutter button and hold it open for as long as you want. Then, after the lightning bolt has shot through your frame, you simply release the shutter button, so the lightning is bright on your image. To eliminate camera shake from manually holding the shutter open, it's worth investing in a shutter release cable. This type of shot requires a lot of luck and patience, but can be extremely rewarding.
7. Normally, when we look at bright objects they jump out at us and dark objects recede into the distance, but in a foggy scene the opposite is the case – suddenly the fence posts or dark trees stand out against the muted foggy mist. So capture a misty landscape and people will stop and stare.
8. Snow might make you feel like snuggling up inside by an open fire but, before you get too cosy, go outside and take some shots. The whiteness of the snow can act as a giant reflector, casting a flattering up-light for portraits – so drag someone out with you.
9. Falling snow provides an excellent opportunity to experiment with shutter speeds). Slow shutter speeds give a more abstract image, while fast shutter speeds freeze the motion of the fluttering flakes. You might like to experiment with using the flash, too, as the watery crystals in the snow reflect the light and add sparkle.
10. Remember that with every storm that passes there's potential for a rainbow – a photographic pot of gold!

So don't look at bad weather as a problem – start seeing it as an opportunity to capture some of the biggest drama that Mother Nature has to offer.

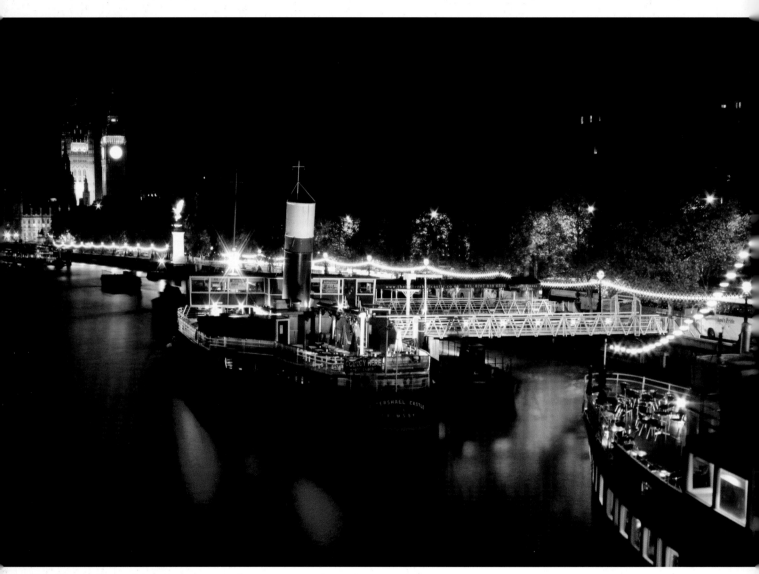

Water becomes silky smooth in long exposures

NIGHT SHOOTER

kit 🔧
- DSLR
- Warm clothing
- Interesting subject matter
- Tripod (optional)
- Shutter release cable (optional)
- Torch (optional)

Don't put your camera to bed just because the sun has gone down. Shooting in the dark brings its own rewards; bright lights twinkle against jet-black skies and long exposure times bring clarity beyond what the human eye can see.

The beauty of night photography is that the long exposure time (using a slow shutter speed setting) required allows any light in the frame to 'burn' into the images, revealing more detail and depth than is visible to the naked eye.

- Firstly, choose an interesting location: fairgrounds, cityscapes, lights on water and busy roads all make good subject matter.
- A tripod and shutter release cable are recommended for stability, but you can make do with just your camera if you use a flat surface and its built-in timer.
- Remember to compose your shots well – just because you're shooting at night, it doesn't mean you can forget the basic rules of photography!
- Always use manual focus when shooting at night because the camera struggles to find focus in low-light situations. Finding focus in the dark can be quite difficult for humans, too. One solution is to shine a torch onto the subject that needs to come out looking sharp and then set the focus. If you don't have a torch, guess the distance between the camera and the subject, then look at the focus ring and spin it round to the guestimated distance.
- Select manual mode and set the aperture number to f11. Generally speaking, if you're shooting a landscape picture, it's best to set the aperture to as high an f-stop number as possible (f11 and above), so that the maximum area of the photograph is in focus.
- A high ISO setting will create too much digital noise; keep the setting below 800 to maintain image quality.
- Experiment with different exposure times and check your images on the LCD screen until you get the correct exposure. If the image looks too dark and lacks detail, you will need to increase the exposure time. If it's looking too bright and a little washed out, select a faster shutter-speed setting.

Remember to minimise wobble over long exposures: use your tripod and shutter release cable (or timer).

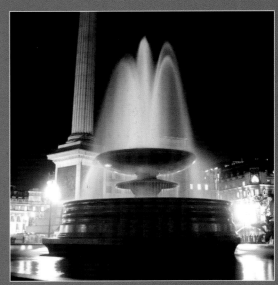

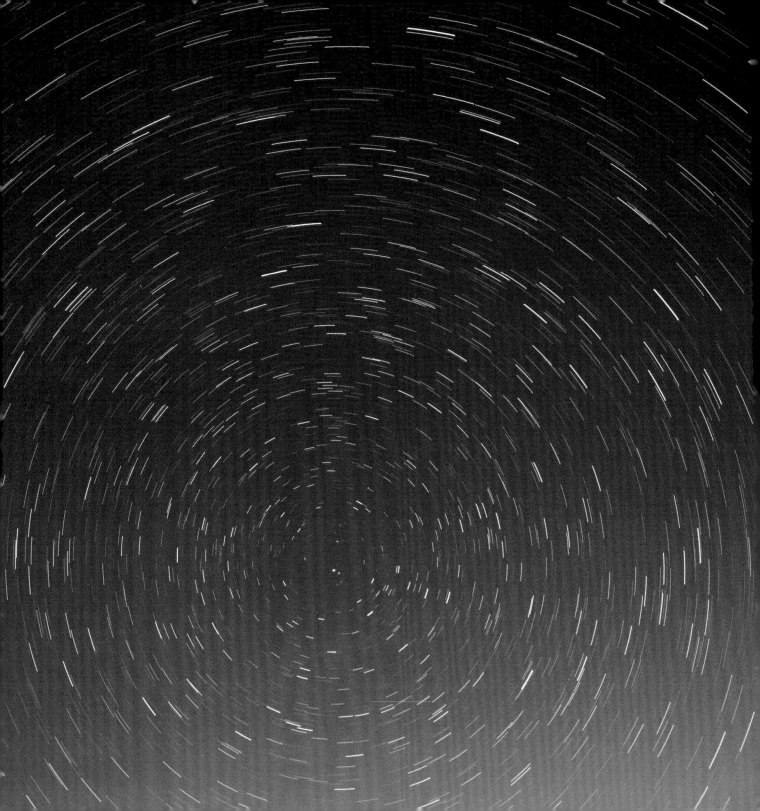

STAR STACKER

kit

- DSLR
- Starry night sky
- Torch
- Warm clothing
- Entertainment
- Compass
- Tripod
- Shutter release cable (optional)
- Computer (optional)
- Digital-imaging software (optional)

Tiny, shiny, silvery slivers (star trails) appear in a photo of the night sky within an exposure time of 15 seconds – all because the Earth rotates on its axis. The slower the shutter speed, the more dramatic the effect will be. By taking multiple long-exposure shots of the night sky from the same place, it's possible to stack these images into a single exposure and create one amazing image. The final stacked image shows the rotation of the Earth against the static night sky.

Deciding on the best place to shoot your photo is best done in daylight. Star-trail photography is ideally carried out away from busy cities, as the light pollution there can ruin your image over long exposures. The night sky needs to be really dark and clear so the stars are at their brightest.

When you've chosen a location, try to find some foreground interest for your photo, such as attractive rooftops, trees or skyline.

Aim to start your shoot a couple of hours after sunset. Bring a torch with you, and some warm clothing. You might also want to bring something to keep you entertained while you're waiting for the exposures to happen – it can get boring hanging around in the dark!

To get the most dramatic results, point your camera north or south (depending on which hemisphere you happen to be in). You could use a real compass – or the one on your smart phone – or just use the night sky as your guide: the northern axis of the earth points towards the North Star and the southern axis towards the Southern Cross. So, if you're in the Northern Hemisphere, direct the camera in the direction of the North Star (and towards the Southern Cross if you live south of the Equator). By angling your camera correctly, you can capture images that effectively show the Earth's rotation.

A cunning way to capture even light trails without any gaps between each exposure is to:

- Get the night shooting basics right first: use the lowest ISO setting possible and always use a tripod.
- Select manual focus and then zoom in on a star, adjust the focus as necessary and check your composition – if you're in doubt, take a shot for some visual reassurance.
- Select shutter burst mode (allowing continual shooting rather than a single shot).
- Put your camera in shutter priority mode and select an exposure time of 30 seconds (the maximum amount of time before you hit the bulb mode on most cameras).
- Attach your shutter release cable and lock it open.
- The camera should keep shooting every 30 seconds until the memory card is full, the battery runs out or you release the shutter.
- While the camera is firing off images, you could pop inside to keep warm. I told you it was cunning! Be careful that there isn't a sudden rain shower, though.

If you don't have a shutter release cable or shutter burst mode on your camera, you could take a series of images using long exposures (20 x 30-second shots, for example). Or you could take a really long exposure of 30 minutes. But I think it's better to take a series of shots because during long exposures the ambient light (from the moon, stars and buildings) can lighten the appearance of the night sky making the star trails appear duller.

If you've gone for the multi-shot option then it's time to stack them into a single image. The good news is that you don't need Adobe Photoshop to do so; some clever people have created free star-stacking software for you to use. Go to www.starstax.net or www.startrails.de to download the software and stack your images.

After a short time spent stacking your images, you should have one lovely shot of a star trail. There's something mesmerising about an image that illustrates our planet's perpetual motion.

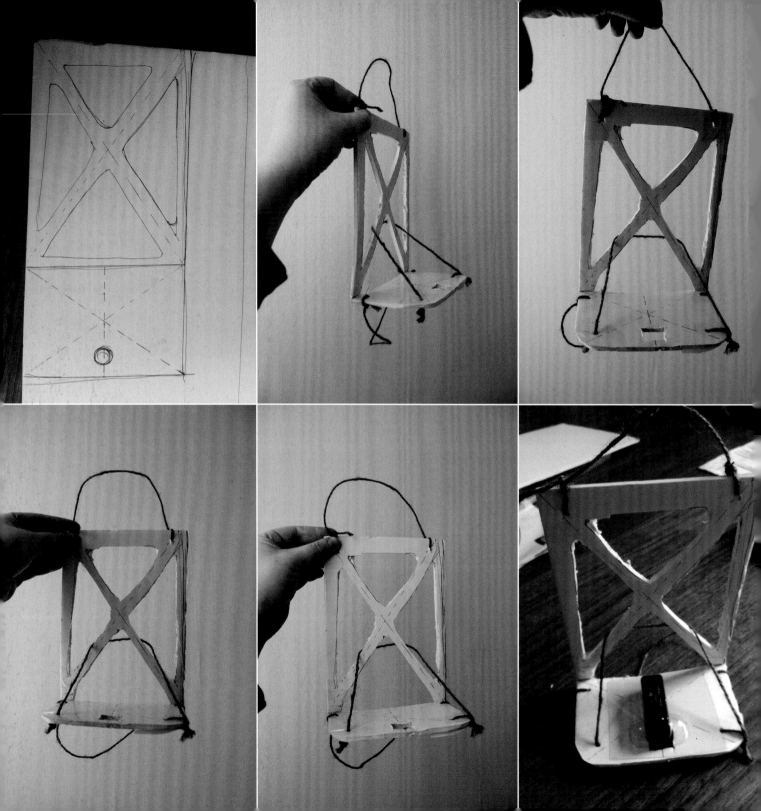

AERIAL PHOTO

Aerial shots are amazing; they offer us a different, bird's-eye perspective on the world. I love gazing out of the window of an aeroplane as it climbs, watching the fields turn into a patchwork quilt of different shades while urban environments are reduced to toy towns. This is a fantastic project for getting those aerial shots without the fuss of packing a suitcase and queuing at the boarding gate.

This project doesn't require a DSLR but, in theory, you could use one, if you select shutter burst mode, use a shutter release cable locked open and have one heck of a lot of helium balloons at your disposal!

I'm no physicist, but here's my attempt at being scientific: the tiny rig I made plus the little camera I used weighed a measly 100 grams in total and required 17 (28-cm party) balloons to get it to lift off. It was a damp day, which affects the amount of balloons needed: damp day = more balloons; hot day = fewer balloons.

My hefty DSLR weighs a whopping 780 grams (plus the weight of a sturdier rig), meaning I would need over 130 balloons to send my DSLR up, up and away. So, to save on balloons, it's best to use a compact digital camera that records video, or buy a little one to do the job, like I did. You could use your iPhone, if you have the nerve: I didn't!

You'll also need some foam board, a ruler, a craft knife and cutting mat, sticky tape, string, an appropriate number of the aforementioned helium balloons and kite string.

- Draw and then cut out the design for your rig on the foam board using a pen and ruler. This 'camera harness' might need to be adapted depending on the type of camera that you are using. The basic principle is a right-angled piece of foam board for your camera to sit happily on. I tried to keep the amount of foam board minimal to keep the rig as light as possible.
- Cut out the rig shape from the foam board.
- Remove the triangular pieces of board from the back of the rig. (This is to keep it lighter, to use fewer balloons.) Be very careful not to cut through the cross supports.
- Score along the fold before bending it to create a handy hinge.
- Strengthen all key areas with sticky tape to make the rig more robust. (We don't want it splitting in mid-air – another good reason not to use your DSLR for this project!).
- Place your camera centrally (you need to have it fairly well balanced) on the bottom of the rig and work out where the lens will go. Remove a circular piece of foam board for your lens to see through. Check that the hole is in the right place.
- Make a small hole in each of the corners at the top of the rig using the pen tip. Thread a piece of string (measuring about 1.5 x the width of the rig) through the holes and fasten each end tightly to the rig.
- Make four holes in the bottom of the rig – one in each of the corners.
- Thread a piece of string (measuring 2 x the width of the rig) through the set of holes nearest the fold and fasten each end tightly, so that the length of string hangs below the rig.

- Take another piece of string (measuring approximately 3 x the width of the rig) and knot it underneath one of the front corner holes, threading the other end through the hole and then around the back of the rig, behind the cross supports, then back to the front through the other gap. Thread it through the other front corner hole and knot it underneath so that the rig is fixed at a 90-degree angle.
- Attach your kite string to the centre of the bottom loop of string hanging from the rig – tying several knots to make sure that it's secure, and attach the other end to something heavy to prevent it from lifting off when you attach the helium balloons!
- Now inflate your balloons with helium, tie them with string and attach their strings to the top loop of string on the rig. Again, ensure that they are fastened to the rig securely.

- Once you've attached the balloons and kite string, you're good to go. Just don't forget to set the video to record before you send your camera up into the sky.
- Choose an open space and you're up, up and away!

There are different ways to convert your moving images to stills – I used Final Cut Pro, but you could use Adobe Premiere, Windows Movie Maker or something similar instead – to export the frames as still images, and then made adjustments to the images using my usual photo-editing software.

When I'd finished with the balloons I gave them out to passers by. A lovely elderly couple was very excited about the unexpected gift!

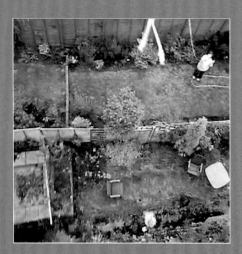
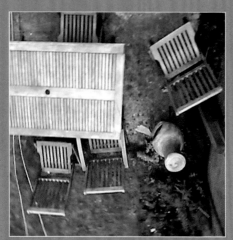

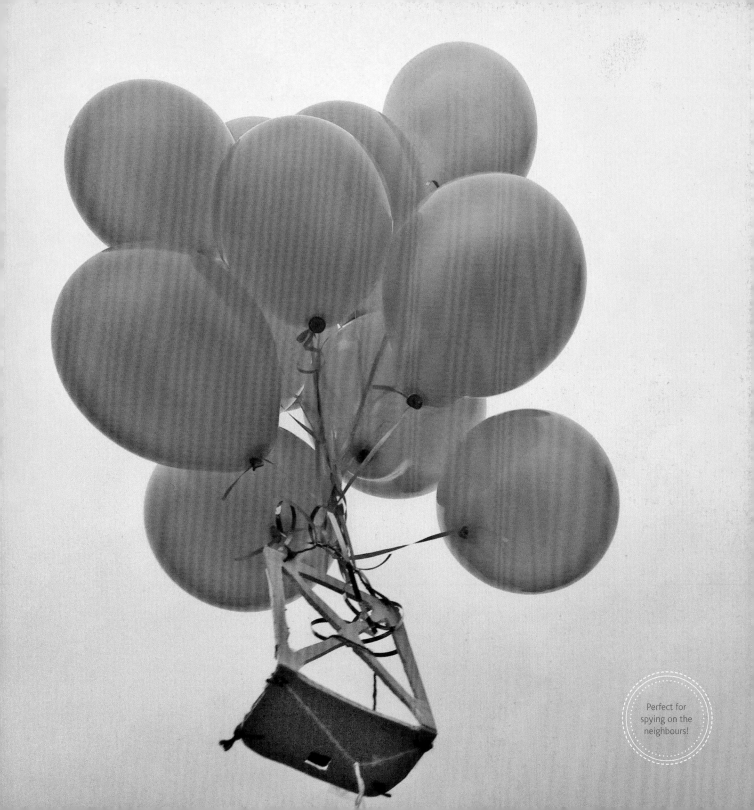

Perfect for spying on the neighbours!

POST-PRODUCTION

CREAM OF THE CROP

kit

- Computer
- Digital images
- Basic photo-editing software

You are more likely to take a bull's-eye shot if your camera's focal point is set to the centre of your frame. Read your camera's manual to find out how you can move the point of focus around the frame and see The Rule of Thirds (p16) for non-centre-weighted composition.

Composition may begin with the viewfinder, but it doesn't have to end there. Even the most basic of photo-editing packages has the 'picture crop' tool, so you can improve your images long after you've pressed the shutter button.

Let's take a closer look at a rather unremarkable photo from my digital archives: image A is suffering from a common compositional error known as 'the bull's-eye', in which the main focal point is in the centre of the image. Bull's-eye can make for boring photographs because the viewer's eyes arrive at their destination immediately – instead of being invited on a visual journey around the image through a series of interesting compositional elements. However, with some judicious reframing you can rescue the picture from the visual dulldrums.

When you alter the space between the edge of an image and its main subject, you're changing how the photograph is 'read'. For instance, in image B you can see that the image has been cropped and the main subject has been pushed towards the corner of the frame to create a sense of visual containment around the butterfly. Image C has a fun feel to it: it's as if the insect has just wandered into the frame.

So, take a photograph and see how many different images you can find within it, simply by adjusting the crop in different ways. Just remember to save each image separately as you go along.

Another way of improving an image is to change its aspect ratio. Whether your images were square or rectangular in shape was previously dependent on what format of film camera you were using. But now, in the digital age, we have the crop tool, so you can take creative control of your images' shapes. When cropping your average 6x4 image to 4x4, you are eliminating a third of the photo.

This process of refinement often results in a more visually impactful image. The square shape of image D has a greater sense of balance and containment than the rectangle (which, with its uneven sides, can be seen to be out of balance). Square format can work particularly well for close-ups of natural surroundings, and for portraiture, which perhaps has something to do with the fact that when our eyes look at a square image, they read it in a circular motion rather than the in left-to-right or up-and-down way in which they tend to read a rectangular one.

A square format seems far more in keeping with fine-art photography, too, so crop your images into a square, print them out and frame them with a large border to showcase your photographic skills. Experiment with converting your images to black-and-white and displaying them in groups of three for an uber arty look.

A

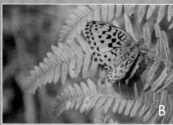
B

C

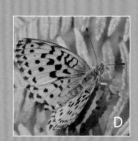
D

NUMEROLOGY

This is a fun and simple photo project. The aim is to gather together photos of numbers 1–100. 'Err, why?' you might ask...

Well, there are several things that you can do with a numerical collection, but first you have to get out there on a number scavenger hunt.

To increase the chances of photographing a full set of numbers, you need to have your camera with you at all times – or gather together a group of people who've also been bitten by the shutter bug to help you in your search-and-snap quest. Organise yourselves by ticking off the numbers you've already bagged for your collection so that you don't waste time on duplications.

It's very useful to have a zoom lens, as you'll be amazed at how many fantastic number-shot opportunities are just out of normal range. The zoom lens enables you to take photos of numbers that will fill the whole frame, which is what you're after.

Once you've got your collection saved on a computer, the post-production options are numerous:

- Hit the 'print' button whenever someone has a birthday or anniversary and you want to make a personalised card using the special number, for a creative and thoughtful gesture.
- Compile all your numerical images into one image, using photo-editing software (no need to buy Adobe Photoshop; even the most basic of software packages has the 'crop', 'copy' and 'paste' functions). Print out the image, stick it to card when someone's birthday comes around and circle the appropriate number. You'll never have to spend ages choosing a birthday card again!
- If gathering numbers 1–100 seems a bit too arduous, you can keep it down to 1–31 and create a beautiful calendar: that's next year's Christmas presents sorted!
- Another cracking way to use your collection of numbers is to make on-trend pieces of graphic art, for personalised pieces of contemporary style without too much effort. Gather together numbers that look good side-by-side: think about contrasting shapes; group any shots of the same number together (for example, all the sevens together for extra luck); or focus on complementary colours. This also means you can double up on numbers and just choose the ones you like best.

NEGATIVES & POSITIVES

kit

- Computer
- Digital image(s)
- Digital-imaging software
- Colour printer with plain paper
- Sun print paper
- Picture frame (or sheet of glass) to keep the two sheets of paper tightly together
- Sunlight!
- A tray with water

We all love digital photography, but sometimes it's nice to go back to basics and experience the thrill of capturing light in all its low-fi glory. This project allows us to combine the fun of analogue printing with a little digital dynamite to start things off.

Pick a digital photo from your collection; try to choose one that's already quite contrasty (showing areas of light and dark). If you have digital-imaging software, increase the contrast in the image before continuing.

- To make the image into a negative, you'll need to 'invert' it. In Adobe Photoshop you'll find this option in 'Image', then 'Adjustments', or you could use the shortcut: 'command' + 'I' if you have a Mac or 'control' + 'I' if you have a PC.
- Once you've got the negative, print it out on plain printing paper – the thinner the better, as the light needs to be able to pass through it – there's no need to use anything high-tech.
- To create an image from your negative, place the print on top of a sheet of Sun print paper (blue side up). It's a good idea to find something with which to hold the two sheets of paper together to increase the chance of

the positive image coming out sharp; I put them inside an old picture frame.

- Now you need to expose the sheets of paper to sunlight so that the light-sensitive paper can do its thing. Place the frame with the sheets inside in direct sunlight for 15–25 minutes.
- You can check how well it is exposing by carefully lifting up the edges of the light-sensitive paper. You should see a positive image of the negative one that's on top emerging on the light-sensitive paper. If there isn't much contrast (areas of bright blue and dark blue) in your print, just leave it exposed to the sunlight for a few extra minutes.
- When the Sun print paper has been exposed for long enough, it's time to 'fix' the image onto it. To do this, place the light-sensitive sheet of paper in a tray of water for about a minute.
- Take the paper out of the water and leave it to dry (keeping it flat). And now you're done!

You could also use the images you created from Shadow Play (see p110) as negatives to make positive images.

orginal

negative

paper sandwich

checking exposure

remove your new positive image

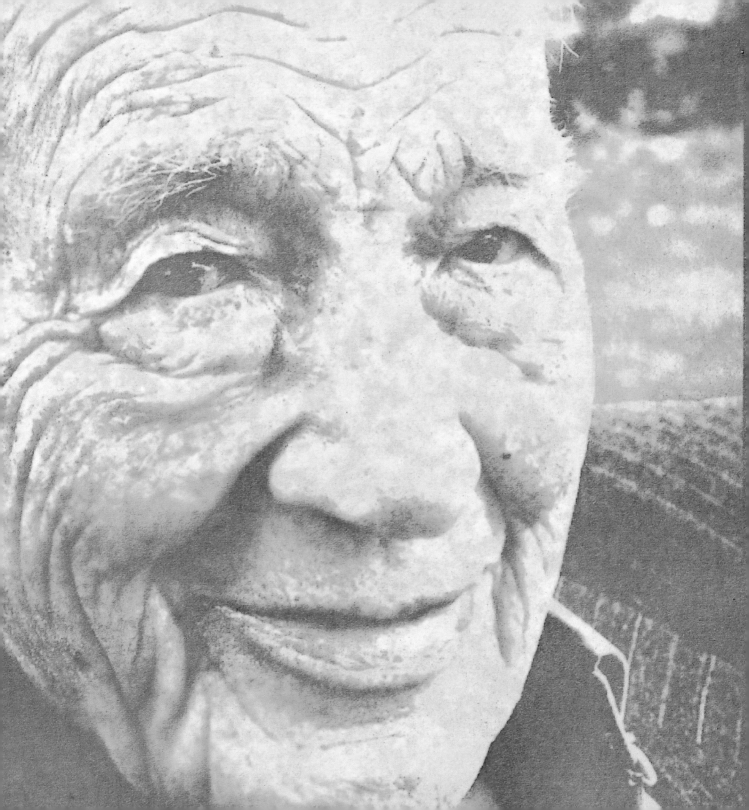

BRING HISTORY ALIVE

kit

- DSLR
- Old photograph
- Original location of your photo
- Scanner
- Computer
- Adobe Photoshop or other photo-editing software

Spot the difference

Very few original features are visible on the current shop front: the tiled floor leading to the flat above the shop is still there, as are the decorative uprights to the left and right of the shop sign.

Use your DSLR and an aged photo to connect the present with the past and bring history alive.

This project is most satisfying when you create a personal connection to bygone times by using a photo from your own family's archives. Just be sure to choose one whose location you're familiar with and can get to easily.

These proud shopkeepers (opposite top) are my grandparents; the photo was taken in 1953 as they posed outside the shop that they ran for eight years. The windows display their best products: dried fruit, chopped ham and corned beef. Today the same shop still sells food, although only a few of the original features remain.

- The key to making the past and present photographs combine convincingly, is to study the lighting in the original before taking the present-day photo – where was the sun when the photo was taken? Is the light in the picture bright, as if the sun was overhead (midday) or does it look soft, which indicates that it was probably taken in the late afternoon? Aim to be at the location at about the same time as the original was taken.
- Take along your copy of the original photo and aim to position yourself in exactly the same spot as the original photographer did. Make sure your camera angle is spot-on (your frame will be wider, but you want the height and positioning to be the same as they are in the original). Visually line up any existing original features to make the match as close as possible, leaving you with minimal editing to do on the computer.

Once you've got an image you're happy with, it's time to start the post-production work. I scanned the original image and uploaded it to the computer along with the new one and then used Adobe Photoshop to put the old photograph on top of the new one. Using the soft-edged 'eraser' tool, I carefully blended the images together. I also used the 'clone stamp' tool to sample a plain bit of paving to superimpose on top of the pavement sign from the foreground of the picture (as it was too distracting).

If you don't have Adobe Photoshop, there is an ever-increasing world of free photo-editing software available to download from the Internet (I recommend either www.photoscape.org or www.gimp.org).

The resulting image has a haunting feel to it: not only is it nostalgic, but it also acts as a reminder of just how much things have changed. I gave a copy of the old photograph to the current shopkeeper who now has it proudly displayed in the shop!

OLT *Proprietor* 121

123 Urban S

t: 020-8-551 7101

BEST CORNED
BEEF 10
CHOPPED HAM. 11
BEST COOKED HAM 2
PORK SAUSAGES 3

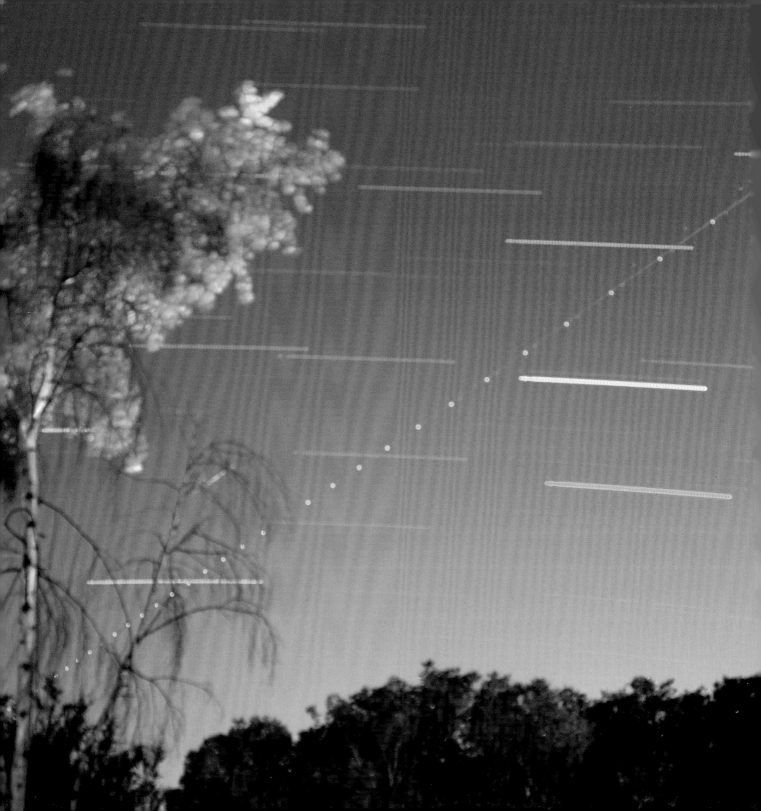

BLOG IT!

kit
- Computer with Internet connection
- Blogging software
- Some interesting photography content for your blog

Show your work to the world and perhaps even build up an army of followers to admire what you do. Blogging can be a great way for photographers to gather feedback, fresh ideas and encouragement. The more you blog, the more people will follow you. So liberate your photos from the hard drive and set them free on the World Wide Web.

Starting a photo blog is a fantastic thing to do, whether you end up recruiting an army of followers or not. A well-maintained blog will provide you with a personal archive of photographs to share with anyone you want. If you get into writing blog posts to go with your images, you'll soon see that the blog helps you gather your thoughts and share what you are passionate about.

Blogging is a two-way process; you can link up with other bloggers and even form a community where you can chat and exchange ideas. (It might sound geeky to the uninitiated, but you'd be surprised at just how addictive it is.) So get involved in the 'blogosphere'! Most bloggers allow comments to be written beneath their posts, so you can leave a link to your blog as a comment on somebody else's to help people discover it.

There are several excellent brands of free blogging software: www.blogger.com, www.wordpress.com and www.tumblr.com, to name a few. And creating your own blog is no trickier than registering for a new e-mail account. You simply sign-up and follow the onscreen directions. If you get stuck, fear not – there are generally plenty of troubleshooting videos and helpful links.

Once you've got your blog up and running, create different 'pages' on it. These are static and can provide 'tabs' at the top of your home page to make your blog look more like a website.

You can use different themes and styles to give your blog a more individual look and feel – transforming it from something basic into something visually exciting.

How your blog looks is down to you. Most of the free sites offer a good selection of designs to choose from. Try using a design that helps reinforce the content of your blog.

When it comes to writing your blog posts, remember to just be yourself. It's also best to keep each post as succinct as possible to ensure you keep your viewers' attention. Hopefully this book has given you plenty of ideas for taking some fantastic photos to blog about.

Now it's over to you!

Blog
The word 'blog' comes from 'web log'. A blog is a form of online diary that works by always displaying your most recent post at the top of you blog's listing. Blogs allow you to upload almost anything you like, from writing and photographs to embedded video and audio files.

GLOSSARY

50mm f1.8 lens: This is a fixed lens (it doesn't zoom in or out – you have to use your legs for that). At f1.8 its aperture is wide, which means that you can use fast shutter speeds in low-lighting situations. It also produces a wonderfully shallow depth of field that can make for some gorgeous portraits. I highly recommend that you add this lens to your Christmas list; it retails relatively inexpensively at around £100.

Aperture: The aperture controls the amount of light that enters the camera – in a similar way to the irises of your eyes, which change in size depending on the amount of available light. In a nightclub with poor lighting, your pupils will be huge; this is because your irises have opened up to allow as much light to enter your eyes as possible in compensation for the low lighting. Conversely, on a sunny day, your pupils will be tiny (and folk will comment on your amazing eye colour); this is because your iris is trying to cut down on the amount of bright light entering.

Aperture priority mode: A semi-automatic mode on your camera's dial, this is denoted by 'A' or 'AV' (aperture value), depending on your make of DSLR. This clever little setting allows you set the aperture, which the camera expertly balances with the shutter speed to give a correct exposure. The aperture controls the depth of field in an image.

Auto mode: The camera selects its own settings. It can be wrong sometimes, so learn how to take creative control by doing more projects.

Blown-out highlight: A highlight in an image that's just solid white, with no other detail. This is normally a result of the image being over-exposed and is best avoided.

Bulb setting: Allows the shutter to remain open for as long as the shutter button is pressed. When it is in shutter priority mode, my camera has a maximum exposure time (shutter speed) of 30 seconds; if I want a longer exposure time, I have to use the bulb setting to hold down the shutter button for as long as necessary.

Catch light: This is a photographers' term that refers to the reflected light in a subject's eyes. The catch light is seen as desirable, as it draws a viewer's attention to the model's eyes and makes them stand out.

Continuous focus mode: Your clever DSLR has lots of different methods for creating shots that are sharp and in focus. In continuous focus mode your camera locks onto what it thinks is the most important part of the image and maintains focus on it. This can be useful, but unfortunately the camera isn't always right, so it might be better to use a different focussing method sometimes.

Correct exposure: This is what is considered to be the right balance of brightness and darkness in an image. Correct exposure is achieved by balancing ISO, aperture and shutter speed.

Digital noise: Occurs when you are using a high ISO setting, such as ISO 800 or 1600. This is the modern day equivalent of 'film grain' from analogue cameras. It is not always noticeable on the back of your LCD screen, but it will be when you upload your photos on a computer. It can often be seen in dark areas of a photo as speckled areas of blues and purples and is an ugly and unwanted by-product of pushing your ISO setting up too high.

DPI: 'Dots per inch'. Often used to describe the printing quality or capturing quality of a device. Generally speaking, the higher the DPI the higher the resulting photo-quality.

Exposure (time): The duration of time that the shutter remains open for (dependent on the shutter-speed setting).

Flash unit (aka flash gun): This is an external light source that can be synchronised with your camera to produce a powerful blast of light. The flash unit can be inserted in the hot shoe (the metal fixing) on top of your camera, or used off-camera by way of a camera sync cord or flash trigger and receiver. It's an expensive piece of kit but well worth it for its versatility.

f-stop: A measurement of how much light is coming into the camera when you select aperture priority mode (ie. the extent to which the aperture is open). It is perhaps the most confusing area of photography; the f-stop works in the opposite way to what you might think. A high f-stop number (such as f18) lets in only a small amount of light, while a low number (such as f1.8) lets in a large amount of light.

ISO: Stands for the 'International Standardisation Organisation'. Catchy, eh? ISO on your DSLR is actually a reference to the old days when film was a necessity for cameras. You would go and buy film with different ISO depending on where you were going to shoot: summer holidays abroad might be ISO 100 or 200; while filming a gig at night might be ISO 800. Your fancy DSLR pays homage to the good old days and sticks pretty much to the traditional ISO numbering system. Changing the ISO setting can increase or decrease the camera's sensitivity to light and alter the exposure. However, increasing the ISO also increases the amount of digital noise that will appear in your photos.

Hair light: This is used in portrait photography to illuminate a subject's hair, and also to make him or her stand out from the background.

Key light: In any lighting set-up the key light is the brightest light. It could be sunlight through a window, a big ceiling light or the light from a flash unit. Additional lights act as fills and highlighters to illuminate other parts of the scene.

Large depth of field: Refers to the fact that a large portion of the image is in focus. Large depths of field are obtained by setting a high f-stop number (such as f22) to give a very narrow aperture. A large depth of field is typically used in landscape photography, where both the foreground and background are in focus.

Macro lens: A macro lens will enable a photographer to take close-up shots. It is often used to take pictures of small objects, like bugs and flowers.

Manual mode: Allows you to take total control and select all your own camera settings.

Negative space: The space between two subjects or around a single subject.

Neutral density filter: This is a filter that can be attached to the end of a camera's lens. It is particularly useful on bright, sunny days because it acts like a pair of sunglasses for the camera, cutting down the amount of light entering it. This might be useful if you want to use a shallow depth of field or a slow shutter speed on a very bright day.

Photogram: A camera-less photography technique in which objects are placed upon a sheet of light-sensitive paper and then exposed to light. The objects are then removed and the image on the paper is set by soaking the paper in water. The resulting image looks like a negative, because the areas that were exposed to the light are dark, while the areas that were covered are white.

Pilot button: The pilot button on a flash unit fires a flash of light. It's a good way to check that the flash is working and is also useful when you come to creating several of the projects in this book, such as Light Stencils (p186).

Reportage photography: From the French word for 'reporting', this term is often used to describe documentary photography that's been captured as an event unfolds.

Ring flash: This type of light is popular in fashion and portrait photography. The ring flash produces a flattering circle of light, which softens shadows around the model. For more information, see p140.

Shallow depth of field: Refers to only a small section of an image looking crisp and in-focus. This is usually obtained by having a low f-stop number (such as f5.6) that gives a wide aperture. A shallow depth of field is typically used to create flattering portrait pictures, (see Clam-Shell Lighting, p166) where distracting backgrounds are in soft focus and the subject is in sharp focus.

Shutter burst: When you take a shot you usually 'click' and move on. But by setting your camera to shutter burst, you'll be able to shoot continuously for as long as you press the shutter button. This is handy if you are at a sporting event: instead of having to take single shots constantly, you're able to press the shutter button and continuously take shots for a short but action-filled period of time, thus maximising your chances of capturing the perfect shot. The number of shots per second depends on your camera. Check your camera's instructions manual to find out how to set your camera to shutter burst.

Shutter priority mode: A semi-automatic mode on your camera's dial, it is denoted by 'S' or 'TV' (time value), depending on your make of DSLR. Set the shutter speed you want and the camera figures out the correct aperture.

Shutter release cable: A length of cord that inserts into your camera at one end and has a switch at the other that replicates the functions of the camera's shutter button. The main advantage of using this bit of kit is that it cuts out camera shake because you're not touching the camera when you press the shutter release button. Having a completely steady camera is useful when you are shooting a long exposure (see Star Stacker, p200). It also allows you to take a shot while standing at a distance from the camera, which is very handy for self portraits (see p58) and the Drip project (see p138).

Shutter speed: A camera's shutter acts a little like curtains, opening to expose the light sensor in the back of your camera to light. The speed at which the 'curtains' open and close is referred to as the shutter speed (or exposure time). Shutter speeds are normally measured as a fraction of a second (such as 1/125). Fast shutter speeds freeze motion (see Drip, p138) and are frequently used in sports photography, while slow shutter speeds allow for motion blur (see Blurred Motion, p74, and Panning Shots, p76).

Single-point focussing: Most cameras have an automatic focus-point selection by which the camera chooses an area of the scene to be in focus. Unfortunately, the camera can often choose the wrong area, so don't leave it to chance – check your camera's instructions manual to find out how to override this setting so that you can choose which single point should be in focus.

Softbox: Available in all sorts of shapes and sizes (though usually square or rectangular), softboxes diffuse the light from a flash unit – bouncing it around internally before passing it through a semi-opaque front panel – to create a soft and even light for photos.

White balance: If any of your images have had a blue or green tinge to them it's because different light sources (light bulbs, strip lighting, daylight, and so on) give off slightly different colours (or temperatures). Our eyes are able to adjust to these slight changes in light-colour, and the same can generally be said for a camera when it's set to automatic white balance. However, 'Auto WB' isn't always accurate, so knowing how to control the white balance manually is a good thing as it enables you to seize creative control. See your camera's instructions manual to find out how.

INDEX

Bob Books
Your Life in Hardback

Turn your photos into a unique
photobook. You can even share and sell
your creations via the online Bob Bookshop.
Bob Books are the perfect platform to showcase
your portfolios, special occasions or travel photos.

Photobooks are available in hardback, paperback and lay-flat
photographic paper. Download our free Bob Designer Software or
select from our other book-designing options via our website:

www.bobbooks.co.uk.

ACKNOWLEDGEMENTS

Photocrafty

Concept, writing and photography by: Sue Venables

Managing Editor: Sophie Dawson
Design & Cover: Harriet Yeomans
Proofreader: Leanne Bryan
Indexer: Diana LeCore
Marketing: Shelley Bowdler
Publisher: Jonathan Knight

Published by: Punk Publishing, 3 The Yard,
Pegasus Place, London SE11 5SD

All photographs © Sue Venables except p168-171
© Wendy Venables reproduced with kind permission,
and vintage photo p213 from personal archive.
'We Can Do It!' p99, J Howard Miller.

The publishers and author have done their best to
ensure the accuracy of all information in *Photocrafty*.
However, they can accept no responsibility for any
injury, loss or inconvenience sustained by anyone as
a result of information contained in this book.

Punk Publishing takes its environmental responsibilities
seriously. This book has been printed on paper made
from renewable sources and we continue to work with
our printers to reduce our overall environmental impact.

SPECIAL THANKS

to Kerry for being photogenic as well as supportive
– two big assets for assisting in the creation of a
photography book. Thanks to everyone who appears
on these pages, and to all those who have offered me
their time, encouragement and ideas – I couldn't have
done it without you.

Also, a big thank you to the inner sanctum: Mum, Dad,
Lou, Wend, Thom, Lesley, Anna, Liv, Julie, Ness, Uncle
Ginge and Aunty Gwen, for a myriad of reasons. Thanks
to Caroline for the expert advice.

A massive thank you to the Punk team, especially, to
Jono for giving me this opportunity, to Sophie who
got the project off the ground and made sense of my
writing, and to Harriet for making it all look fabulous.